Charles Meryon and Jean-Francois Millet

Etchings of Urban and Rural 19th-Century France

edited by
Patricia Phagan

with essays by
William U. Eiland
S. William Pelletier

Georgia Museum of Art
The University of Georgia

Exhibition Itinerary:

Georgia Museum of Art
University of Georgia
Athens, Georgia
December 12, 1992 - January 19, 1993

Gertrude Herbert Institute of Art
Augusta, Georgia
March 18 - May 1, 1994

Madison-Morgan Cultural Center
Madison, Georgia
May 8 - June 19, 1994

Chattahoochee Valley Art Museum
LaGrange, Georgia
August 5 - September 18, 1994

This project is supported in part
by the Georgia Council for the Arts
through the appropriations of the
Georgia General Assembly through
the National Endowment
for the Arts.

*Charles Meryon and Jean-François
Millet: Etchings of Urban and Rural
19th-Century France*
Designed by Keith Greenstein
and Leigh Ann McCowen.
Typeset in Novarese and Clearface.
Printed on Karma by University Printing,
University of Georgia.

Cover photography by Dennis O'Kain.
Photographs for catalogue numbers
17, 18, 30 provided by the New York Public Library.

Library of Congress No. 92-39756
ISBN 0-915977-10-9

Cover: Charles Meryon
 Le Stryge (The Vampire), 1853
 (Cat. no. 2)
 Etching in dark brown ink on old, pale green paper
 169 × 129 mm. (platemark)
 D-W 23 iv/viii; S 27 v/x
 Collection of Dr. and Mrs. S. William Pelletier

Lenders to the Exhibition

Dr. and Mrs. S. William Pelletier, Athens, Georgia

S. P. Avery Collection, Miriam and Ira D. Wallach Division of Art, Prints and Photographs, The New York Public Library, Astor, Lenox and Tilden Foundations

Frank Raysor II, New York, New York

Contents

Introduction and Acknowledgements

Patricia Phagan

In a phase of sweeping change, Paris in the middle of the 19th century experienced a surge of newcomers from the countryside, a boom in economic prosperity among the middle and upper classes, and the vast rebuilding of the oldest parts of the city. Two studies from the 1980s complement earlier writings and analyze the representation of the urban in French art during this period. Dennis Paul Costanzo wrote of the attitudes, print media, and rebuilding program which prompted the changes in pictorial images of Paris during the Second Empire. Bonnie L. Grad and Timothy Riggs discussed the changing attitudes toward the urban as well as the rural in 19th-century France by studying contemporary prints and photographs. In focusing primarily upon Jean-François Millet and Gustave Courbet, the art historian Robert Herbert, in a series of earlier works, emphasized the idea that French artists at mid-century chose the much-discussed peasant as a symbol of those social and industrial changes that were occurring.

When S. William Pelletier, long a supporter of the Georgia Museum of Art, suggested an exhibition of prints from his collection of Millet and Charles Meryon, I considered it an opportunity to approach the urban and the rural as they pertain to two important etchers of the 1850s. These changes in Parisian and French life are set into a broad context in the accompanying essay by William U. Eiland. In his biographical essays, entries, and cataloguing notes, Dr. Pelletier informs us of the personal backgrounds of each artist and of specific prints in the exhibition.

Meryon and Millet created most of their well-known etchings in or near Paris during the 1850s. Meryon was raised in Paris and lived most of the decade in the heart of the city. Indeed, by July 1849, he had moved near the Pantheon, to 26, rue Neuve Saint-Etienne-du-Mont, the address inscribed on several prints in the exhibition. From 1850 to 1854, he devoted himself to etching a series of prints of Paris, called *Eaux-fortes sur Paris*, for which he created elaborately detailed drawings. Millet, from a small village in Normandy, resided off and on in Paris as a young man. In the same year that Meryon moved to his new quarters, Millet had settled in the small rural community of Barbizon. During the 26 years that he lived there, he visited Paris intermittently. The dates of his early prints are uncertain, though a few appear to have been done in Paris around 1850. Around 1855-1856, however, Millet focused his attention on a series of etchings. At the urging of his friend Alfred Sensier, Millet created *La Couseuse* (cat. no. 25), *La Baratteuse* (cat. no. 26), *Le Paysan Rentrant du Fumier* (cat. no. 27), *Les Glaneuses* (cat. no. 28), *Les Bêcheurs* (cat. no. 29), *La Veillée* (cat. no. 30), *La Cardeuse* (cat. no. 31), and *La Gardeuse d'Oies* (cat. no. 32), generally based upon his own drawings or paintings. In the 1860s, Millet executed his last four plates as commissions.

In 1848, both Meryon and Millet lived in Paris and experienced the turbulent Revolution of June 1848. Meryon was a National Guardsman during the conflict while Millet fought on the barricades. With the uprising of workers against the coalition government, the poorer sections of Paris became a battlefield. Harshly suppressed, the uprising was followed by the election of Louis Napoleon as president, the *coup d'etat* by him in

Meryon and Millet

December 1851, and, from December 1852 until September 1870, Louis Napoleon's reign as Emperor Napoleon III. During his rule, known as the Second Empire, there existed marked prosperity for the few, in contrast to the large numbers of peasants and urban-industrial workers, whose lives improved relatively little. Seeking opportunities, the French peasants moved to the city in greater numbers, squeezing into older areas which became crowded and crime-ridden. In the 1850s, the prefect of the Seine district, Baron Georges-Eugène Haussmann, led a phenomenal program of architectural change to make room for the new populations. Thousands of buildings were destroyed and new ones erected to accommodate them.

With the influx of new peoples and the further crowding of the city, urban subjects in French art increased. They figured prominently in the Paris Salon exhibitions. For example, in the Salon of 1850-1851, Ernest Meissonier showed a canvas depicting revolutionaries of the June insurrection sprawled on a drab Paris street (*The Barricade, Rue de la Mortellerie [June 1848]*, Musée du Louvre, Paris). References to urban subjects appear more often in prints and photographs, however. Corresponding to the Meissonier oil is an etching and drypoint, *Barricade*, by Adolphe Hervier, created the month of the fight. Grad and Riggs show that many printmakers at mid-century viewed the city rather darkly. The gloomy perspectives of these artists recall the thoughts of influential thinkers such as Charles Fourier who considered the building of communities in the country more conducive to one's well-being than the limitations of the crowded city. This interpretation of the urban setting as an alienating place was expressed particularly well in Meryon's Paris set of etchings and in lithographs by Gustave Doré.

The events of 1848 also lifted the country dweller into the consciousness of many urban residents, including sympathetic artists. Those peasants who remained in the countryside had strongly opposed the new, coalition French government of February 1848, and they became increasingly hostile. Their power was such that with the support of their votes, Louis Napoleon was elected president.

References in mid-century French art to rural life occur frequently. For example, Millet, in his paintings, drawings, and etchings of rustic life, responded to memories of his country upbringing in Normandy and to the rural ambience of Barbizon. With his important paintings, *The Stone-breakers* (formerly, Dresden Museum; destroyed in World War Two) and *A Burial at Ornans* (Musée du Louvre, Paris), Gustave Courbet portrayed rural workers in an unromantic fashion laboring outside on the road and paying final respects at an interment. With the June revolution still in the air, many middle-class critics viewed these pictures with suspicion. Interest in peasant themes was further expressed at mid-century with a surge of interest in previous artists who dealt with peasant imagery, such as the 17th-century Dutch etcher Adriaen van Ostade and the Le Nain brothers of 18th-century France. For example, Léopold Flameng, a good friend and supporter of Charles Meryon, in 1860 created an etching after the Le Nain painting, *La Nativité*.

Etching, a technique used in decorating armor and guns, rose to prominence in the 17th century in Italy and Holland. Though there are many steps involved in creating an etching, generally, an artist uses an etching needle to scratch a design into a waxy ground that coats a copper plate; he or she then immerses the plate into acid which bites into the design; and after having inked and wiped the plate, the artist runs the plate, covered with dampened paper, through a press. Rembrandt, especially, used the medium to its fullest potential as a vehicle for seemingly effortless drawing. In the 18th century, outside of Italy, artists used etching in this free manner far less, preferring to create firm, burin-like lines or to incorporate etching in the far more controlled reproductive engravings which dominated the period. Gradually, however, more and more artists—both neo-classicists and romanticists—experimented with the medium, finding in it an extension of their drawing. Finally, in the 1860s in Paris, etching became a popular trend.

In his review of etching at the Salon of 1861, the critic Philippe Burty in the new

journal, *Gazette des Beaux-Arts*, noted the surge of popularity of etching. "*Tout le monde lui sourit*" ("All the world smiles at it"), he stated. In the same year when the magazine commissioned *La Bouillie* (cat. no. 33) by Millet, its editor, Charles Blanc, wrote that contemporary artists and collectors sought etchings because they liked the intimate and improvisational qualities that could be achieved through them. A few painters, Blanc noted, saw that with etching they themselves could sketch easily on the coated plates and, in essence, create many drawings of the same design. A measure of the attitude toward the medium was expressed in 1862 by the critic Charles Baudelaire who cautioned against too much popularity for etching; he hoped it would not become as popular in Paris as it was with the "ladies" in London. That year, the Société des Aquafortistes was formed in Paris, dedicated to promoting the medium and publishing monthly portfolios of original etchings by participating artists, many of whom were among the most experimental artists of the time. The Société published Millet's *La Grande Bergère* (cat. no. 34) in 1861 and *Ministère de la Marine* (not in the exhibition) by Meryon in 1865, the year he joined.

In the 1850s, however, creative etching had not yet become fashionable. It appears that reproductive engraving and etching still dominated the world of the connoisseur, as evidenced by the notices in the *Gazette des Beaux-Arts*. In fact, as an apprentice, Meryon had etched the title page of a series of prints after Dampierre by his instructor, Eugène Bléry. The experience inspired Meryon in the direction of creating a set of prints of Paris. The relatively new, draftsmanly medium of lithography also attracted many, particularly romanticists and French caricaturists.

The resurgence of etching as a creative medium evolved fitfully. Landscape painters living in or near Barbizon began to etch in the 1830s and 1840s. Others also turned to the medium. In 1835, the romantic landscapist Paul Huet created an album of six etchings, after which he gained increasing recognition for his prints. In 1843, Hervier published an album of eight etchings, entitled *Croquis de voyage*. Bléry, introduced to etching after 1826, executed detailed, directly-drawn plates of views of the forest of Fontainebleau. Indeed, albums of etchings, recalling earlier volumes devoted to picturesque scenes of French architecture and landscape, appear to have increased at mid-century. In 1850, Bléry created his set of prints after Dampierre. In 1850 and 1851, the Barbizon painter Charles Daubigny published landscape etchings in two albums. From 1850 to 1854, Meryon executed the prints of the Paris set. In 1859-1860, his friend, Flameng, published a series of 26 etchings of Paris, called *Paris qui s'en va et Paris qui vient*. In 1858, James McNeill Whistler created his "French set," a suite of etchings of Paris printed by Auguste Delâtre, the master printer. Throughout the decade, Félix Bracquemond created intriguing, often mysterious prints and offered technical advice to artists new to the medium.

In the 1850s, when Meryon created the Paris set, there existed a long tradition of printed depictions of the French city, seen early in topographical views and maps. Gradually, printmakers began to portray Paris cityscapes in more picturesque terms. For example, in the 17th century, the Dutch etcher Reynier Nooms (known as Zeeman), created a series of architectural etchings of Amsterdam and Paris. His views present solid, medieval buildings around which bustle small energetic figures of boatmen and travellers. From Italy, the Baroque artists Jacques Callot and Stefano Della Bella were among several artists of the time who etched views of the Seine, the Pont-Neuf, and other attractions. In the early part of the 19th century, peaceful views of Paris grew in popularity, and European artists created watercolors and etched albums of Parisian scenes. At mid-century, however, one frequently sees views which introduce a note of uncertainty. For example, Daubigny in the 1840s created dark, often threatening prints for the books, *Les Mystères de Paris*, *Notre-Dame de Paris*, and *Le Diable à Paris*. In *Rue de la Vieille Lanterne*, a print from his album on Paris, Flameng suggested a crime-ridden street with menacing, claustrophobic tones.

Rural imagery had appeared in etchings by Claude Lorraine in the 17th century and by previous artists, but it was the Dutch etcher

Meryon and Millet

van Ostade who focused his attention exclusively on scenes of peasants at leisure, seeking alms, and in quiet interior spaces. Extraordinarily popular in the first half of the 19th century, scenes of rustic life following the Dutch traditions of van Ostade and Rembrandt flourished. For example, in 1843, Jacque, Millet's friend and a prolific etcher, executed two albums of prints of rural scenes. He continued to create etchings based on his knowledge of the rural countryside and of the Dutch etchers. In addition, Alexandre Gabriel Decamps and Hervier executed several plates depicting genre during these years.

From 1850 to 1854, Meryon created the prints that formed his Paris set. The twelve major plates focus upon medieval and Renaissance buildings and bridges in the old sections of Paris in and around the Ile de la Cité. With their imposing architectural masses and inconspicuous social dramas, the prints exude a close, often forbidding air. In the same era, in the 1850s and early 1860s, Millet executed his series of etchings of peasant life. Of distinctly contrasting mood, Millet's prints present an atmosphere of calmness and suggest a certain solidity of character set with warm tones and airy, fresh settings.

Signs of the urban-industrial revolution are apparent in works by both artists. Meryon expressed it with images of belting smokestacks and decaying urban foundations whereas Millet responded by turning his back on the city and choosing his vision of the life of the peasants as a constant theme. Furthermore, each chose to dwell on the old ways. Meryon, partially inspired by his admiration of Victor Hugo's 1831 novel, *Notre-Dame de Paris*, chose for his major arena old Paris, especially the cathedral and its environs. His prints may also be viewed as works created within the widespread Gothic Revival of the early and mid-century. Whereas Meryon looked to old Paris, Millet chose to etch peasants solemnly engaged in the age-old tasks of churning butter, spinning wool, or breaking up the soil for spring planting. Though Meryon and Millet present different views, one urban and the other rural, the undercurrents of nostalgia in their prints intertwine and make sense when seen from the vantage point of a drastically changing world.

It is also interesting to point out that Paris was the training-ground for both artists. Having met Bléry at the Salon of 1848, Meryon trained for about six months under him, learning the craft by copying etchings by Salvator Rosa, Adriaen van de Velde, Zeeman, and others. On the other hand, Millet went to Paris in 1837 to study and he very probably learned to etch from his friend, Jacque. From Millet's letters, we know that the noise, narrowness of the streets, jostling horses and carriages, and grime of the city disagreed with him. While both learned how to etch in Paris, they also both looked to experts associated with the craft and art of printmaking. For example, although Meryon and Millet made proofs themselves, they used the professional printer Delâtre to print many of their plates. In 1861, for instance, Delâtre printed an edition of Meryon's Paris set. Not only did their paths intersect in the choice of a printer, but the year before, Meryon printed a set of plates by Millet, the idea being urged by Sensier who was familiar with Meryon's sensitive printing.

It is also appropriate to remark that Dr. Pelletier collected most of these prints on view and so it is his choice of artist, his reasoning, which provides still another point of departure for comparing the etchings of Meryon and Millet. A connoisseur who values exquisite draftsmanship, careful printing, and representational accuracy, he recalls those earlier American collectors, of the 1920s, especially, who admired and sought these qualities in the print boom of the time. Prints by these later artists, such as John Taylor Arms and Gerald Brockhurst, stand in pointed contrast to those contemporary prints by artists whose works expressed other concerns, whether modernist or social. A sense of the poetic in "everyday life" seems to underly many of Dr. Pelletier's choices, whether they be Meryon and Millet or Rembrandt and van Ostade, whose etchings also form part of his print collection.

For his patience and goodwill, I would like to thank S. William Pelletier, who has supported the museum and its print collecting for around 25 years. Many thanks go, too, to William Eiland, director of the museum, who

enthusiastically supported the exhibition. Lenders to the exhibition also include Frank Raysor II and the New York Public Library. To them I am immensely grateful. At the latter, I particularly thank Roberta Waddell, Margaret Glover, Starr Figura, Barbara Woytowicz, Wayne Furman, and the Department of Copy Services. At the Georgia Museum of Art, I appreciate the unstinting energies of Lynne Bowenkamp, Annelies Mondi, Patricia Wright, and Gail Bridges. Thanks go, too, to Bonnie Uter, Keith Greenstein, and Leigh Ann McCowen for coordinating the complex task of designing and publishing the catalogue.

Patricia Phagan
Curator of Prints and Drawings
Georgia Museum of Art

Works to which the author refers are listed in the Selected Bibliography.

**Meryon
and
Millet**

Reflections on a Gilded City:
The Paris of Napoleon III, Meryon, and Millet

William U. Eiland

In the middle of the 19th century, Paris was, as Baudelaire characterized her, that "most restless of capitals." No longer the city of Louis XIV and the *ancien régime*, still haunted by the grandiose, Napoleonic dream of herself as the heart of Europe, she was a city in search of itself. Saddled with a pre-revolutionary infrastructure, she faced the pressures, all too conducive to turmoil, of exploding population growth. At the same time that the seemingly endless masses from the countryside—new Parisians in search of a new life—were filling the old Paris beyond capacity, the city, like France, sought to adapt to the conditions of the Industrial Revolution, to become modern.[1] But what was the new Paris, the new France, to be? For Emperor Napoleon III, touched by his uncle's dream and ever mindful of the symbolic value of the city, Paris was to be the gilded cultural, if not military, capital of France, Europe, and the world. The Emperor saw himself as a kind of benevolent, enlightened leader who, like Augustus, might claim to have found his city of brick and left it of marble. To that well-meaning, even visionary end of a new Paris, he oversaw a massive physical transformation of a city already in the throes of social and economic change. But change is also in a sense loss, and Napoleon III's vision was not shared or understood by everyone. For some, like Charles Meryon, fixed their gaze not on the future but on the past and the Paris that was daily disappearing before their bewildered, uncomprehending eyes. To Meryon these changes were nothing more than hostile, destructive acts: his Paris was a place where evil forces gnawed at what was beautiful and good. For others it was better to escape. In the works of Jean-François Millet, Paris makes

herself felt in her absence, for his art reflects a poignant longing to find solace in the timeless rituals of the vanishing peasantry, increasingly swallowed by the rapacious city. Paris was, then, at least three cities, at least three visions of one place seen from different vantage points: Napoleon dreamed about the future, Meryon looked to the past, and Millet turned away.

Once again, in 1848, a Parisian cold turned into European pneumonia. The Republicans in France, and their working-class allies, had grown tired of the authoritarianism, conservatism, and corruption of the regime of the "Citizen-King," Louis-Philippe. On February 24th, a new revolution broke out and forced Louis-Philippe to flee to England, as Charles X had done at the beginning of the July Monarchy in 1830. Proclaiming a Second French Republic, the Republicans of 1848 held an election for a Constituent Assembly that soon forgot its promises and appeared to turn its back on the urban proletariat. In the bloody fighting of the June Days in Paris, the protests of the working class were brutally quashed. A regime born of revolution suppressed the least powerful of its supporters and failed to find reconciliation for the disparate elements demanding representation.

A compromise put forward by the monarchists, who would perhaps have preferred a return to the *ancien régime*, was found in the person of Louis-Napoléon Bonaparte, whose most attractive qualifications for presidency of the new republic was his magical last name, one that appealed particularly to the voters in the countryside, who were hostile to the coalition

government of the Second French Republic. By December, he had become the head of the Republic, and four years later, proclaimed himself Emperor of the Second French Empire. From 1848 until 1870, the fortunes of France, and to a large part those of Europe, rested on the decisions of this mild-mannered, rather dapper nephew of the great Napoleon, who had himself transformed the continent.

Excoriated by Victor Hugo from his exile on Jersey as "Napoléon le Petit," quasi-deified by Charles Sainte-Beuve as "Saint-Simon on Horseback," the new emperor was a well-meaning man who was probably never able to reconcile his sympathy for socialism with his belief in a "Bonapartism" of control and centralization. He reigned over a country in the throes of profound material, cultural, and physical change, nowhere more noticeable than in Paris. A period of transition, the Second Empire witnessed political and cultural debates over such questions as progress versus tradition, authority versus democracy, city versus country, and social and economic justice versus the rights of property holders and the industrial magnates. From the beginning of his regime, Napoleon III was considered, and thought of himself, as a moderating counterbalance to the reaction of the arch-conservatives and the excesses of the radical revolutionaries. Eventually, it can be argued, Napoleon's aggressive and wrong-headed foreign policy accounts for the low esteem in which the Second Empire is held, for it was during this period of relative domestic stability that France consolidated its laws, increased its economic power, and added immeasurably to its reputation as Europe's cultural center.

One of the basic tenets of Napoleon III's Bonapartism was that economic vitality and prosperity were by-products of his imperial system. The Emperor himself believed strongly that government, while maintaining order, must encourage economic expansion, and that such activity must of necessity "trickle down" to the masses. Of particular concern to him were the living conditions of the urban and rural working people, and he expressed often his belief that real support for his regime came from the twenty-nine million Frenchmen who were illiterate and less well-off than the other million educated, prosperous citizens. While the bourgeoisie flourished between 1850 and 1870, the working class swelled, but its members did not share proportionally in the new wealth being generated from above.

Paris was the only desirable destination for the Empire's *arrivistes* just as it was mecca for the rural under- and unemployed. After 1850 fashionable and influential Parisians were rarely bored because social life in the capital was rarely boring.[2] After the somberness of the reign of Louis-Philippe and the turmoil of the revolutionary years, the French, particularly the expanding middle class, were ready to enjoy themselves. The new Emperor and his court provided that amusement in the form of elaborate balls, extravagant public *fetes* and *soirées*, and endless charades. The French were titillated by what appeared to be the public display of private vices. Rachel, la Castiglione, la Païva, and *Nana* epitomized the decadence of Paris, and it is no accident that the word *demi-mondaine* first appeared in the vocabulary of Parisians in the 1850s. One anecdote told as emblematic of the regime and its facade of trendy intellectualism recounts the adventures of a courtesan who declined the advances of a government official because she was in too much haste to return home and read Renan's *Life of Jesus*, which currently enjoyed a simultaneous *succès d'estime* and *succès de scandale*. The young woman explained her haste to finish the book because she had just gotten to the good part and wanted to find out how the story ended.

The extravagance and the glitter were indicative of an oft-remarked characteristic of the reign of Napoleon III, namely the greater prosperity and conspicuous consumption of French society during the period. The Bonapartes lavishly displayed this new wealth, and in a nation where the legitimist aristocracy remained aloof, the imperial circle became the embodiment of the desire to be amused and to spend copiously in search of entertainment. Napoleon III and his court symbolized the grandeur of France, and it was in the Emperor's own interest to display as vividly as possible the prosperity engendered by his regime. He did not restrain himself from impressing not only the nation but Europe as well with the support his regime gave to

industry and to art. As Emperor, he had the means to demonstrate and to augment the glory of France, and in so doing to fulfill one of the basic tenets of Bonapartism that France was the natural leader of Europe whether economically, militarily, or culturally.

The *coup d'etat* of December 2, 1852 made Louis-Napoléon not only Emperor of the French but also a very wealthy man. Along with the imperial crown came "palaces, châteaux, houses, domaines, and manufactures."[3] The endowments of the crown did not stop at just the buildings, but also their contents: diamonds, pearls, statues, museums, libraries, and paintings, which, now in effect, belonged to the Emperor.[4] The sovereign was the possessor of monuments and art objects formerly belonging to the state, and for the most part he could do with them as he liked, with the assumption that none would be alienated, destroyed, or left in disrepair. Maintenance on all these palaces, museums, and paintings was provided through the civil list, administered by and for the Emperor. In short, by virtue of his seizure of the imperial power, he controlled within the appanage of the crown the art treasures of France. In this sense alone, considerable artistic centralization already had occurred, and it was ultimately the new Emperor who would decide to augment or to diminish that collection. As head of the state and as possessor of the endowment of the crown, he effectively stimulated the drive to administrative unity of the arts by serving as a central figure in any decisions affecting them. To a degree no other head of state had, this sovereign actively sought to encourage the fine arts, as long, of course, as they served his aims and ideals.

From all available accounts Napoleon III was practically devoid of any artistic understanding whatsoever, but to his credit at least he realized it and, without apologizing, sought the advice of those he believed more capable of cultural policy-making. As Emperor of the French and as successor to the first Bonaparte, he realized the importance of the arts in preserving the prestige of France. What he lacked in artistic temperament, however, he tried to make up for by tolerance and a regard for the tastes of others. In fact, the Emperor's good intentions are evident throughout the reign, and his good will towards artists is demonstrable. He was well-disposed to artists and aesthetes, and he often sought their company in Paris, Compiègne, and Biarritz. If he actually preferred the conversation of the historians or scientists, it was because he could better understand their language. Napoleon III was not a stupid man, but with limited aesthetic sensitivity of his own he failed to recognize genuine creativity and originality in others. If he was ill-served by mediocre artists, it was not from any desire to denigrate or to ignore the artistic forces of change and rebellion that we now admire; rather, he, as well as Empress Eugenie, were ignorant of those forces.

The Emperor, who always looked over his shoulder to see the shadow of his uncle, faced an entirely different set of realities in the Europe of 1853, in part, realities bequeathed by Napoleon I. In his famous socialist pamphlet, "On the Extinction of Poverty in France," Napoleon III envisioned a sort of Saint-Simonian utopia where the utility of the arts would be as important as their abilities to distract, to educate, or to inspire.[5] Napoleon III's economic and social policy for France involved directly his concept of the application of the arts, particularly the plastic arts, for the embellishment and decoration of his capital. Paris was to be the center of Europe, and her society would prove the standard by which the other courts of Europe would be judged. Aside from the diplomatic components in this tactic, Napoleon was well aware of the salutary effect such a policy would have on the domestic front. Desiring a capital where money flowed, the Emperor thought openly that the luxury of the rich made work for the laboring classes. Whether consciously or not, he was following a simplified version of the Mandevillian thesis of *The Fable of the Bees*, holding that the rich stimulated the economy by their demands for luxury goods. The drones or workers of society benefitted in proportion to the excessive spending of the rich and powerful. The desire of the latter for luxury goods gainfully employed many artisans and workers, and the economy was propelled by the indolence and material desires of the rich. He fully expected that the new aristocracy of the Empire, the new dignitaries of the state, would indulge in conspicuous consumption.

His ministers and agents were well paid, but he expected them to spend those enormous salaries and give work to the poor.[6]

For example, the Prince Jerome Bonaparte was the recipient of an immense endowment from the Crown, ostensibly for the upkeep of the Palais-Royal, his residence, and the Emperor reproached him for not receiving society more often, for not spending more of that endowment.[7] For the Emperor, riches carried with them the concomitant responsibility of spending. The duty of the rich is to spend; a principle of the condition of affluence is that expenditure makes work for the less affluent ranks of society. The transformation of Paris had a less obvious purpose, therefore, than simply making it a more elegant capital for a *parvenu* court. It would also help establish a contented and prosperous working class that rallied to the Empire which had given it work and the prospect of upward social mobility.

Official art that met the censorship standards of the early Empire was rarely critical and could hardly be termed revolutionary or even progressive. And, as stimuli to official art and society in the Second Empire, Napoleon III, his family, and ministers set the standards, inspired such creativity as they could, and, finally, paid the sinecures and commissions that sustained not only favored artists but others as well.

Personally, the Emperor was always more interested in the applied sciences and history than in art and letters. Alluding both to his mother's real love of music and his own distaste, he said music was "Like gout, it skips a generation."[8] Nonetheless, he personally intervened with the directorship of the Opera to have Wagner's *Tannhäuser* produced, even though the opera would eventually cost his government a great deal of money and precipitate a cultural crisis. His understanding of painting was no greater than his understanding of music. His favorite painter was Winterhalter, whose competent but uninspired portraits became the official ones of the imperial couple. When a new portrait of the Emperor became necessary, he sat for both Flandrin and Cabanel, highly respected artists of the period. When both portraits had

been finished, he professed his inability to judge either one on artistic merits alone but decided that he preferred the one by Cabanel because the other made him look too sad.[9] Every year he set aside 100,000 francs for acquisitions by the Comte de Nieuwerkerke, the Director of the Louvre, this apart from the money he spent from his personal funds at the end of every Salon to buy paintings that had particularly pleased him.[10] Recognizing his own shortcomings, Napoleon depended a great deal on Nieuwerkerke for advice on the *beaux-arts*, but on the one occasion when he fortunately disregarded Nieuwerkerke entirely—in his decision to buy the famed Campana Collection—he quickly compensated by increasing the director's power.

Napoleon's government is nowadays criticized by art historians for its disregard of the great painters of his day. Courbet's castigation of the Empire is well-known, as is Baudelaire's, both of whose opinions are only partially justified. In 1863, in the brouhaha over the Salon of that year, it is the emperor's tolerance that one discerns rather than his malevolence toward new schools of painters. Again, he intervened because he believed that the anger and rage of the refused painters must be assuaged. The polemic had reached into his cabinet, the Minister Vaillant bringing the problem to his attention.[11] The jury for the Salon had refused some 2,800 paintings deeming them unworthy of official exposition. Predictable in his concern for fairness, the Emperor himself visited the Salon to view not only the accepted paintings but also those rejected. He decided that in spite of his incompetence he had to intervene because so many painters were angry, even though official opinion had deemed their refused works unworthy. Not wanting to offend either group, he compromised and ordered that the famous Salon des Réfusés be organized. This novel decision was a surprising one both for the academicians who composed the jury and for the refused artists themselves. He decided that fifteen days after the opening of the official Salon, the Salon des Réfusés would open to exhibit any paintings not accepted officially. Predictably, the officials of the Salon obstructed this upstart exposition and minimized the importance of the works

exhibited there. Generally, however, the Emperor's decision was a very popular one, and the art world was in a state bordering on ecstasy, considering that in some way imperial sanction had been given to heretofore unrecognized artists. So many entries were received for this second Salon that there was hardly space to show them all, and so successful did it become that it was commonly known as *le Salon de l'Empereur*.

But because Napoleon gave new artists a public arena did not mean he understood them. Edouard Manet exhibited three paintings at the *Salon de l'Empereur*, one of which was the famous *Déjeuner sur l'herbe*, but the painting outraged the imperial couple, who judged it indecent. Thanks to their judgment, which was broadcast generally, the painting became the subject of considerable ridicule, sarcasm, and abuse—in short, a true *succès de scandale*, since unmistakably, the imperial displeasure had made Manet famous.

No artist who desired to live by earnings from his works could afford to ignore the Salons; for some without influential patrons of their own or at the beginning of their careers, governmental assistance was the only recourse to penury and starvation. Both Meryon and Millet benefitted in small measure from such assistance. Daniel Fox maintains that artists, those men engaged in the *beaux-arts*, were an effective and articulate pressure group during the Second Empire, especially since Napoleon's reign paid lip service to the ideals of 1848 and the widely-diffused attitude of a more democratic artistic establishment. For Fox, the "Salon des Réfusés was the result of a tolerant, not an authoritarian, government art policy."[12] Further, he asserts, it prefigured modern purchasing policies of liberality in acquiring works of art. His conclusion regarding the development of patronage in the nineteenth century bears noting since it applies specifically to the Second Empire:

But the nineteenth century seems to have been a period when artists achieved creative freedom while meeting the demands of a broadening and aesthetically insecure public. Artists struggled against government attempts to encourage an official style while diffusing patronage more widely. They won their fight for a liberal official arts policy, but after much frustration and many disappointments.[13]

That fight's battleground was Second Empire Paris.

For example, Napoleon III's affection for the young sculptor Carpeaux was well-known and accounted for many of the latter's commissions. Carpeaux's talent was publicly acknowledged, but of that Napoleon was only dimly aware. He simply liked the young man and often made sure his name appeared among those officially invited to Compiègne. Perhaps jealous of the imperial favor as well as of the younger man's obvious talent, official artists and architects often abused him, and some loathed him all the more for what they took to be his arrogant manner.[14] Napoleon III, however, supported him and gave him commissions at every opportunity. So well did he enjoy chatting with Carpeaux that he would often visit him while he was working. This sometimes worked in the artist's favor. Hearing of a bitter dispute between the imperial architect Lefuel and Carpeaux over the latter's *Flore*, the Emperor one day mounted the scaffold to inspect the sculptor's progress. After a rather casual conversation, the sovereign told him about his work, "C'est vraiment le Triomphe de Flore," by which witticism he meant that the Emperor supported the sculptor even in the face of his own architect's criticisms.[15]

Like her husband and despite her court admirers, the Empress Eugenie lacked artistic judgment. Her tastes tended toward the gaudy and led to a fashion, often noted in memoirs of the period, called *espagnolisme*. This romantic exoticism carried over into her artistic predilections, or perhaps, it was a direct link to her lack of judgment. One might have expected more, unfairly perhaps, from her than from the Emperor in these matters, since Mérimée had been her mother's lover and remained a fixture at the Court. As a child, she reported, Stendhal had read *La Chartreuse de Parme* to her as she sat on his knee.[16] Although her unfortunate reputation in other matters has obscured the few but real contributions that she made to the history of the decorative arts, Doña Eugenia, as Count von Hübner always referred to her, was not an uncultivated woman.

If nothing else, the Empress remembered the brief period in her youth when she joined a Fourierist *phalanstère* devoted to the rights

of women. This socialist "cell" advocated emancipation and full citizenship for women. In addition to her furtherance of women's causes with the Education Minister Victor Duruy, she, acting as regent in 1865, personally caused a sensation by decorating Rosa Bonheur, the painter, with the cross of the Legion of Honor. This honor profoundly reverberated throughout the country and was much remarked by the newspapers of the day.[17] After all, no other woman had ever been inducted into the Legion. Yet one should not read too much into the Empress' decision. Eugenie liked to surround herself with painters, and her patronage of Bonheur is only remarkable because of the painter's sex.

In spite of her early experiences with Mérimée and Stendhal,[18] Eugenie had no real taste for music, poetry, or painting. The Countess von Metternich credited her with a talent for watercolors and a certain architectural flair, but from other accounts, a portrait of her emerges as a woman who accepted others' judgment of what was aesthetically valuable and exercised her own taste only in decorating the imperial palaces. Her fondness for artists was predicated on their ability to carry out some decorating scheme that she had imagined would suit a certain room or palace. Mérimée himself was not entirely pleased with her private entertainments and considered her too eager to approve melodrama and farce at the expense of real drama and comedy.[19] What spoke to her in music, painting, and literature was only its gaudiness of style. She obviously did not share the concerns of the creative minds of her times who were later exalted, although the artists she supported were always "correct" according to official or established taste.

Because of her lack of any real artistic culture, the Empress accepted the opinions of the establishment and favored academic painters and sculptors. Since one of her responsibilities was the decoration of the imperial residences, she commissioned works from artists already given the approval of the art establishment: Cabanel, Dubuffe, Chaplain, Hébert, and Müller. Eugenie had a superstitious attachment to Marie Antoinette and preferred the period of the late eighteenth century to all others.[20] So widely known was this passion for the beheaded queen and her period that her taste was baptized "Louis XVI Impératrice."[21] The artists to whom Eugenie gave her commissions responded with alacrity to her tastes and filled her decors with flowers, *putti*, birds, and arabesques. Her private apartments, as described by Augustin Filon and others, were decorated in a peculiarly eclectic style but one in which her taste for the eighteenth century flourished. She did, however, have a painting by Ingres in her bedroom, but this attests not so much to her taste as to the strength of the *ingriste* mode in Second Empire painting.[22]

Eugenie's plans to decorate Saint-Cloud involved her in a dispute with Nieuwerkerke that demonstrated publicly a problem in imperial patronage. She insisted on borrowing from the Louvre either a Rubens or a Raphael to carry out her scheme, but Nieuwerkerke refused, saying these works belonged to the state represented by the Louvre rather than to the crown. Eugenie responded emphatically that these paintings belonged to the Emperor, who, as it turned out, had to settle the issue by ordering that she be given instead a *Sainte Anne* by Murillo.[23] Not long after, another contretemps developed over the paintings in the *Palais de la Banque*. Eugenie wanted the Poussin, the Guercino, and the Guido Reni restored and put back where they were. Nieuwerkerke, however, won this argument, insisting that copies be put there and the originals go into the Louvre.[24]

The Empress shared her husband's desire to make Paris the center of the cultural universe. Her decorating schemes were certainly not merely wifely diversions but were consciously meant to give work to artisans and artists. Napoleon III and Eugenie seized the opportunity of re-decorating the imperial residences in the early 1860s to give employment to several thousand craftsmen and to encourage through commissions native artisinal industries, especially those developing new techniques in metalwork, electroforming, and galvanic silver plating. These were precisely those innovations that held possibilities for creating relatively inexpensive "art" that would be available to more of the populace.

Social life in Paris naturally revolved around the court, but the salon of the Princess Mathilde, Napoleon's cousin, was a powerful rival. The imperial court attracted as many

artists and writers as it could, and a certain component of each group was invited to almost all court functions. These invitations were drawn up well in advance and were usually for the weeks spent at Compiègne, although Mérimée usually accompanied the court to Biarritz.[25] The invitations themselves are proof of the imperial desire to gather together men of science, letters, government, and the arts. From the departments which he administered, each minister submitted a list of distinguished men in their fields to the Empress, who then chose those she thought would make a harmonious company. Groups of guests were invited for six days and each group contained two students from the Polytechnic, Saint-Cyr, and Normale. The idea was to maintain contact between the Emperor and the illustrious minds of his day, and to give men of talent an opportunity to approach directly their sovereign with some pet project.[26] These invitations indicate a genuine desire of the Court to maintain contact with a variety of the artists of France, and although it can be argued that these invitations only represent the most superficial type of patronage, abundant evidence reveals that real government commissions often resulted from discussions with the Emperor at Compiègne or Biarritz.[27] An equally important concern was to maintain the cultural *éclat* of the imperial capital city.

Adding luster to that reputation were the gatherings in Princess Mathilde's drawing rooms. Mathilde, an avid collector of paintings, watercolors, pastels, sculpture, and drawings, distinguished between her literary and her artistic salons. To the latter she had as regular guests Meissonier, Fromentin, Carpeaux, Gavarni, Doré, J. Lefebvre, Carolus-Duran, Gérôme, and Bouguereau. Mathilde fancied herself a student of Eugène Giraud's and, in fact, painted both pastels and watercolors, some of which were exhibited in the Salons.

While the Empress devoted her attention to the decorators and cabinet-makers of Paris, Mathilde prided herself on offering social prominence to the city's artists. As a close relative of the Emperor and as the consort of his Superintendent of Fine Arts, Nieuwerkerke, she exercised direct influence on art policy during the Second Empire. As Nieuwerkerke's mistress, she wielded great power over appointments and commissions.[28]

Neither Louis XVIII, Charles I, nor Louis-Phillippe in their reigns had spent as much money on artistic activity or held the same quality salons as the Bonapartes did during the Second Empire. Whatever their tastes, as disparate as Eugenie's *espagnolisme* and Mathilde's academicism, the imperial aristocracy contributed largely to the reputation of Paris as the cultural center of Europe at mid-century. The central position of the family meant that at the head of society and government a concentration of powerful personalities existed, desiring in their different ways to cultivate and to encourage artists.

In specific artistic concerns, Napoleon III practiced the same equivocation that he did in other matters. In one thing, however, he was consistent: his desire to unify and to concentrate his power in all areas of government, including administration of the arts. He was well aware of his uncle's professed desire that the arts serve Bonapartism by associating that name with the cultural glory of France.[29] He, too, was a Saint-Simonian despot who believed strongly in the need for direction, unity, and centralization for talented men at the top, who by virtue of their positions could organize all facets of society in orderly and efficient manner. His prescription for a prosperous France called for the satisfaction of the various groups that composed her society.[30] Artists were certainly one such group, and an Emperor so thoroughly imbued with Saint-Simonian ideas could not stifle his desire to reorganize the system of state patronage.

The Emperor's will to change governmental patronage coincided with a time of enormous physical change in Paris as well. The Paris of 1850 had much more in common with the Paris of 1650 than it did with the one of 1870. Napoleon III thought of himself as a new Augustus who, having begun his reign in a city of mud and sewage, would transform it into a city of marble and gold.[31] Not incidentally, such rebuilding would also do away with the narrow streets and alleys so convenient for barricade-building. If his reign is judged harshly on all other accounts, and perhaps it should be, his greatest success may have been in the transformation of Paris into a modern city.

The completion of the Louvre, and its continuing decoration, and the building of the new Opera and the Central Market were egregious examples of these policies. In the grandiose rebuilding of Paris, however, these were but three of the showier projects. The transformation of the capital during the Second Empire revealed a fundamental, interdependent relationship between the ascendant city and the ebbing countryside.

The population of Paris in 1861 was 1,696,100 inhabitants.[32] Just thirty years earlier the population had been 861,400 people: primarily as a result of migration from the countryside, the capital had doubled in size. Not surprisingly, the city was ill-equipped to handle the new arrivals, whose very numbers alarmed native Parisians with the certain prospect of unrest. The reasons for the influx, as the government recognized, were obvious: a superabundance of jobs, higher wages, free schools, charitable organizations for the indigent, and, not least, an easy means to get there thanks to the building of railroads.[33]

The city had grown haphazardly for centuries, and in the mid-19th century betrayed its medieval character in the warren of dark alleys and the dilapidated structures of its slums. The city's ring of fortifications in its earlier years had been extended somewhat in the 18th century, but the ultimate effect had been to force more people into limited space, so much so that buildings in the central district had risen higher, public and green spaces had been all but eliminated, and streets made more crowded and dangerous. Small shops and tenement apartments vied for space in a dense area on the Right Bank, where parks and open spaces were tiny or non-existent. In the worst of the dark slum quarters around the church of Saint-Eustache, the gutters were open sewers. The well-to-do lived primarily in the western part of the city, and today's fashionable Ile de la Cité was a dismal ghetto in 1850. Tolls on the bridges between the Left and Right Banks, decaying and badly maintained streets, and poor lighting all discouraged mobility. Cesspools and cemeteries seeped and leaked into the streets and the river. Hopelessly old-fashioned, the sewage system and water supply were inextricably bound and the ostensible source of cholera epidemics during the Empire. Paris was malodorous, dangerous, and dark.

To modernize his imperial capital, Napoleon chose Baron Georges-Eugène Haussmann who in 1853 was transferred from Bordeaux to undertake the renovation of Paris. Until 1870 when he was removed from office, he oversaw one of the most remarkable building and demolition campaigns in history. His plans were so dramatic that they were not accomplished without considerable opposition, less because of any nostalgia for the old city than out of astonishment at such "irresponsible," massive expenditure. Of principle concern to Haussmann was the creation of great open spaces where broad, tree-lined boulevards intersected and where the great architectural monuments of the past and the ones of the future—the opera, the railroad stations—sat imposing in their grandiose solidity. The monuments, palaces, and museums would serve as the anchors for the new city and proclaim the accomplishments and grandeur of the regime, especially with the profusion of emblematic "Ns" and imperial eagles. Light and space came to the city in parks and public places and in the newly cleared areas around more important buildings. Existing tenements were condemned and demolished, new sewage and water systems installed, and buildings erected according to uniform standards. The workers and poorer classes of the central city were relocated to the periphery where they were joined in increasing numbers by peasants tired of the countryside's toil and low wages. This area would become *le cordon rouge*, or the so-called "red belt" constricting the city of the bourgeoisie and aristocracy.

Modern Paris is one of the most striking legacies of the Second Empire. The wide boulevards, the orderly parks, and the monumental vistas that please modern inhabitant and visitor alike are attributes of Paris that have been admired and imitated ever since. Maxine du Camp, a severe critic of Napoleon's Empire, could not help admire its accomplishments in urban planning:

I would like for a magic wand to put Paris back the way it was twenty years ago at the time of the February Revolution. There would be a cry of horror, and no one would be able to understand how a people as vain as the Parisians were able to live in such sewers.[34]

But Haussmann had other contemporary critics who deplored his high-handed manner,

his disregard for criticism, and his lavish spending. One, Victor Fournel, castigated him as the "Attila of the straight line."[35] Some social critics and historians today see the "Haussmannization" of Paris as a nefarious scheme to dispossess the poorer elements of the old city and relocate them on the periphery where they could be better controlled but not necessarily better housed. The success of the Communards in mounting resistance to the army in 1871, however, is evidence that Haussmann failed to make the city barricade-proof. In any event Haussmann oversaw the building of 85 miles of new streets and roads, had constructed over 4,000 acres of new parks, gardens, and squares, and, in just the five years between 1852 and 1857, supervised the erection of some 24,000 new buildings.

Among contemporary commentaries, the *Journals* of the Goncourt Brothers are particularly revealing because of the acuity of their perceptions and the catholicity of their interests. They noted the feverish changes to the capital and regretted, if anything, that the smaller, more intimate city of their youth was fast disappearing.[36] In a much-repeated passage of 1866 the writer Victorien Sardou deplored the changes to the city while at the same time indicating their necessity: "... the old Paris is lost, the real Paris? A city which was narrow, unhealthy, insufficient, but picturesque, varied, charming, full of memories."[37] Such nostalgia for the medieval Paris, according to the historian Henri Malet, may have been ill-founded in the realities of Paris of 1850 and was part of the romantic revival of interest in the Gothic led by Viollet-le-Duc.[38] Another critic, one who was influenced by the Gothic revival and who would have shared Sardou's sentiments, was Charles Meryon, whose *Eaux-fortes sur Paris* some see, and possibly misread, as a visual rebuke to the builders of the new imperium.

In 1848 Charles Meryon witnessed first-hand the events of February and June. In the four months between "revolutions" he went from being an enthusiastic supporter of the new Republic to an embittered ex-National Guardsman, sickened by the bloody futility of the June days. He also discovered in the studio of Eugène Bléry his life's mission, etching the cityscapes on which his fame depends. He dated his decision to devote his art to representations of the city from a fortuitous encounter with a view of the Seine and Louvre etched by the 17th-century Dutch artist Zeeman.[39] Historians and biographers have also seen the influence of Piranesi and Meryon's contemporaries, the painter John Barthold Jongkind and printmaker Auguste Péquenot, whose *12 Eaux-fortes* contained two views through the arch of the old Pont Notre Dame. Meryon himself allowed that the inspiration for his *Eaux-fortes*, and their ultimate arrangement, sprang from Victor Hugo's *Notre-Dame de Paris*, and it is no accident that the series begins and ends at the medieval heart of the city, its cathedral, which at that time was undergoing restoration. James Burke and others have rightfully seen Victor Hugo's novel of 1831 as the "wellspring" for the Gothic revival and the national preoccupation over the next fifty years with the history and culture of the French Middle Ages.[40] Meryon's cityscapes are one of the more obvious examples of this romantic attachment to all things medieval.[41]

But Meryon's drawings and etchings reveal a more political and social character than a superficial reading as nostalgic pleas for urban preservation would suggest. Unquestionably, Meryon was devoted to the city of Paris and, in fact, lived in its poorer, darker quarters. If on no other point, Meryon and his Emperor were in agreement on one thing: Paris was the center of European culture and civilization, not only past but modern as well. Although Meryon's *Eaux-fortes* precede the complete Haussmannization of Paris, his etchings are often described simplistically as a plea to salvage the capital's medieval character. The product of a highly personal vision, Meryon's etchings nonetheless reflect the city's irresistible pull for the teeming provincial masses, who poured into the city. Crowds, perhaps mindful of the clock, pass hurriedly over the bridge in *La Tour de l'Horloge* (cat. no. 8), and in *La Morgue* (cat. no. 14) on-lookers surge over a parapet as witnesses to the tragedy below. The throng on the *Pont-au-Change* (cat. no. 13) pass beneath a balloon marked "Hope," and, considering later states, this conjunction may have been an ironic comment on urban man's condition.[42]

Meryon's letters and his etchings betray a certain urgency in documenting old Paris. That he disapproved of Napoleon's plans for

demolition is not entirely obvious; even less clear is his opinion of the various restoration projects already underway or planned. No trace of scaffolding appears in *Le Stryge* (cat. no. 2), although the project to restore the cathedral had begun in 1844 and would not end until 1864, and the gargoyle itself was only recently carved. Not only the bridge but the surrounding riverfront as well, seen in *Le Petit Pont* (cat. no. 3), were demolished soon after Meryon published his print. The Tour Saint Jacques, which dominates the background of *Le Stryge*, was itself slated for destruction because it stood in the way of plans to widen the rue de Rivoli. Saved at the last moment, the Tower was restored in 1853-1855, but the surrounding area was not so lucky. Meryon praised the restoration of the Pont-Neuf in the verses accompanying the print and depicted precisely the reconstruction of the Palais de Justice in *La Tour de l'Horloge*. Dennis Costanzo perceptively remarks the ambiguity of Meryon's opinion on the changes to his beloved Paris: "If Meryon's attitude toward the transformation of the ancient city was cautiously optimistic, his feelings remained tensely ambivalent as restoration merged and became confused with demolition."[43] Meryon tells the viewer in the verse in his etching of *La Rue des Mauvais Garçons* to go and see for themselves what hides in this "gîte sombre," but to go quickly while there is still time![44]

The same ambivalence is evident in Meryon's depictions of the oppressive prison-like housing of *La Rue des Mauvais Garçons*;[45] in fact, his awareness of the crowding of new urban dwellers into wretched, squalid conditions contrasts markedly with his romantic antiquarian's love of medieval Paris. Two etchings of 1855 and 1856 entitled *La Loi Solaire* and *La Loi Lunaire* are said to betray Meryon's "intense dislike of urban overcrowding,"[46] but another interpretation of these two bizarre and fanciful etchings is that, as prescriptives for the urban dweller to cope with his environment, they betray Meryon's inherent distrust of the city. To make way for the new housing and to relieve the congestion of the old city, Haussmann's plan called for the demolition of the structures not only on that street but also those on the rue de la Tixéranderie in another of Meryon's etchings (cat. no. 9). *La Pompe Notre Dame* (cat. no. 11) itself, in use since the 17th century, would

be demolished in 1854, and the morgue moved to a new building in 1864. In preparing the plates for the second edition of the *Eaux-fortes sur Paris* to be printed in 1861 by Auguste Delâtre, Meryon altered some of the scenes to account for the changes but in other, new works emphasized the picturesque qualities of the city's domestic architecture.

One of the etchings that Meryon reworked was *Le Pont-au-Change* (cat. no. 13), an early state of which appears in the current exhibition. As a possible political commentary by Meryon on the government of Napoleon's Second Empire, however, it is necessary to discuss a later state of the etching.[47] In the print on view, onlookers from the bridge in front of the Palace of Justice watch as a man in the foreground appears to be drowning. Is he about to be rescued by the men in the boat? Are they the earth-bound deliverers of the "Hope" emblazoned on the balloon hovering over the bridge and toward which they seem to turn? Does the balloon symbolize the potential for justice in the government building? Meryon seems to answer these questions with a disturbing and emphatic "no" in the tenth state, where the balloon is replaced by a swirling, angry swarm of dark birds that seem to issue from one of the palace's towers and circle not only the hopeless man in the water but his rescuers and the people on the bridge as well. A crescent moon promises a dark night.

Lars-Ingemar Lündstrom attributes the surreal imagery of later plates to Meryon's advanced schizophrenia,[48] but James Yarnall, in an important article on Meryon's interest in the Cabala, disputes the claims of those who view Meryon's "eccentricities" solely as symptomatic of mental pathology. He argues that critics have neglected Meryon's very real political and mystical concerns, and he relies, accurately, on Philippe Burty's analysis of his friend's intentions in reworking *Le Pont-au-Change*:

Meryon was infected, even this early with the idea that, at the close of day, eagles and other birds of prey were let loose from the Tuileries, whose threatening flight carried trouble into the peaceful minds of the citizens, and recalled to them the triumph of the *coup d'état* of 1851.[50]

Baudelaire's comment from a letter of 1860

further explains Meryon's intentions in changing the plate: "In one of his large plates, he substituted for a little balloon a flock of birds, and when I brought to his attention that it was unbelievable to put so many birds into a Parisian sky, he replied that *those people* (the government of the Emperor) had often released eagles to study the presages, and that this had been printed in the newspapers, including *Le Moniteur.*"[51] The implications from Baudelaire's and Burty's statements, however, are that Meryon's naive politics arose not from a consistent or developed theory of resistance to the Empire but from his paranoid delusions. The article, in fact, appears to reinforce rather than dispute the notion that Meryon's political and mystical symbolism arose from an almost incoherent, certainly disordered understanding of the sources of his discontent. No doubt Yarnall is correct in noting "Meryon's opposition to Napoleon III's assumption of power and his resentment of the policies and practices of the Second Empire," and no doubt he is correct to depend on Aaron Sheon's further observation that other prints such as *Le Petit Prince Dito* and *Fluctuat nec Mergitur* are "both thinly veiled contemptuous references to Napoleon III and the Second Empire," but such expressions are so peculiar, so idiosyncratic, that they miss the mark and are blunted by their bizarre, indecipherable symbolism.

Fantastic winged creatures also crowd the sky in Meryon's print of 1865, *Le Ministère de la Marine,*[53] where they appear to be on the attack against a building that the artist believed was responsible for an earlier betrayal of the French colony in New Zealand. Subtitled "Fictions et Voeux," it also may represent the promise of Napoleon's professed Saint-Simonianism and the reality of his "fictive" empire, and as Margaret Stuffman points out, the Ministry had indeed been stormed by an angry mob in 1848.[54]

Perhaps *La Loi Solaire* and *La Loi Lunaire* do arise largely from Meryon's interests in cabalistic sources, but the text accompanying each etching also makes clear Meryon's desire to prescribe a healthy response to the woes of urban living. He advocates sunlight and air as his solar law and upright dormition as the lunar law, both laws designed to aid the urban dweller of those "Large Cities... born only out of Sloth, Greed, Fear, Luxury and other evil

passions."[55] Whether or not these works illustrate Meryon the social critic and reformer, they certainly indicate a naive and bizarre grasp of reality. In this context, the drowning man in *Le Pont-au-Change* becomes less powerful as an element of the iconography of political criticism when one remembers that Meryon had a deep-rooted, irrational fear of water.

Although ambiguous and confused, Meryon shared, and perhaps precipitated, distrust among artists for the policies of Napoleon III. His ambivalent attitude toward Haussmann's projects of demolition and reconstruction are characteristic of other artists' concerns, including even some of those writers and intellectuals close to the imperial circle. Meryon took his cue from Victor Hugo, a virulent critic of Napoleon III, and the two artists professed hatred of the new regime, but Hugo's opposition was more rational, pointed, and effective. Both men hated the regime's gaudiness and its preference for the superficial to the detriment of the substantial.

The very splendors of the imperial court masked what was essentially an urban bourgeois domination of taste in the visual arts. It was not only the royal couple who ignored the early impressionists but the buying public, the bourgeoisie, as well. Quite rightly, Jean-Marie Moulin argues that "For Napoleon III, exercising power in the artistic domain was but one aspect of social action."[56] Most important for the emperor and his entourage was to distribute available funds to as many artists and craftsmen as possible. The tastes of the court were of little importance in giving artistic direction during the Second Empire. For that role, one must look to the predominant class, the bourgeoisie, whose economic power was ultimately of more importance in promoting artists than any official lists.

With money and leisure, the middle class began to exercise the power of their purse in matters of taste during the Second Empire. The art that was most successful appealed to the mainstream, the conventional, and the traditional character of publicly sanctioned academic standards. The bourgeoisie demanded an art of the beautiful. The earthy peasants of Millet have little in common with

the idealized country maidens of Bouguereau and Merle. Even the exoticism of the Romantics was suspect after 1848. It was too excessive and reminded the bourgeois patrons of the violence and unruliness of the passionate classes. The *menu peuple*, subjects for the Realists and Naturalists, were too coarse and vulgar, and the bourgeoisie preferred idealized, classicized representations of how it viewed itself, a new aristocracy. Moulin calls the Second Empire "the naive phase of bourgeois art,"[57] a time marked by the *juste milieu* in painting and sculpture and by imitation and eclecticism in the decorative arts and in architecture.

The pleasures of contemporary life were predicated on the prosperity of the Empire, but the *arrivistes* among the ruling class sensed the fragility of their present position and turned to the past for reassurance. At the same time, optimism in the progress of society was widespread, enough so that art, or more precisely decorative crafts, seemed to be available to everyone. The enthusiast for the new technical processes could appeal to the art of production as justifying its acquisition. Painting and sculpture could also be perfected, especially by the introduction of the new and cheaper techniques of photography into the process, which particularly suited a parsimonious public.

In imitation of the legitimist and Bonapartist aristocracy, the urban middle class discovered the countryside in the 19th century. By the time of the Second Empire "bourgeois families were abandoning the city for its rural environs" during the summer "season."[58] Parisians tended to rent houses or stay in hotels for the long summer months, and, if necessary, the head of the household commuted into the city to handle his business affairs. Those who could not afford months in the country went for weekends or at least Sundays. As rail connections improved, more and more Frenchmen and their families took advantage of leisure time to escape the cities for rural recreation.

Artists also joined in the migration,[59] so much so that the mid-19th century in France became the heyday of French landscape painting, with the Barbizon painters as leaders of the movement. Taking as his thesis the

political nature of the movement rather than the subject matter of the paintings themselves, Robert Herbert offers a succinct explanation for the pervasiveness and popularity of landscape painting:

Beginning in the late 1840s, and reaching their peaks in the 1850s, are all these allied events: the growth and renovation of Paris; an awareness of the depopulation of the countryside; the upsurge of peasant themes in literature and popular music; the revival of the Le Nain brothers; the rise to great prominence of landscape as a major category of painting, and the mushrooming of animal and genre painting at the same time; the concomitant development of vast city parks (landscapes for city-dwellers); the great boom in riverain and seacoast resorts (seascapes for city-dwellers on vacation); the sudden notoriety of Courbet and Millet.[60]

For Herbert, the image of the rural proletariat embodied, paradoxically, the attitude of the artist toward the urban-industrial revolution.

Even though the government took pains to study the issue of depopulation of the countryside, the exodus continued at an alarming rate. Nevertheless, it is a widespread but fallacious assumption that Paris drained the provinces. Urban growth in France, compared to other industrializing countries, was fairly moderate, and it was not just to the capital that emigrants flowed in steadily mounting numbers. J. F. Gravier has called this rural exodus the "desertification" of the French land, and, in the context of a declining rate of population growth, it may have appeared to contemporary observers that the countryside would indeed be deserted except for the visiting bourgeoisie in the summers. Paris was a powerful lure, especially for young people, but it was not strong enough a reason to leave the countryside and villages were it not for the lack of opportunity, the instability of the family structure, and the dismal prospects for social mobility.[61] The peasant, then, who remained amid the bleak conditions of the country, and whose life Millet depicted with such realistic grimness, stood as a reminder of the social upheavals effected by the industrial revolution.

1848 was a watershed for artists in general and for Jean-François Millet in

particular. Daubigny, Diaz, Troyon, Jacques, and Rousseau all were allied with the Republican cause. Millet fought in the barricades, although T. J. Clark finds his a more diffident or desultory kind of involvement than the other revolutionaries. The same pro-Republican artists received commissions from the new republic and some, Rousseau, Diaz, and Dupré among them, even worked in the artists' section of the constituent assembly. The jury-free Salon, proclaimed by the Second Republic and carried over into the early years of the Second Empire, was less restrictive, and, along with the established academic paintings whose subjects belonged to religion, history, and mythology, some "modern" plein-air landscapes began to be shown. The Barbizon painters looked to 17th-century Dutch examples for a more democratic, less idealized view of man in nature.[62]

Perhaps influenced by Constable as well, these artists avoided mention of the industrial encroachment on the countryside. Their public seemed to demand an unspoiled landscape, a bucolic, tranquil Nature that was reassuring in the face of the progress of smokestacks and crowded cities. The peasant, and his way of life, held associations of industry, frugality, and routine, but Herbert sees this image of the peasantry as, in effect, containing a hidden meaning for the artists themselves. Widespread public discussion of the depopulation of the countryside brought the peasant, the wood gatherer, the quarry worker into the consciousness of the artist, who could, consequently, use the rural proletariat as a counterweight to the effects of indus-trialization: as symbol of a pre-industrial past, as the keeper of the rural heritage, or as natural components of the unspoiled countryside. Yet, Millet avoided the picturesque in his portrayals of the peasantry. Instead, he offered a direct connection of viewer to laborer and a veritable catalogue of the ritual of farm life: sowing, reaping, digging, carding, herding. Much of this work is drudgery, chores assigned by fate and accepted with the resignation and determination of the stooped shoulder and the bent back. The purposeful *Gleaners* (cat. no. 28) bend and turn in the rhythms of unwanted but foreordained toil, just as *The Diggers* (cat. no. 29) perform the monstrous, necessary act of preparing the earth for planting. They are bound to the land by the fate that made them a part of the social order.

Such an art as Millet's provoked discussion among his contemporary critics as to whether these were "socialistic" images. Brutish, loutish even, Millet's figures caused less controversy than Courbet's, but were, nonetheless, viewed as objects of social criticism. After 1849 and his move to Barbizon, Millet adopted naturalism to convey the truth of his oft-quoted Biblical motto, God's curse on Adam and all his sons: "In the sweat of thy face shalt thou eat bread." In leaving the city behind, "black, muddy, smoky Paris,"[63] Millet rediscovered the routines of his early life, even if, as the son of a prosperous peasant his had been a relatively pain-free youth, compared to the real suffering of woodcutters, faggot-gatherers, and gleaners. After all, Millet had been sent to art school. Yet Clark also finds, in ways that Herbert and others do not, the real political content of Millet's works in these pictures after 1853. They represent for the lowest elements of rural society a visual record of the hopelessness of their way of life. Their struggle for survival is doomed by forces outside their control. "Look at the titles of the great pictures from the 1850s—The *Gleaners, The Diggers, Death and the Woodcutter, Women Gathering Faggots, Man with a Hoe, Killing the Pig, Peasant Woman Grazing her Cow*, even in the grim sense Millet intended, *The Angelus* itself. They are, unexpectedly, a systematic description: picture by picture they indicate the key tasks and situations of this particular society. They are a portrait of a class, and a society, in dissolution. But not, for that reason, without a kind of despairing and aggressive class-consciousness of its own."[64]

But Millet never considered himself a social reformer, and, in fact, appears to have had no program to espouse other than a nostalgic respect for the peasant as victim in the face of rapid change. Twelve years after his death in 1875, two letters were published in which Millet attacked the Commune and repudiated Courbet. Camille Pissarro was annoyed and wrote to his son Lucien that the letters revealed the "petty side of this talented man," and, further, "Because of his painting *The Man with the Hoe*, the socialists thought Millet was on their side, assuming that this artist, who had undergone so much suffering, this peasant life, would necessarily have to be in

Meryon and Millet

agreement with their ideas. Not at all.... He was just a bit too biblical. Another one of those blind men, leaders or followers, who unconscious of the march of modern ideas, defend the idea without knowing it, despite themselves!"[65] Ironically the peasant pictures of Millet and others were often interpreted for their socio-political value regardless of the intentions of the artist and, in fact, could be turned against their "revolutionary" brethren: "Images of the peasant generated during this period articulate the fear, hopes, and fantasies of newly emerging social groups. Implicit in the celebration of 'peasant' values—piety, industriousness and submissiveness—was a tacit criticism of the less-tractable urban proletariat."[66] The notion that these are essentially political pictures has been turned on its head.

Millet's works from this period, in particular the prints in this exhibition, depict a world of bucolic isolation, places where the "cry of the earth" is louder than the din of the tram and lorry, where dim candlelight and smoky darkness substitute for the gaslight and shadow of Napoleon's new Paris. Indeed, the absence of Baudelaire's restless city is a significant characteristic of Millet's *oeuvre* as a whole. Sybil-like women sew, cook, and churn; muscular, coarse men hoe, dig, and carry. In *La Bouillie* (cat. no. 33) a mother cools the broth for her infant as evidence of her ceaseless toil rests on the table behind her. In another, *La Cardeuse* (cat. no. 31), Millet saves the image from a sort of nostalgic sentimentality by giving his woman and her task a simple grandeur. Intent on her task, her hands bent and almost misshapen, she is as solid and imposing as one of Michelangelo's female figures. The woman churning butter, *La Baratteuse* (cat. no. 26), works quietly, so concentrated on her task that she seems to ignore the cat rubbing at her hem. All of life is work, so that even a man at rest calls attention to his task by leaning on his shovel. The goosegirl guards her charges even as she rests for a weary moment against a tree; while watching the sheep or the goats, the shepherdess and the goatherd knit or separate thread.

These are decidedly not the almost coquettish peasant girls of Bouguereau, Lefebvre, and Merle. These more academic painters found earlier models in the maidens of Greuze; by contrast, Millet's peasants evoke the tradition of Le Nain and the Dutch masters of the 17th century. The innocent maidens of Bouguereau satisfied an essentially urban audience with its demands for a mythology of the countryside where always barefoot adolescents have time for daydreaming, for girlish secrets, and for lazy gamboling. Millet's folk, on the other hand, follow the rituals of the seasons. They wear patched, handmade cloaks and trousers. Their clumsy *sabots*, heavy and obvious, rest solidly on the earth. His *Gleaners* cover their heads with homespun kerchiefs, not with garlands picked on rambles in the forest.

The dialectic of city versus country in discussions of Second Empire art is evident and convenient for assessing the complex of forces that made of this period a bridge between the Romanticism of the earlier century to the Impressionism of its later years. All too often the art of the Second Empire, the "official art" of the academicians, has been vilified, ignored, forgotten, or used as a foil to the progressive movements occurring outside established channels. The artists, in our case Millet and Meryon, were not immune to the social, economic, and political forces at work in Napoleon's Empire, and surely to understand the stimulus for art, we must understand to what degree it is a reaction or change from the status quo, in this instance the *ingriste*, idealized, and genre conventions of politically and commercially "safe" art. Essentially conservative, even reactionary, Millet and Meryon represent the rural and the urban responses to "official" art and both, in the context of 19th-century art rather than Second Empire art, were harbingers of themes that became increasingly pervasive. In their prints and drawings and in the paintings of Millet, they allow us to join them as witnesses, the one eccentric, the other *dégagé*, to the rapid change, social dislocation, and economic upheavals of the Second Empire, the frivolity and gaiety of its capital city notwithstanding.

The author acknowledges with gratitude the assistance of Tina Mason and Peggy Sorrells in the preparation of this essay.

William U. Eiland

Endnotes

1. Adeline Daumard, *Les Bourgeois de Paris au XIXe siècle*, Paris: Flammarion, 1970. See p. 17.

2. See William U. Eiland, "Napoleon III and The Administration of the Fine Arts." Ph.D. diss., University of Virginia, 1978, pp. 17-66.

3. *Les Constitutions de la France depuis 1789*, présentation par Jacques Godechot. "Sénatus-consulte du 12 décembre 1852, sur la liste civile et la dotation de la couronne," Paris, 1970, pp. 300-301.

4. "La dotation mobilière comprend les diamants, perles, pierreries, statues, tableaux, pierres gravées, musées, bibliothèques et autres monuments des arts, ainsi que les meubles contenus dans l'hôtel du Garde-meuble et les divers palais et établissements impériaux." Art. 4, *Ibid*, p. 300.

5. Louis-Napoléon Bonaparte, "De l'extinction du pauperisme en France," Paris, May 1844. In 1848 Alexandre Pierre published passages from this article in a propagandistic brochure, *Extraits des Ouvrages de Louis-Napoléon Bonaparte*, a copy of which is available by title in the Bibliothèque Nationale in Paris.

6. Suzanne Desternes and Henri Chandet, *Napoléon III homme du XXᵉ siècle*, Paris, 1961, pp. 190-191; see also Georges Roux, *Napoléon III*, Paris, 1969; and, particularly, Pierre Angrand, "L'état mécène. Période autoritaire du Second Empire (1851-1860)," *Gazette des Beaux-Arts* (May-June 1968), pp. 303-348.

7. Desternes and Chandet, p. 191. See also Edgar Holt, *Plon-Plon, The Life of Prince Napoleon, 1822-1891*, London, 1973, pp. 118-119.

8. Desternes and Chandet, p. 166.

9. Philippe de Chennevières, *Souvenirs d'un Directeur des Beaux-Arts*, Paris 1883-1889, pp. 8-9.

10. *Ibid.*, p. 10.

11. See Daniel Fox, "Artists in the Modern State: the Nineteenth-Century Background," *Journal of Aesthetics and Art Criticism*, 22 (1962) pp. 135-148; and Pierre LaBracherie, *Napoléon III et son temps*, Paris, 1967, p. 193.

12. Fox, p. 140.

13. *Ibid.*, p. 147.

14. Edmond and Jules de Goncourt, *Journals: Mémoires de la vie littéraire*, vol. 2, pp. 201-224, 227, 236, 237.

15. Desternes and Chandet, p. 167.

16. Augustin Filon, *Recollections of the Empress Eugenie*, London, 1920, p. 13. Filon was one of the Prince Imperial's tutors.

17. Harold Kurtz, *The Empress Eugenie, 1826-1920*, London, 1964, p. 199. *L'Opinion Nationale*, an opposition newspaper commented on Bonheur's decoration: "We applaud with both hands. Decidedly, our civilization begins to recognize that women also have intelligence, even when they are on the throne." The decree of decoration signed by Eugenie is found in A.N. [Paris, Archives Nationales], O5 31. For Eugenie's support of women's rights, see Barshak, p. 147, as cited immediately below.

18. Erna Barshak, *The Intimate Empress: An Intimate Study of Eugenie*, New York, 1943, pp. 114ff. See also Robert Sencourt, *The Life of the Empress Eugenie*, London, 1931, p. 150.

19. Kurtz, p. 122.

20. Barshak, pp. 140-141.

21. *Ibid.*, p. 140. See also Desternes and Chandet.

22. Indeed, Ingres was *the* living master of French painting according to not only academics but also to the public. Delacroix, of course, followed in importance. Both men died during the Second Empire, the former in 1867, the latter in 1863.

23. Chennevières, p. 104.

24. *Ibid.*, p. 105.

25. See Mérimée's correspondence with Panizzi, the librarian at the British Museum in: Prosper Mérimée, *Correspondence Générale*, 17 vols., Paris and Toulouse, 1941-1964.

26. Jerrold Blanchard, *The Life of Napoleon III*, 4 vols., London, 1874-1882, vol. 1., pp. 350-353.

27. *Ibid.*, p. 352. The guest lists are a veritable litany of distinguished men of the period: Emile Augier, Dumas *fils*, Camille Doucet, Octave Feuillet, Flaubert, Emile de Girardin,

Gautier, Paul Janet, Ernest Legouve, Paul de Musset, Gustave Doré, Thomas Couture, Carpeaux, Désiré Nisard, Jules Sandeau, Sainte-Beuve, De Sacy, Français, Auber, Felicien David, Gounod, Mermet, Ambroise Thomas, Claude Bernard, Verdi, Renan, Longet, Milne-Edwards, Nelaton, Delaunay, Leverrier, Pasteur, Ponsard, Viollet-le-Duc, Mérimée, etc. See particularly in this regard: Pauline de Metternich, *Souvenirs (1859-1871)*, Paris, 1922.

28. At the instigation of the great tragedienne Rachel, the Prince Jerome, Mathilde's brother, contributed to the classical mode of the period by commissioning a model reconstruction in 1855 of the Temple of Empedocles. He also had constructed on the avenue Montaigne the "Maison Pompeienne," where classical theater could be produced.

29. For a short discussion of the first Napoleon's interests in the arts see Bruno Foucart, "L'Artiste dans la Société de l'Empire: Sa Participation aux Honneurs et Dignités," *Revue d'Histoire Moderne et Contemporaine* 17 (July-Sept., 1970), pp. 709-719. Napoleon I said "mon intention est de tourner spécialement les arts vers les sujets qui tendraient à perpetuer le souvenir de ce qui s'est fait depuis quinze ans," and further that "jamais regne ne fut plus propre à nourrir dans l'âme la pensée et le sentiment du beau, à offrir tant de prodiges à leur enthousiasme, à leurs travaux tant de nobles subjets, à leurs efforts de si nombreux encouragements..." (p. 709). Napoleon III elaborated "L'idée napoléonienne n'est point une idée de guerre, mais une idée sociale, industrielle, commerciale, humanitaire." As a humanitarian idea, he included the encouragement of culture. [Alain Decaux, "Alain Decaux face au prince-président: Les deux visages de Napoléon III," *Historia*, 351 (1976), p. 41.

30. See H. N. Boon, *Rêve et Réalité dans l'oeuvre économique et sociale de Napoléon III*, The Hague, 1963. This thorough and provocative work is convincing as to the extent of Napoleon III's Saint-Simonian principles. These ideals are evident throughout the Emperor's own writings, but this study carefully delineates these ideas in a lucid, forthright fashion.

See also in this regard Paul Janet, "Le Socialisme moderne: l'école Saint-Simonienne-Bazard et Enfantin," *Revue des Deux Mondes*, XXVII (Oct., 1876), pp. 587-618, and Sebastien Charlety, *Histoire du Saint-Simonisme*, Paris, 1931, esp. p. 264 for a discussion of the *crédit intellectual*.

31. See David H. Pinkney, *Napoleon III and the Rebuilding of Paris*, Princeton, 1958, p. 3, where he quotes Napoleon III: "I want to be a second Augustus, because Augustus...made Rome a city of marble."

32. Pinkney, p. 152. Different statistics are given in a French study, *Les Fortunes françaises au XIXᵉ siecle. Enquète sur la répartition et la composition des capitaux privés à Paris, Lyon, Lille, Bordeaux et Toulouse d'après l'enregistrement des déclarations de succession*, ed. by Adeline Daumard, Paris, 1973. See, in particular, the chapter "Les Fortunes des Parisiens au XIXᵉ siècle," pp. 182-267. Another indication of the growth of the capital is Louis Chevalier's assertion that "The City had twice as many inhabitants in 1851 as in 1801." (Louis Chevalier, *Laboring Classes and Dangerous Classes in Paris During the First Half of the Nineteenth Century*, trans. by Frank Jellinek, New York, 1973, p. 185.)

33. J-P Poussou, "The Population Increase of French Towns between 1750 and 1914, and its Demographic Consequences," trans. by Peter Compton in *Urban Population Development in Western Europe from the Late-Eighteenth to the Early-Twentieth Century*, ed. by Richard Lawton and Robert Lee, Liverpool University Press, 1989, pp. 68-92. See Pinkney, pp. 154-155.

34. Quoted in Henri Malet, *Le Baron Haussmann et la Renovation de Paris*, Paris, n.d., p. 113. My translation from the French: "Je vondrais qu'un coup de baguette put remettre tout à coup Paris dans l'état où nous l'avons connu il y a vingt ans, à l'heure de la Révolution de Février. Ce serait un cri d'horreur, et nul ne pourrait comprendre qu'un peuple aussi vaniteux que les Parisiens ait pu vivre dans de pareils cloaques."

35. Quoted by Françoise Choay, *The Modern City: Planning in the 19th Century*. New York, 1969, p. 15. Choay emphasizes the

radical nature of Haussmann's plans for the urban *regularization* and the revolutionary manner of their application: "In spite of the fact that in 1850 France was economically behind Great Britain, Paris was the object of the first perfected plan for regularization of a city in the industrial age." (*Ibid.*)

36. Goncourt Brothers, *Journal*, esp. vol. 2, 1862-1865 and vol. 3, 1865-1870, Paris, n.d.

37. Sardou's statement is found in *Maison neuve* and quoted in the checklist accompanying the exhibition *City and Country in French Prints, 1850-1900*, The University of Michigan Museum of Art, Ann Arbor, Michigan, 19 Oct.-23 Dec., 1990, s.p.

38. "Ville médiévale, a-t-on dit. Mais il faut s'entendre. Seuls en réalité les édifices religieux dâtent véritablement du Moyen-Age.... Les constructions laïques sort moins anciennes. ...l'immense majorité des maisons dâte en 1853 de deux on trois siècles au plus. Les plus vieilles remontent au bon roi Henri ou à son prédécesseur. Ce sont des maisons pittoresques, soeurs de celles que nous ont conservées de place en place les villes de province." Malet, p. 112.

39. Meryon wrote of his discovery of Zeeman's print: "dès ce moment je conçus même ce projet que je méditais vaguement, d'entreprendre une suite de vues de Paris de mon choix..." From "Mes Observations sur l'article de la Gazette des beaux-arts (Liv ⁽ᵐ⁾ du 1ᵉʳ juin, 1863)," handwritten manuscript in the Toledo Museum of Art, quoted in Loys Delteil, *Charles Meryon*, vol. II: *Le Peintre-graveur illustré*, Paris 1907, no. 9, *Le Pavillion de Mlle. et une partie du Louvre*; also by Winfred Porter Truesdell, "Charles Meryon," *The Print Connoisseur*, 2 (March 1922), p. 234. See also for a discussion of Meryon's career and technique, Dennis Paul Constanzo, "Cityscape and the Transformation of Paris during the Second Empire," vol. 1, Ph.D. diss., University of Michigan, 1981, pp. 68-81. Costanzo gives the quotation from Meryon on page 69. The more general influence of Piranesi is clearly demonstrated in the catalogue *Meryon's Paris/Piranesi's Rome*, Rutgers University Art Gallery, New Brunswick, 1971. In his biography, *Meryon*

(Paris, 1926) Gustave Geoffrey notes the direct influences of Ducerceau and Piranesi on Meryon's technique and vision respectively, and Margaret Stuffman, in her essay "Zur Tradition des pariser Stadtbilder und Meryons individuellem stil," (see note no. 42 below), discusses the role of Viollet-le-Duc's dictum, that France's essential spirit is Gothic, and what it meant to Meryon (pp. 15-21).

40. James D. Burke, *Charles Meryon Prints and Drawings*, exhibition catalogue, Yale University Art Gallery, New Haven, Connecticut, 1974, p. 2.

41. In addition to Costanzo's work on Meryon and cityscape, see also Gabriele Hammel-Heider, "Bemerkungen zu Meryons Stadtlandschaften," *Zeitschrift für Kunstgeschichte*, XL, no. 3-4 (1977), pp. 245-264.

42. For discussions of Meryon's artistry and technique, see S. William Pelletier's essay in this volume and his sources. In addition see Burke's catalogue for the exhibition at Yale as well as William A. Brady, "Some Meryon Drawings in the MacGeorge Collection," *Print Collector's Quarterly* VII (1917) pp. 113-155; Paul L. Grigant, "Some Unpublished or Little Known Meryon Drawings in the Toledo Museum of Art," *Art Quarterly* XIII (1950) pp. 228-240; *A Catalogue of Etchings and Drawings by Charles Meryon Exhibited at the Grolier Club*, exhibition catalogue, New York, 1898; Jean Ducros, *Charles Meryon, Officier de Marine, Peintre-Graveur, 1821-1868*, exhibition catalogue, Utah Museum of Fine Arts, Salt Lake City, 1971; Roberto Papini, *Meryon o della visione fantastica*, Florence, 1928; and Margaret Stuffmann, et. al, *Charles Meryon: Paris um 1850. Zeichnungen, Radierungen, Photographien*, exhibition catalogue, Stadtelsches Kunstinstitut und Stadtisches Galerie, Frankfurt, 1976. For further study on individual prints see, Aaron Sheon, "Charles Meryon in Paris," *Burlington Magazine*, 110, Dec. 1968, pp. 721-722 on *Le Stryge*; also Adele Holcomb, "*Le Stryge de Notre Dame*: Some Aspects of Meryon's Symbolism," *Art Journal*, 31, Winter 1971-72, pp. 150-157.

43. Costanzo, pp. 75-76.

44. Quel mortel habitait en ce gîte sombre? Qui donc là se cachait dans la nuit et dans l'ombre?

Etait-ce la vertu, pauvre, silencieuse?
La crime diras-tu quelqu'âme vicieuse...
Ah! Ma foi, je l'ignore; si tu veux le savoir,
Curieux, vas y voir. Il en reste temps encore.

45. Noted also by Hammel-Haider, p. 252-253; see n. 9.

46. Costanzo, p. 85, n. 26. Meryon's *Eaux-fortes* had a profound influence on Charles Baudelaire, who also found in alienation and despair suitable responses to the ambiguity he felt at the razing of the city and the squalor and overcrowding that required it.

47. Loys Delteil and Harold J.L. Wright, *Catalogue Raisonné of the Etchings of Charles Meryon*, New York, 1924, 34; X/XII.

48. Lars-Ingemar Lündstrom, "Charles Meryon, peintre-graveur schizophrène," *Acta Psychiatra Scandinavica*, XL, suff. 180, 1964, p. 160.

49. James Leo Yarnall, "Meryon's Mystical Transformations," *The Art Bulletin*, LXI,2 (June 1979) pp. 289-300. See Burke, pp. 62-68 for a complete discussion of the various states of this print. Burke includes the verses to accompany the first six states that end with the plaintive declaration "L'espoir qui nous leurrait, va mourrir au rivage!" (Hope dies on the shore, perhaps, in the very halls of justice). Burke's catalogue is invaluable for its publishing of the accompanying texts to the various etchings. No full-scale study has yet been made of Meryon's writings.

50. Quoted in *ibid*, p. 291; see Philippe Burty, *Charles Meryon*, exhibition catalogue, Fine Arts Society, London, 1879, p. 66, for a complete discussion.

51. Yarnall, p. 291, for example, and see Pelletier's essay in this catalogue.

52. *Ibid.*, esp. note 7.

53. Delteil-Wright, 45; V/VI. In "Charles Meryon's Oceanic Sketches: A Precocious Primitivism," (*The Print Collector's Newsletter*, vol. XXIV, no. 2, May-June 1993, pp. 44-49), Frances Connelly argues that an analysis of Meryon's Oceanic sketches reveal that the *Eaux-fortes sur Paris* were "considerably shaped by Meryon's experiences in the South Pacific and, in fact, [were] the result of a creative fusion bringing that 'primitive' world into

the center of modern Paris" (p. 44). One example of this influence is *Le Stryge*, where Meryon shifts from Oceanic to Gothic grotesquerie. Meryon also seems to have used such imagery for political and social commentary in other works, where the primitive symbols of Oceanic culture either war against or stand in silent rebuke to the symbols of modern Paris and its powerful government: "Maori war canoes and large fish swoop down on the Ministry of the Marine in one etching dated 1865-66, while a figure wearing a New Caledonian mask is on one of several canoes lying offshore in another, *College Henri IV* of 1863-64" (Connelly, p. 48). Adding force to this argument that Meryon adapted Oceanic imagery for a personal, political commentary is *Le Petit Prince Dito*, mentioned in the text above, where Meryon adorns the figure on horseback with a New Caledonian mask. See R. D. J. Collins' discussion in "Charles Meryon's *Ministère de la Marine*," *New Zealand Journal of French Studies*, vol. 9, no 1, 1988, pp. 41-51, as well as his other articles "The Landscape and Historical Paintings of Charles Meryon," *The Turnbull Library Record*, Wellington, N. Z., 8, Oct. 1975, pp. 4-16 and "Les 'Projets' de Charles Meryon," *Nouvelles de l'estampe*, May-June 1990, pp. 5-12. In addition to Ducros' catalogue cited above, for illustrations of Meryon's early sketches, see Collins' "Auguste Delâtre, Interprète de Charles Meryon," *Gazette des Beaux Arts*, November 1983, pp. 169-77.

54. See Hammel-Haider, pp. 261-262 for a discussion of *Le Ministère de la Marine*; Yarnall, p. 292 and note 11; and Stuffman *et al.*, p. 24.

55. Burke, p. 108; *La Loi Solaire*, 1855, Delteil-Wright, 1855, 93; *La Loi Lunaire*, (second plate), 1866, Delteil-Wright, 92; V/VI.

56. Jean-Marie Moulin, "The Second Empire: Art and Society," *The Second Empire, 1852-1870: Art in France under Napoleon III*, exhibition catalogue, Philadelphia Museum of Art, 1978, p. 12.

57. *Ibid.*, p. 14.

58. Michelle Perrot, ed., *A History of Private Life*, IV, *From the Fires of Revolution to the Great War*, trans. by Arthur Goldhammer, Cambridge, 1990, p. 299.

59. See in particular, Kermit S. Champa, et al., *The Rise of Landscape Painting in France: Corot to Monet*, exh. cat., Currier Gallery of Art, Manchester (N.H.), 1991.

60. Robert L. Herbert, "City vs. Country: The Rural Image in French Painting from Millet to Gauguin," *Artforum* (February 1970) p. 46.

61. Poussou, *op.cit*, pp. 89-90.

62. See Robert L. Herbert, *Barbizon Revisited*, New York 1962; and T. J. Clark, *The Absolute Bourgeois, Artists and Politics in France 1848-1851*, Princeton, 1982.

63. Herbert, "City vs. Country," p. 49.

64. Clark, pp. 79-80. For Clark's discussion of the city/country issue after 1870, see his chapter, "The Environs of Paris," in *The Painting of Modern Life, Paris in the Art of Monet and His Followers*, New York, 1984, pp. 147-204. Clark's discussion of the woodcutters of northern France indicates that he believes they constituted a class-conscious, proto-revolutionary segment of the peasants' class. For a discussion of the image of the woodcutter, see Kenneth McConkey, " 'Dejection's Portrait': Naturalist Images of Woodcutters in Late Nineteenth-century Art," *Arts Magazine*, vol. 60, no. 8 (April 1986) pp. 81-87. Millet's *Death and the Woodcutter* is central to his discussion (pp. 82-83).

65. Letter quoted by Ralph E. Shikes, *The Indignant Eye: The Artist as Social Critic in Prints and Drawings from the Fifteenth Century to Picasso*, Boston, 1969, p. 206.

66. Monica Juneja, "The Peasant in French painting: Millet to Van Gogh," *Museum*, XXXVI, 3 (1984), p. 168.

Charles Meryon and Jean-François Millet: Two French Printmakers of the Second Empire

S. William Pelletier

The prints of Meryon and Millet are very familiar to students of 19th-century French graphic art. Each produced exceptionally fine prints. However, their subject matter differed entirely. Meryon's most successful prints are humanistic visions of the city, interpreting the architecture of medieval and Renaissance Parisian buildings and bridges while Millet focused on peasant life in rural France, particularly around the village of Barbizon. Their methods also varied. Meryon built up his designs with tireless perseverance, after making meticulous preliminary drawings of details; then, too, he often reworked his plates through many states. Joseph Pennell claimed that Meryon was no artist because he did not make a sufficient number of mistakes: "And in this plate [*La Morgue, Paris*] there are no mistakes, erasures, foul biting, none of those qualities found in all spontaneous, vital etching—Meryon is perfunctory, perfect, pathetic."[1] Compare this statement with Meryon's letter to Jules Andrieu: "For often I must patch my plate so much that I am more tinker than Etcher."[2] Yet Meryon's amazing mastery over his medium allowed him to produce plates which *appear* as if there had been no mistakes in spite of his patching! Meryon did to perfection that which Whistler proclaimed all through his life to be the greatest technical achievement possible: he concealed the art which produced Art.[3]

By contrast Millet usually gave a more summary treatment of his subjects, preferring to suggest rather than to elaborate in great detail. He omitted details he considered extraneous, for his object was to interpret the inner life of his subjects. Of Millet's twenty etchings and drypoints, ten are in a single state. Of the remainder, most are in from two to four states. Only in *Le Départ pour le Travail* are there eight states, the last three of which involve posthumous alterations.

Meryon, though living on the edge of sanity, is one of the most interesting and original printmakers. An artistic immortal, his strange and haunting *Eaux-fortes sur Paris* influenced generations of printmakers and ensure that his name will be inscribed in the annals where Dürer, Schongauer and Rembrandt will live for generations. On the other hand, at around the same time, Millet etched the peasants of rural France with sympathy and truth, creating powerful images that revolted against the high drama of academic French art. His prints are perfect expressions of his genius, full of melancholy and mystery. "The massiveness of his figures makes him a pre-cubist, like Corot, who was then painting buildings as blocks and cylinders."[1]

As noted, many differences exist between Meryon and Millet. But in several respects they are similar: both artists produced their prints around the same period of the Second Empire and thereabouts, Meryon from 1849-1866 and Millet from 1846-1868. Both artists were superb draftsmen. Both were wretchedly poor and experienced great difficulty in marketing their prints even for trifling sums. Finally, each artist was a poet, seeking passionately to express his vision accurately, yet infusing the poetic element into all his graphic interpretations.

Charles Meryon (1821-1868)

Charles Meryon was born in Paris on November 23, 1821, in the private hospital of Dr. Piet in the rue Feydeau aux Batignolles. His mother was Pierre-Narcisse Chaspoux (1793-1838), a ballet dancer in the Paris Opera who used the stage name Narcisse Gentil.

Meryon and Millet

Meryon's father was an English physician, Charles Lewis Meryon (1783-1877). Born in France of Huguenot parents, he had emigrated to England as a child, became a naturalized British citizen and was educated at Oxford. He became the private physician and biographer of Lady Hester Stanhope, the renowned traveller and adventuress.[5] In 1821, the year of his election as a Fellow of the Royal College of Physicians, Dr. Meryon formed an attachment with Mademoiselle Chaspoux, then aged twenty-eight. He had made her acquaintance before the birth of her daughter, Fanny, when she was living under the protection of an English nobleman. They met through the accident of residing in the same house at 10 Warwick Street, London, a convenient location for his daily visits to St. Thomas Hospital. After Dr. Meryon returned from his second journey to the East, he renewed his acquaintance with Narcisse Chaspoux. She left England before the birth of their son, and although they corresponded almost to the end of her life, the former relations were not renewed.[6]

Charles Meryon's illegitimate status haunted him throughout his life. His father did not acknowledge him until he was nearly three years of age. At that time, on August 9, 1824, Dr. Meryon went to Paris where he formally recognized his son and provided funds for his education. Charles was eventually baptized at the Oratoire rue St. Honoré on September 27, 1829, in the Church of England, his mother being godmother. Intelligent and gentle, she bestowed upon her son ardent affection, and watched over his early education with great care.[7] At the age of five he was enrolled at Passy and later entered the Pension Savory under the name of Gentil and proved an excitable and fitful scholar.[8]

In 1837, at age sixteen, Meryon entered the Naval College at Brest.[9] The following year his mother died. Most biographers state that she died insane, but this idea is contradicted by Meryon's own account of his mother's illness, recorded in a letter to his father, dated January 16, 1839, and based on details provided by his sister, who was with her at the time of her death. "Never during her illness did she lose her reason. But a few minutes before her death, believing me to be near her,

she recommended me to be of irreproachable conduct, and gave me her blessing."[10]

After two years of naval training Meryon took a series of sea voyages, departing from Toulon on October 15, 1839, on the *Algiers*, and travelling later on the *Montebello*, visiting Algiers, Tunis, Smyrna, Athens, Argos, and Tiryns.[11] On his return to Toulon, he took lessons in pencil, watercolor, India ink, and sepia with Victor Cordouan, a well-known painter of southern landscapes. From 1842 to 1846, he served as midshipman under Captain Bérard on the corvette *Rhin* and he visited Brazil, Australia, New Zealand and Oceania.[12] The charm and unusual character of these unfamiliar countries, palm-covered islands, phosphorescent seas, and coral strands stimulated his imagination and led to numerous drawings which later were translated into the etchings of 1863-1866, in illustration of his travels (Delteil-Wright 63-72[13]; Schneiderman 59, 68-69, 87-89, 95, 97, 99, 100[14]).

In 1846, Meryon returned to Paris and was given six-month's leave because of his poor health.[15] In November he wrote to his father of his "grande décision" to devote himself to art as a vocation.[16] In a letter of January 1855 to a friend, Léon Godard, he said "I did not wear the uniform many years, and I only put it off because I did not feel solid enough either physically or morally to wield authority over men whom I consider for the greater part as the most devoted, the most honest, in every way the best one can meet.... This is the reason, together with a natural inclination to art which I have always felt, that I ventured on the road I am treading today." His nerves had been shattered by seeing one of his companions brutally attacked by natives in New Zealand, and subsequently burned alive, before his eyes.[17] He failed to report at the end of his sick leave, submitted his resignation as lieutenant, and ultimately received his discharge from the navy on September 17, 1846.

At the age of twenty-five Meryon became a professional artist with 20,000 francs which his mother had bequeathed him. He lived in the rue Saint-André-des-Arts and rented a studio in the rue Hautefeuille. He took lessons from a former employee at the Ministry of

War, Charles François Phelippes, a painter and pupil of Jacques-Louis David, and learned to draw in charcoal from casts of the Apollo Belvedere and the Olympian Zeus. He also visited the Louvre, copying works there. His attitude toward the old masters was not one of profound reverence. For example, Meryon gave Philippe Burty a detailed drawing in red chalk "which he had copied with minute exactness from the marvellous drawing from the hand of Raphael, representing Psyche holding in her hands a vase of crystal." Meryon remarked, "In my copy I have been obliged to correct one of the eyes, which is not in its proper position." He also made studies at the Louvre after the cartoons of Giulio Romano.[18]

Meryon produced a highly finished drawing for a projected painting of *The Assassination of Marion Dufrène, Captain of a Fire-Ship, at the Bay of the Isles, New Zealand, the 13th of August, 1772.* The drawing was accepted and exhibited in the Salon of 1848. It was a key point in Meryon's artistic career because it permitted him to break from his teacher Phelippes and led to his acquaintance with Eugène Bléry, an artist known for his fine landscape etchings.

His aspiring career as a painter was cut short, however. Meryon suffered from partial color blindness, a condition which brought an end to his plans for painting. For instance, Meryon was not able to distinguish clearly the ripe fruit on a cherry tree from its leaves. In another example, in his box of pastels, he mistook red for yellow and pink for green. However, certain colors such as carmine, gold, cobalt, and lapis lazuli, he could "distinguish with extreme delicacy." Finally, Burty recounts a story that one of Meryon's fellow officers told him. During one of their naval voyages the officers were shooting sea gulls from the quarter-deck of the ship. Meryon asked, "What color do you make out their breasts to be?" "A spotless white" was the answer. "You are wrong," replied Meryon, "the color is an inimitable rose." "That's impossible," the officer replied. "However, we'll soon see." After the bird was shot, its breast was found to be of "a salmon-colored rose of an extraordinary tint."[19]

Meryon had encountered some landscape etchings by Eugène Bléry in the collection of Monsieur Schultz, a neighbor and art lover who was then residing in the rue Saint-André-des-Arts. The young artist wanted to take lessons in etching from the master who so impressed him and quickly contacted Bléry. From December 1848 to July 1849, Meryon worked with the older artist in his home.[20] From him Meryon learned the technique of etching, at the time a neglected medium. Meryon's first etching was a face of Christ (D.-W. 1; S. 1), a copy of a miniature by Elise Bruyère, a pupil of Van Daël, after a painting by Philippe de Champaigne. Burty, in his first catalogue raisonné of Meryon's etchings, commented favorably on this print: "This etching of which perhaps only one proof is extant, shows the most beautiful sentiment and great brillance." To which Meryon replied: "This judgment is much too flattering, I need not say that I do not accept it. The head has a few pretty details, but the modelling of the face lacks coherence and breath." The print exists in a single impression formerly in the collection of Howard Mansfield and now in the Art Institute of Chicago. Other early prints (D.-W. 2-16; S. 2-8, 12-19) were made under Bléry's supervision. There are copies after etchings by older masters: Karel du Jardin (Dutch, about 1622-1678), Salvator Rosa (Italian, 1615-1673), Adriaen van de Velde (Dutch, 1636-1672), J. P. de Loutherbourg (French, 1740-1812), and Reynier Nooms, called Zeeman (Dutch, about 1623 before 1667). With Bléry, Meryon mastered the techniques of etching, but it was Zeeman's works which most deeply influenced him. Meryon purchased in Eugène Vignères' print shop for a few sous some of Zeeman's etchings of Paris and maritime scenes done about 1650. He was struck by the dexterous clearness of the lines made with the needle, with the quietness of the tone, and the brilliancy of the biting. He mastered Zeeman's style and it informs Meryon's early prints.[21]

In the fall of 1848, Meryon travelled to Normandy and Bourges.[22] By July 1849, he had moved to 21, rue Neuvelle Saint Etienne-du-Mont.[23] Here "the dark rooms succeeded each other like the cabins on the lower deck of a ship."[24] In this gloomy apartment Meryon produced that marvelous set of etchings which remains an astonishing manifestation of his artistic genius—his *Eaux-fortes sur Paris.*

Apparently, an etching by Zeeman inspired

Meryon to create a series of prints of Paris. One day while looking at a portfolio of etchings at Vignères' he saw Zeeman's *Le Pavilion de Mademoiselle avec une partie du Louvre* and conceived the idea for a series of etchings devoted to the city he loved. This print, he wrote:

caught my eye, as much by the interest of the things it represented as by the brillance of its execution, by the life which enlivened the whole scene; I took it immediately with the intention of reproducing it so as better to digest it, and from that moment, I conceived the idea, which I vaguely pondered of undertaking a series of views of Paris, of my own choosing, and of which, to my mind, la Pompe Notre-Dame should lead the van.[25]

Between 1850 and 1854, he produced *Eaux-fortes sur Paris*, a series of twenty-two plates (D.-W. 17-21, 23-38, 40; S. 20, 22-30, 33-36, 38-45) which is considered his finest work and upon which his fame as a printmaker mainly rests. Of these twenty-two plates, nine consist of a title plate, verses, and head and tail pieces, leaving thirteen subjects which are major prints, though not all are large ones.

Meryon's method of developing sketches for his etchings was unusual. Having decided on a subject, he would sketch the scene over and over again, drawing studies of details which were exceedingly precise. At home he would stick all these sketches together and then compose a completed drawing. He used a very hard, fine-pointed pencil employing it as if it were a graver.[26] Asked why he drew the bottom areas first and then worked upwards, he replied: "Are not the buildings themselves constructed from the foundations upwards? Why then should I reverse the process when I am sketching them?"[27]

Henri Béraldi's comments on Meryon's technique are interesting:

In art it is technique that counts, and Meryon's is incomparable. One aspect of it is especially arresting—the beauty, the proud firmness and precision of his lines. To produce these fine straight lines it is said that the etcher used to stand the plate upright on an easel, and holding the needle in his extended hand like a sword, draw the lines from the bottom upwards. Meryon sometimes makes his lines so vigorous that they appear somewhat hard. Some of his skies are rather solid. But must we reproach him for this? Let us refrain, for it is upon this extreme firmness that the extreme

originality of his style is based. Meryon's etchings, be it noted, are not of the traditional, free, spontaneous variety generally produced by painter-etchers. They are more the work of a line-engraver. Although producing original prints, Meryon employs a line constantly analogous to an engraver's line.[28]

Meryon's first original work, *Le Petit Pont, Paris* (cat. no. 3), was completed and accepted in the Salon of 1850. Without practice or preparation other than his work as copyist and imitator, Meryon struck a new note in etching, new in its "color," in its austere grandeur, in its mastery of medium, and in its evocation of the spirit of the place.[29] *Saint-Etienne-du-Mont, Paris* (cat. no. 10) was exhibited in the Salon of 1852. The Salon jury rejected the marvellous *La Galerie Notre-Dame, Paris* (cat. nos. 5 and 6) and the haunting *Rue des Toiles, à Bourges* (cat. no. 16) in 1853, but accepted *La Pompe Notre-Dame, Paris* (cat. no. 11) and *L' Abside de Notre-Dame de Paris* (cat. no. 15) into the Salon of 1855.

At this time, Baron Georges-Eugène Haussmann, under the command of Louis-Napoléon, was reconstructing Paris—creating handsome modern streets and boulevards from the picturesque labyrinth of old Paris, not restoring and preserving, but ruthlessly demolishing and obliterating. Much of the quality of Meryon's work is due to his intense affection for the romantic landmarks whose destruction he foresaw with bitter regret. Passionately, he desired to preserve an adequate memorial for the quaint streets, towers, and buildings. For Meryon, old Paris was bounded on the north by the Seine, on the south by St. Etienne-du-Mont, on the east by the Apse of Notre Dame, and on the west by the Pont Neuf. Within this small area he has preserved in his prints a record of the old city.[30]

While Meryon created the Paris prints, his financial resources were very limited and no viable market for his etchings developed. He placed the Paris etchings on sale at Vignères' and Rochoux's for 30 francs a set, which consisted of fifteen etchings, eleven large and four small.[31] He sometimes accepted one or two francs for a single etching. In a letter of August 19, 1853, to Monsieur Géhaut, he offered eight of his finest etchings of Paris at 1 or 1.5 francs each, for a total of 10 francs for the set.[32] On July 21, 1866, Meryon signed

a receipt for 25 francs for a complete set of the Paris etchings sold to Baron Pichon.[33] Imagine impressions of *Le Stryge, Le Petit Pont, La Galerie Notre-Dame, Le Pont-au-Change,* or *La Morgue* on green paper at a cost of less than one dollar each! Today, single impressions of early states of these prints often fetch thousands of dollars.

In this connection, a pathetic story about Meryon was told to Frederick Keppel by Monsieur Beillet, a printer who after working at the same printing press for forty-five years, had recently retired on a pension of six francs a day. According to Keppel, "Meryon came stealing into his atelier, looking even more nervous and wild than usual, and bringing with him two sheets of paper and the plate of his Abside de Notre-Dame. 'Monsieur Beillet,' said he, 'I want you to print me two proofs of this plate,' and added timidly, 'I cannot pay you till I sell them—don't refuse me!' 'How much did you charge him for the printing?' I queried. 'Oh dix sous les deux.' (Ten cents— that Meryon could not pay for two proofs of his loveliest plate). An exclamation of pity on my part was mistakenly appropriated by the practical old printer, for he added 'Mais oui, Monsieur, I never got my money.' "[34]

Meryon had few friends, but the engravers Léopold Flameng and Félix Bracquemond supported him faithfully. Charles Baudelaire, Théophile Gautier, Paul Mantz, and M. Burger also admired his work.

With time, Meryon suffered an increasing amount of poverty and isolation. Daily he became more unsociable. His state of mind may be ascertained in the mysterious *La Rue des Mauvais Garçons, Paris* (cat. no. 7). An abstruse verse written at the top of the third state reads as follows:

What mortal used to dwell in this dark lair?
Whoever used to hide himself o' nights in such a shady hole?
Was it poor silent Virtue?
Crime, you say—or some vicious creature, perhaps?
Ah! faith, I cannot tell. If you wish to know, O curious one, go and see. There is still time.[35]

Meryon was almost starving, when, depositing regulation proofs at the Office of the Minister of the Interior, he met the librarian, Jules Niel. This gentleman, an eclectic amateur known for his refinement and taste who equally appreciated the French masters of the 15th century and the romantic works of Eugène Delacroix, grasped instantly the great value of Meryon's work. He took an interest in Meryon and arranged for the Ministry to purchase several sets of prints for its library and to order copies to be made after historical drawings.[36] In October 1856, the writers and critics Edmond and Jules de Goncourt came to Niel to examine his collection of Meryon prints. Their impressions of Meryon provide sensitive contemporary commentary on the tenor of his work and life. The Goncourt brothers appreciated the sense of the past and of mystery in Meryon's etchings and also sensed the artist's mental deterioration:

It seems as though a hand of the past had held the engraver's needle and that more than the very stonework of old Paris has been brought to these sheets of paper. Indeed, in his images, one could say some of the soul of the old city has been revived. It is as though magical reminiscence of old quarters, foundering oftentimes as in a dream, troubles the mind of a clairvoyant conscious of perspective—the poet-artist—who has Lunacy and wretchedness seated nearby on his bench.... Poor unhappy madman, during the clear moments beyond his lunacy, takes endless walks to capture the picturesque strangeness of shadows in the great cities.[37]

Although praise and recognition were accorded Meryon after this time, his artistic ability began to falter as his mental problems grew more acute. A small band of collectors and friends began to buy his etchings. Among them were Jules Niel; A. Wasset, of the War Office; Philippe Burty, the discerning art critic; Benjamin Fillon, the historian of Poitou and La Vendée; Baron Jérôme Pichon; Henri Le Secq, a photographer and enlightened collector; Adolphe Pagues; Commandant Gustave Adolphe de Salicis; Émil Galichon; Alfred Sensier; Monnerot; Dr. Coffin; Dr. Gachet; Philippon; Louis Valentin; Hippolyté-Alexandre Destailleur, a noted architect of the period; and a few occasional buyers. These were too few to provide Meryon with sufficient income to live, even modestly. His delicate health suffered as a consequence.

In the spring of 1857, Louis Prosper, the Duke of Aremberg, who had seen Meryon's series of Paris etchings at Montpellier in 1855-1856, sent for him. Prosper installed him in the village which adjoined his château at Enghien, about twenty miles from Brussels.

Meryon was to reproduce at his leisure certain of the views in the park which he considered the most picturesque. A daguerreotype camera was provided and he took lessons in the new art at Brussels.[38] The change of surroundings and the comfortable circumstances provided him failed, however, to revive his spirits, and one day, suddenly, and without the slightest reason, Meryon left his generous host and returned in March 1858, to live in Paris. He took rooms first in the rue du Faubourg Saint-Jacques in a house owned by the mother of Léon Gaucherel, the painter and engraver, and later in a miserable little hotel at no. 81 of the same street. He had not long taken up his residence at the latter address when his malady began to show signs of getting worse. Burty reported that Meryon dug up his garden with feverish activity, not to plant, but in search of imaginary bodies buried there. At night, he imagined his bed was a boat fighting against the tempest on an ocean whose waves were blood. Delâtre, the printer, would often come and tend him. However, Meryon refused to leave his bed, and used to threaten with a pistol anyone who ventured to approach too near.[39]

On the evening of May 11, 1858, Léopold Flameng came with a drawing-board, a sheet of grey paper and some black crayons, and although Meryon made difficulties, the engraver succeeded in making a very good drawing of him. The sketch shows Meryon sitting up in his night-shirt and wearing a cravat loosely tied in a large bow. His features, with their sharp lines, emaciated by his self-imposed fastings, are full of melancholy and irony. When the drawing was completed Meryon asked to be allowed to see it, and bounding out of bed tried to seize it and tear it up. Flameng fled, knocking over a chair in his haste.[40] The next day, May 12, 1858, two attendants carried Meryon, who went very quietly with them, to the asylum at Charenton-St.-Maurice. He was then 37 years of age. In the "certificate of 24 hours," an official certificate given after the patient had been kept under observation for that period, Dr. Calmel described him to be "suffering from melancholy madness, complicated by delusions."[41]

While Meryon was at Charenton, the first criticism of his work was published by Charles Baudelaire in the writer's review of the Salon of 1859:

A few years ago, a forceful and unique man, a naval officer, it is said, had begun a series of etched studies done from some of the most picturesque vantage points of Paris. Because of the sharpness, delicacy and certainty of his design, M. Meryon brought to mind some old and excellent etchers. I have rarely seen the natural solemnity of an immense city depicted with more poetry. The majesty of piled up masonry, the bell towers pointing a finger to the sky, the obelisks of industry vomiting their coalitions against the heavens, the marvellous scaffolding, in a day when beauty is so paradoxical, that imposes its structure on the substantial main portion of the architecture while monuments are being repaired, the tumultuous sky wrought up by anger and bitterness, the depth of the perspective augmented by contemplation of all dramas confined therein—none of these complex elements that compose the mournful and glorious scenery of civilization are overlooked. If Victor Hugo had seen these excellent prints, he would have been content.... But a cruel demon has touched M. Meryon's brain; a mysterious delirium has confounded his faculties which seem both substantial and brilliant. His nascent glory and his work have been interrupted suddenly. And since then, we are eagerly awaiting reassuring news about this unique officer who has become a masterful artist overnight and who said goodbye to the solemn adventures of the ocean to depict the dark majesty of the most restless of capitals.[42]

It is understandable that Meryon's work was bound to excite the enthusiasm of Victor Hugo, the author of *Notre-Dame de Paris*, who was himself an artist of considerable stature. Hugo viewed Meryon's prints after Baudelaire sent several impressions to him while the older writer was in exile in Guernsey. Hugo wrote to Baudelaire on April 29, 1860:

Since you know M. Meryon, tell him that his splendid etchings have dazzled me. Without color, with nothing save shadow and light, chiaroscuro pure and simple and left to itself: that is the problem of etching. M. Meryon solves it magisterially. What he does is superb. His plates live, radiate and think. He is worthy of the profound and luminous page with which he has inspired you.[43]

In 1863, Burty published other laudatory comments about Meryon's prints by Victor Hugo:

These etchings are magnificent things. We must not allow this splendid imagination to be worsted in the struggle in which it is engaged with the Infinite whilst studying Nature or Paris. Strengthen

him with all the encouragement possible. The breath of the universe breathes through all his works, and makes his etchings more than pictures—visions.[14]

In August 1854, the asylum at Charenton discharged Meryon, after fifteen months of hospitalization. Regular meals and hours, after a life of deprivation, had a good effect on his health. His etchings became more popular, and good friends, such as Dr. Gachet, both admired and cared for him. In a letter written to Aglaüs Bouvenne of December 1, 1881, Dr. Gachet provides a fascinating picture of the artist:

Meryon was of short stature, of rather a bilious and nervous temperament, and physically dry and shrunken. He was simple in his dress, easily took offence, and was guarded in his looks. He avoided pleasure and comrades. He loved solitude and work. By nature unhealthy and dull, he was temperate, ate little, and drank still less. He was always uneasy, and seemed the prey to a disturbing suggestion of some kind. You might have said that his thoughts wandered away from his body, for at times he appeared to be far away from, and unconscious of, the society in which he happened to be. In fact, he did not love society. He dined at my house more than once, but always with the greatest circumspection, and after much hesitation. The painter A. Gautier had some influence over him and seemed to please him. They came together to my house. It was only with the greatest difficulty that, with the help of Gautier, I was able to obtain the *Eaux-fortes sur Paris*, and then only two at a time.... He promised to let us know the cause of his sadness, and it was no doubt the starting-point of his mental disease.... He found himself unhappy, and believed that he was alone on earth, surrounded by people with bad intentions.

His nature was sensitive, straightforward, and delicate, but his brains were ill-balanced.... He himself was of no account. You could not tell him that his work was good, or that he had talent, it was not possible to praise him in his presence. To do so was to make yourself his enemy.... For some things he had a horror. Water, for instance. He could not think of it, and made no secret of his aversion. One day I asked him whether he had ever painted marine subjects or seaports. He replied that one should not reproduce water. That the sight and vicinity of water was sinister and dangerous. These notions were deeply rooted in him. As soon as he spoke of water his face assumed a sad and lugubrious air.[15]

Meryon could be extremely disconcerting to chance visitors. Sir Francis Seymour Haden relates his visit to Meryon's quarters in Montmartre:

One day, though I knew the difficulty of approaching him, I went to see Meryon. I found him in a little room, high up on Montmartre, scrupulously clean and orderly; a bed in one corner, a printing-press in another, a single chair and small table in another, and in the fourth an easel with a plate pinned against it, on which he was standing at work. He did not resent my visit, but, with a courtesy quite natural, offered me, and apologised for, the single chair, and at once began to discuss the resources and charms of Etching. He was also good enough to allow me to take away with me a few impressions of his work, for which, while his back was turned, I was scrupulous to leave upon the table what I was sure was more than the dealers would then have given for them; and so we parted, the best of friends. But what followed shows how, even then, his mind was unhinged. I had walked fully two miles in the direction of Paris, and was entering a shop in the Rue de Richelieu, when I became aware that Meryon, much agitated, was following me. He said he must have back the proofs I had bought of him; that they were of a nature to compromise him, and that from what he knew of "the Etched Work which I called my own," he was determined I should not take them to England with me! I, of course, gave them back to him, and he went his way; and it was not till after his death that I became aware that about this time he had written to the Editor of the *Gazette des Beaux Arts*, to caution him against being taken in by me, and to impart to him the conviction that the plates which I pretended to have done were not done by me at all, or even in that century, but that, doubtless, I had discovered, and bought them, and signed and adopted them as my own![16]

Meryon met Baudelaire in late 1859, sometime after he was released from the asylum at Charenton. In poor finances again, he wrote for assistance to the Minister of State in charge of the Arts for assistance and received a small but insufficient sum.[17] His affairs continued to deteriorate. Baudelaire, in a letter of March 9, 1860, urged the publisher Poulet-Malassis to publish a new edition of the *Eaux-fortes sur Paris*, adding that "This Meryon does not know how to go about things; he knows nothing of life. He does not know how to sell; he does not know how to find a publisher. His work is readily saleable."[18] In 1861, Auguste Delatre printed the plates of the Paris set after Meryon retouched them with the burin to add corrections and to repair the wear caused by previous printings. On the plate of *Le Pont Neuf, Paris,* for example, he

reduced in size the houses of the rue Dauphine. In other examples, he corrected several figures in *La Morgue, Paris*; added more balloons in *Le Pont-au-Change, Paris*; added beams of light in *La Tour de l'Horloge, Paris*; and added ravens in *La Galerie Notre-Dame, Paris*. After Delâtre printed an edition of fifteen to thirty impressions from each retouched plate, the plates were destroyed.

Burty records that this was Meryon's weakest period owing to his mental instability.[49] At this time he was working on a proposed set of etchings of subjects from his Pacific voyage of twenty years earlier. However, these prints lack the inspiration and vitality of the Paris set. In other activities in 1862, he exhibited *Le Grand Châtelet* (D.-W. 52; S. 74) and *Tourelle, rue de l'École de Médecine, 22, Paris* (D.-W. 41; S. 72) at the International Exhibition in London.[50] Four prints were accepted in the Salon of 1863: *Tourelle, rue de l'École de Médicine, 22, Paris* (D.-W. 41; S. 72); *La rue des Chantres, Paris* (D.-W. 42; S. 85); *Le Grand Châtelet à Paris, vers 1780* (D.-W. 52; S. 74); and *Nouvelle-Calédonie: Grande Case Indigène sur le Chemin de Ballade à Poëpo, 1845* (D.-W. 67; S. 87).[51]

Burty's catalogue of Meryon's prints was published in 1863 in the *Gazette des Beaux-Arts* and was based on conversations and correspondence with Meryon, who wrote out detailed responses to the publication. The manuscript, *Mes Observations*,[52] once in the collection of H. H. Benedict of New York, is now in the collection of the Toledo Museum of Art.

Meryon continued to show prints in the Paris Salon exhibitions, specifically in the Salons of 1864, 1865, 1866 and 1867. In 1864, he exhibited *L'Arche du Pont Notre-Dame, Paris* (cat. no. 4); *Océanie, Ilots à Uvéa (Wallis): Pêche aux Palmes, 1845* (D.-W. 68; S. 88); *Presqu'île de Banks, Pointe dite 'des Charbonniers,' Akaroa: Pêche à la Seine* (D.-W. 69; S. 89); in 1865: *Greniers Indigènes et Habitations à Akaroa, Presqu'île de Banks, 1845* (D.-W. 70; S. 97); and in 1867: *État de la petite Colonie Française d'Akaroa, 1875* (D.-W. 71; S. 95).

Of the 1860s, Burty wrote as follows:

I went, as often as I could do so without indiscretion to pass a short time with him in his little atelier, No. 20 in the Rue Duperre. It was half filled with a wooden printing-press which the police allowed him to keep, and from which he struck off his trial proofs. The walls were bare with the exception of a portrait of his friend Decourtive, in a frame which he had carved with a penknife out of a piece of cork, and which he had painted with water-colours and a fern-leaf, to which he attached some sort of superstitious reverence. I once surprised him in the act of washing the room with his feet bared, although it was winter.... We talked at length, he of the undeserved ills of his childhood; of his mother, whom he adored.... Somehow I always left him more worried and discouraged than I found him. He never of his own free will touched upon the subject of art. He appreciated beyond everything the work of Bracquemond, but he knew hardly anything about art.... I had much trouble to obtain from him the biographical notes and the list of his etchings, which I published in the *Gazette des Beaux-Arts* in 1863. He made me promise only to mention as states those which he regarded as characteristic. He afterwards annotated my work with minute care in a series of letters, of which all but few, unfortunately, were incomprehensible. A short time afterwards he quarrelled with me, without any real or apparent reason, as he had with M. Niel...and M. Rochoux, the printseller who had assisted him with an infinite tact and forbearance.

But Misery followed hard at his heels. He took his meals at the meanest of mean restaurants, and he breakfasted for a few sous off fruit and fish cooked in milk and flavoured with a few drops of vinegar.

It was impossible to assist him though his friends took the most out-of-the-way means to accomplish this end. Those who watched over him had again to call in medical advice, and Meryon was for the second time placed in confinement on the 12th of October, 1866. The obligatory certificate, taken twenty-four hours after admission, reported "typemanie chronique avec hallucination des principaux sens," and the certificate issued at the end of the first fortnight stated that there were "des signes de délire partiel." An obstinacy of will even to the point of death is the principal result of this stage of the disease.[53]

At the asylum he worked like a child upon the copper plates which were placed before him. He occupied himself by writing long, incoherent, and guilt-filled letters. In 1867 he was enough better that a doctor accompanied him to the Universal Exhibition, where several of his etchings were exhibited. But a violent thunderstorm brought on a severe relapse from which he did not recover. In his mental state,

he believed himself to be Christ held captive by the Pharisees. In his mind, there was not enough food in the world, and he would not wrong the feeble and outcast by taking their sustenance. Therefore, he refused to eat, and on Friday, February 14, 1868, he died of exhaustion brought on by starvation.[54] A few days later his body was buried in the cemetery of Charenton-Saint-Maurice. In the presence of a few friends—Bracquemond, Auguste Delâtre, Philippe Burty and Dr. Foley—Commandant Gustave Adolphe de Salicis, Meryon's old comrade-in-arms, spoke the following touching words:

Meryon is dead! In this cold trench that eminent artist ends the first part of his existence. In the flesh we shall see him no more; but from to-day the History of Art will be incomplete without the name, for he was wanting in none of the qualifications requisite to secure him a place in the illustrious roll; neither in the talent, nor in, alas! that other essential—suffering. Under the rule and the impulsion of the unseen God, Meryon sacrificed everything on His altar—youth's happy visions, an enviable career, a patrimony, health, reason. Above this poor troubled barque, at every instant harried and urged onwards towards shipwreck, there always hovered and sung a bird, whose hue was of the purest white. The barque has disappeared beneath the wave, but the spotless bird, typical of his soul, has flown upward. Let us to-day forget to grieve for him who was called "Miserable Meryon," for he will henceforward be called "Meryon the celebrated" on earth, whilst the better part of him has already taken its place in the serene atmosphere of eternity. What matters it now that he, like the rest of us poor human creatures, bore about with him imperfections, and if life was to him a time of sore trial? He has even now expiated that, and in the unknown world above there, he is enjoying that—the least of happinesses—which on earth he always strove for and never attained; for he now has *Rest*.[55]

Set into the black Brittany stone covering the grave is a large brass plate, upon which his friend Bracquemond etched an inscription. Upon it was drawn a death's head over two reversed torches. Beneath is the name *Meryon*, the dates of his birth and death and his monogram, framed with a laurel wreath and his etching tools: a burin, a hand-vice, a crayon, and a bottle of mordant. At the left is engraved the ship of the City of Paris as an adaptation of his own etching of the Arms of Paris (D.-W.21; S.36). Two impressions were taken from this plate before it was attached to the stone.[56]

Meryon's Graphic Work

This survey of Meryon's printed *oeuvre* will deal primarily with the principal plates of his *Eaux-fortes sur Paris*, since his stature as an etcher rests primarily upon this series. Only a few prints outside this set are of the same inspiration, freshness, and vitality. The prints of the Paris set are characterized by two distinct features. Technically, they represent supreme mastery of the etching craft whereas artistically, the prints evoke an atmosphere of mystery, intrigue, and foreboding. They seem to focus upon darkness and shadow more than upon light. Meryon's poetical imagination enabled him to draw architecture as no one else had ever done. In his *Eaux-fortes sur Paris* the very stones seem to breathe. He imbued the views of Paris with a living quality, full of poetry and drama. Meryon's etchings are more than pictures; they are visions of a fertile imagination. He translated the poetry, mysterious and grand, of old Paris which the citizens of the Second Empire soon would see disfigured and destroyed. Under his needle, architecture became a poem. He borrowed from reality only its external features; he preserved the details of the construction, but instilled in them his melancholy reflections and the secrets of his mind. Without noticeably changing the appearance of a building, he invested it with social and historical significance, as in his etching, *La Morgue*, which he drew in the likeness of a tomb. Thus his prints have a twofold value: they are simultaneously historical documents and works of art.[57]

Studying his etchings, one is impressed with the richness of material that was available in Paris for the artist who contemplated it as a living entity: the quays, the river enlivened by the moving vessels, the populated streets, the shadows on the massive walls, "the windows aligned and almost touching like cells in a honeycomb, the roofs and innumerable chimneys standing out against the sky." No artist before Meryon had ever viewed Paris in this way or had thought of translating its many graces.[58] In this Paris set, as inventor, as etcher and as poet, Meryon stands alone, perhaps the greatest etcher since Rembrandt. *Le Stryge*, *La Rue des Mauvais Garçons*, and *La Morgue* will stand for generations as the prototypes of countless prints by later etchers.

Meryon published the *Eaux-fortes sur Paris* from 1852 to 1854. He intended it to consist of twelve large views and ten small prints of verses and miscellaneous items (see table below). According to Burty, the twelve large prints were issued in three parts.[59] Because impressions of the title page, verses and incidental pieces are rare, complete published sets are extremely rare. From Burty's two-part catalogue published in the *Gazette des Beaux-Arts* in 1863, and Meryon's replies recorded in the manuscript, *Mes Observations*, it is clear that Victor Hugo's *Notre-Dame de Paris* provided the primary inspiration for the Paris etchings.

Charles Meryon *Eaux-fortes sur Paris*

Large Views

1.	*Le Stryge*	D.-W.23; S.27
2.	*Le Petit Pont, Paris*	D.-W.24; S.20
3.	*L'Arche du Pont Notre-Dame, Paris*	D.-W.25; S.28
4.	*La Galerie Notre-Dame, Paris*	D.-W.26; S.29
5.	*La Tour de l'Horloge, Paris*	D.-W.28; S.23
6.	*Tourelle, Rue de la Tixéranderie, Paris*	D.-W.29; S.24
7.	*Saint-Etienne-du-Mont, Paris*	D.-W.30; S.25
8.	*La Pompe Notre-Dame, Paris*	D.-W.31; S.26
9.	*Le Pont Neuf, Paris*	D.-W.33; S.30
10.	*Le Pont-au-Change, Paris*	D.-W.34; S.40
11.	*La Morgue, Paris*	D.-W.36; S.42
12.	*L'Abside de Notre-Dame de Paris*	D.-W.38; S.45

Small Prints

1.	*Titre des Eaux-fortes sur Paris*	D.-W.17; S.22
2.	*Dédicace à Reinier Nooms, dit Zeeman*	D.-W.18; S.33
3.	*Ancienne Porte du Palais de Justice, Paris*	D.-W.19; S.34B
4.	*"Qu'âme Pure Gémisse"*	D.-W.20; S.35
5.	*Armes Symboliques de la Ville de Paris*	D.-W.21; S.36
6.	*La Rue des Mauvais Garçons, Paris*	D.-W.27; S.38
7.	*La Petite Pompe, Paris*	D.-W.32; S.39
8.	*L'Espérance*	D.-W.35; S.41
9.	*L'Hôtellerie de la Mort*	D.-W.37; S.43 & 44
10.	*Le Tombeau de Molière, au Père-Lachaise, Paris*	D.-W.40; S.34A

The original order in which the etchings were done is uncertain. The order in Burty's catalogue and in the Deteil-Wright catalogue follows Meryon's own rearrangement of the pieces of the set in 1861.[60] Conflicting evidence suggests a different original order. For example, Meryon wrote his father that *Le Petit Pont, Paris* (cat. no. 3) was his first original print[61] and signed and dated an impression: *1850*. But Burty reports that *L'Arche du Pont Notre-Dame, Paris* (cat. no. 4) was the first of the series.[62] Meryon's final order of 1861 assigns the first place to *Le Stryge* (cat. no. 2 and cover). Four prints were dated 1850 in their final states published in 1861, but were inscribed with other dates in states published before 1861.[63]

There is some evidence to suggest that Meryon printed several of the early states of the Paris set himself. Thus Burty mentions that Meryon's little studio at No. 20, rue Duperré was half filled with a wooden printing press on which he printed his trial proofs.[64] An impression of the fifth state of *Le Pont-au-Change* in Toledo is signed and inscribed by Auguste Delâtre: *"Tiré par moi chez mon ami Meryon/ Aug. Delâtre" (printed by me at the home of my friend Meryon)*, again suggesting that Meryon had a printing press in his apartment. Meryon sent his father some trial proofs in 1850.[65] On certain impressions he wrote *"imp"* after his signature to indicate that he had printed the impressions himself; on other sheets he indicated whether Delâtre or another printer had done the printing. Together with Delâtre, Meryon produced exquisite impressions of the early states of *Eaux-fortes sur Paris*, printed in dark brown and black inks on the finest of papers—pale green, tan, yellowish, and white—of old Dutch manufacture or imported from Japan. After 1855-1856, he himself printed no etchings in large numbers, letting Delâtre and others do this work. As mentioned, the final printing of the Paris set, after retouching of the plates by Meryon, was carried out by Delâtre in 1861, in editions of fifteen to thirty impressions.

Eleven of the plates of the Paris set were copied by Edmond Gosselin, a print dealer, and published in 1881 in a portfolio titled: *Eaux-fortes sur Paris d'après C. Meryon, E. Gosselin fecit MDCCCLXXXI.* Five of these deceptive copies bear Gosselin's initial or initials. The following plates were copied: *Titre des Eaux-fortes sur Paris; Le Stryge* (state iv with verses; with monogram *E.G*); *L'Arche du Pont Notre-Dame, Paris* (*G* in lower right corner); *La Galerie Notre-Dame, Paris; La Rue des Mauvais Garçons, Paris* [two states: (a) before verses and (b) with verses]; *Tourelle de la Rue de la Tixéranderie, Paris* (state iii with monogram *C.M.*); *Saint Etienne-du-Mont, Paris* [two states: (a) before the words *Imp. Delâtre, Paris* and (b) with these words]; *Le Pont Neuf, Paris; Le Pont-au-Change, Paris* (state v, sharp plate corners; *EG 82* in lower right corner); *La Morgue, Paris* (with *1881 E.G.* in top right corner); and *L'Abside de Notre-Dame de Paris* (with monogram *E.G.*).

The following are comments on impressions in the exhibition. Preceding numbers refer to the catalogue numbers of works illustrated and described in this catalogue.

1

Titre des Eaux-fortes sur Paris (Title Page to the "Etchings of Paris"), (D.-W. 17; S. 22). 1852.

This title page, etched on the surface of the block in fanciful letters, is rather rare and occurs in a single state. Impressions were printed on ivory, brown, grayish-brown, pale green, blue and gray papers. Philippe Burty wrote: "The etching represents a block of limestone, with shell-marks and the imprint of moss deeply imbedded in it, and was intended to be typical of the foundations of Paris, the original specimen having been taken from the quarries of Montmartre."[66]

2 and cover

Le Stryge (The Vampire), (D.-W. 23; S. 27). 1853.

This print represents a gargoyle, restored by E. F. Viollet-le-Duc. Set on the north tower of Notre Dame, the figure rests his head in his hands and contemplates the city below. In the middle-ground the tower of St. Jacques looms over the city more prominently and dramatically than it does in reality.[67] It is a powerful evocation of the medieval spirit and was inspired by the chapter, "A Bird's-Eye View of Paris" in Victor Hugo's book, *Notre-Dame de Paris.*[68] It may also have been inspired by the photograph of *Henri Le Secq at Notre Dame* by Charles Nègre which has been dated

1850-1853.[69] This etching expresses medieval sculpture from a new viewpoint, and Meryon's interpretation was afterwards borrowed by artists such as Auguste Lepère and Charles Jouas.[70] Meryon originally named the print, *La Vigie* (The Lookout). The present title, *Le Stryge* (The Vampire), appears in the last two states of the print done about 1861. The artist stated his preference for this title in *Mes Observations*. In a letter to his father of April 17, 1854, Meryon wrote:

this monster which I have represented does exist, and is in no way a figment of imagination. I thought I saw in this figure the personification of Luxuria [lust]; it is this thought which inspired me to compose the two verses at the bottom of the print, in which I neglected to count the syllables, ignorant as I was at that time of the rules of versification.[71]

The two lines of verse mentioned in Meryon's letter appear in Gothic characters in Delteil's fourth state and describe the monstrous character of the gargoyle which became Meryon's "personal demon," a symbol of the evil forces of sin and suffering which corrupted the soul of the city:

Insatiable vampire, l'éternelle Luxure
Sur la grande Cité convoite sa pâture

These lines have been variously translated as:

Lust, a foul vampire, insatiable and lewd,
Fore'er o'er the great city, covets its obscene food[72]

or

The Insatiable vampire, eternal lust
forever coveting its food in the great city[73]

or

Vice, like a vampire, gloats with greedy eyes
O'er the vast city where his quarry lies[74]

or

Insatiable vampire, Eternal Luxuria
Coveting the Great City as its feeding place[75]

In the next state Meryon removed this verse. The fourth Delteil state bearing the distich is a rarity coveted by collectors, especially if it is on 18th-century pale green paper upon which Meryon printed certain of the earliest impressions of the Paris set.

In the winter of 1860-1861, Meryon in speaking with Jules Andrieu about an early impression of *Le Stryge*, remarked:

You can't tell why my comrades, who know their work better than I do, fail with the Tower of St. Jacques. It is because the modern square is the principal thing for them, and the Middle Age tower an accident. Even if they saw, as I see, an enemy behind each battlement and arms through each loophole; if they expected, as I do, to have the boiling oil and the molten lead poured down on them, they would do far finer things than I can do. For often I have to patch my plate so much that I ought indeed to be a tinker. My comrades are sensible fellows. They are never haunted by this fellow (*Le Stryge*). The monster is mine, and that of the men who built this Tower of St. Jacques. He means stupidity, cruelty, lust, hypocrisy, they have all met in that beast.[76]

Meryon made two careful pencil drawings for this print. One is a study of the chimera and the Tour Saint-Jacques (Sterling and Francine Clark Art Institute, Williamstown, Massachusetts). The other is a study of the city and the birds and is found in the same institution.

The fourth Delteil state of *Le Stryge* illustrated is in a warm-brown ink printed with plate tone on the rare pale green, 18th-century laid paper. Delâtre's printing of this state was sensitive to Meryon's printing requirements. In contrast, impressions of the seventh and eighth states, printed by Delâtre in 1861, are in black or dark brown ink on white papers, and are not so carefully printed. The soft tonal relationships and atmospheric effect of the early impressions differ markedly from the harsh contrasts, lack of detail, and dullness of the later states.[77]

3

Le Petit Pont, Paris (The Small Bridge, Paris), (D.-W.24; S. 20). 1850.

As mentioned earlier, Meryon wrote to his father in a letter of August 5, 1850, that this was his first original etching, an impression of which he sent to him.[78]

Philippe Burty's comments on this print are instructive:

This view is taken from the towing-path, at the foot of the Quai de la Tournelle. The towers of Notre-Dame, which rear themselves in the upper part of the composition, are much too high, regard being had to their real dimensions and the laws of perspective. We should be called upon in several instances to draw attention to errors of this nature were they not entirely voluntary ones, and on the whole permissible. Méryon never pretended that his

plates had the cold exactitude of a photograph. When he took his first sketch from—below from the water's edge, for instance—it is evident he placed himself in a position which, if reproduced, would have been unrecognizable to the majority of spectators. He mounts, therefore, to the bank, and with a facility almost unequalled tacks on to his first idea the view which usually struck the passer-by from the parapet. By these two operations he composed a picture which at the same time is a real view.[79]

This conscious departure from photographic accuracy is characteristic of Meryon's work. Rather, it was the soul of the place that he sought to depict, instead of the physical facts. Though his etchings strike one as being realistic, he did not work from Nature in an ultimately literal and imitative fashion.[80]

Interestingly, in the print, the profile of a sphinx appears just to the left of the bridge. This was apparently accidental as indicated in Baudelaire's comments to Poulet-Malassis in a letter of January 8, 1860:

In one of his other plates, he [Meryon] pointed out to me that the shadow cast by a portion of the stonework on the side wall of the *Pont Neuf* looked exactly like the profile of a sphinx;—that this was entirely coincidence on his part and that only later did he take note of this peculiarity, recalling that this design had been made shortly before the Coup d'Etat. But now—the Prince is the creature at the present time, who by his deeds and his countenance is most like a sphinx.[81]

Meryon executed numerous preliminary study drawings for this print. He printed the first four states (Delteil) himself while Delâtre printed subsequent states. Delteil's fourth state, illustrated here, is printed in a warm-black ink on thick, cream-colored wove paper, giving a brilliant effect. This first of Meryon's original etchings is one of his finest works and is surpassed by perhaps only two or three other prints of the Paris set. The fifth Delteil state, with faint parallel lines in the sky, was published in an edition of 600 in *L'Artiste* (vol. V, no. 14, December 5, 1858).

4

L'Arche du Pont Notre-Dame, Paris (The Arch of the Notre Dame Bridge, Paris), (D.-W. 25; S. 28). 1853.

This print features a view of the Seine just above the water level. Beneath the arch, to the left, the pilings of the Pompe Notre-Dame

(cf. D.-W.31; S.26) are visible. Further along, one can see the Pont-au-Change (cf. D.-W.34; S.40), behind which are the towers of the Palais de Justice (cf. D.-W. 19; S.34 A&B).

Philippe Burty states that Meryon used a *chambre noire* (camera obscura) in preparing this print, but was later forced to revise the resulting drawing.[82] Meryon, however, corrects this statement to a *chambre claire* (camera lucida).[83] Drawings prepared as preliminary studies for this print are in the Art Institute of Chicago, the Boston Museum of Fine Arts, the Carnegie Museum of Art, and the Toledo Museum of Art. The final preparatory drawing at Williamstown (Sterling and Francine Clark Art Institute) is like the etching. Meryon printed states i through v himself and Delâtre printed states vi and vii after substantial retouching by the artist. The impression of the fourth state illustrated is a beautiful, evenly-printed one in black ink, with plate tone, on pale green, 18th-century laid paper.

5 and 6

La Galerie Notre-Dame, Paris (The Gallery of Notre Dame, Paris), (D.-W. 26; S. 29). 1853.

This view from inside the Gallery of Notre Dame looking out over the city, shows the Tour de l'Horloge (cf. D.-W.28; S.23) at the center. In the following, Burty quotes from Victor Hugo's passage, "A Bird's Eye View of Paris"[84]:

...the eye dwells on a maze of roofs, chimneys, streets, bridges, squares, spaces and towers; and especially toward the West on the Palais de Justice, settled down on the borders of the river midst its group of towers.[85]

The technique used in this etching is noteworthy. Solidity is given by the firm use of the needle, the lines are laid with precision, but with a deliberate tremble that conveys charm; the biting is clean and there is a brilliant play of light and shadow. Meryon in a letter to Burty indicated his preference for cleanly wiped plates:

The finest proofs, those that you must study to judge a print properly, are those printed firmly and evenly, that is to say, wiped as cleanly as possible, so long as the lines remain full, showing the work quite clearly. On the other hand, prints where spreading of ink contributes to the effect, may be rejected as having borrowed an alien method. When I began to etch, I was often led astray in this; but more and more I have come to the conclusion that

only straightforward printing should be accepted; and in any case, this demands more real skill on the printer's part. There are, however, instances where a more heavily printed proof makes a right appeal, but this is an exception which the special advantage alone can authorize or excuse. In any case, this kind of printing is not suited to my prints, with their too simple and too methodical execution.[86]

This print beautifully renders Gothic architecture in a delicate study of direct and reflected light. It exhibits marvellous chiaroscuro. For the quality of reflected light, it is probably Meryon's finest work. Victor Hugo was very favorably impressed with Meryon's etchings, describing them as "more than pictures—visions,"[87] and this one was his favorite.[88] Yet, despite its superior qualities, this print was rejected at the Salon of 1853.

There are several study drawings for this print at the Art Institute of Chicago and a complete sketch for it, dated "7 Dec.," in the Bibliothèque Nationale, Paris.

Two impressions of this subject are illustrated. The first (cat. no. 5; D.-W.26 iii/v; S.29 iv/vi) is a beautiful, rich impression in dark brown ink on ivory-colored laid paper with a *HUDELIST* watermark. The second, which features the next state (cat. no. 6; D.-W.26 iv/v; S.29 v/vi), belonged in Victor Hugo's personal collection and is printed in black ink on ivory-colored laid paper.

7
La Rue des Mauvais Garçons, Paris (The Street of the Bad Boys, Paris), (D.-W. 27; S. 38). 1854.

According to Burty this etching was the tailpiece to the first part of the *Eaux-fortes sur Paris.* He commented:

The composition is singularly powerful. It quietly shows that antithesis so often to be met with in the old quarters of great towns, the sun enlivening at certain times the foetid runnel, and gilding the walls of the unsavoury hovel.[89]

During the captivity of Francis I, mischievous gangs of adventurers, chiefly French and Italian, known as the "Mauvais Garçons," preyed upon Paris and its environs. They frequented the street, which became crime-ridden and dangerous.[90] Though this street no longer exists (it was replaced by the Rue Grégoire-de-Tours), the cornerstone with the inscription, *Rue des Mauvais Garçons*, is preserved in the Musée Carnavalet.

In this etching Meryon has converted a street of drab houses into a sinister place, ripe with the seeds of vice or crime. This print, Baudelaire's favorite,[91] is a masterpiece of mysterious truth and in Burty's opinion, an expression of Meryon's state of mind.[92] It has always impressed connoisseurs as a most powerful and impressive work, fraught with ambiguity—enigmatic and suggestive of long past tragedies. It is one of the most striking and singularly powerful pieces of the Paris set, and though of small dimensions, it has haunted the minds of many artists. Campbell Dodgson's perceptive comment is appropriate to this piece:

...for Meryon the streets of Paris were haunted places, peopled with ghosts and wet with tears. Their atmosphere was infected by old crimes and miseries and sins.[93]

There is a complete drawing for this print, inscribed "*B*," at the Bibliothèque Nationale, Paris. The location of another drawing, annotated "*C*," formerly in the B. B. Macgeorge collection, is currently unknown.

The impression illustrated is of the third state and is printed in black ink on thin, beige-colored laid paper. At the bottom of the print inscribed in Meryon's hand is the statement: "*12. Juni 1854. Je certifie qui le tirage est uniform à la présente épreuve C. Meryon.*"

8
La Tour de l'Horloge, Paris (The Clock Tower, Paris), (D.-W. 28; S. 23). 1852.

This subject was drawn and etched in 1852, while architectural alterations were in progress which substantially changed the appearance of Le Châtelet. The clock tower is shown partly covered by scaffolding and standing at the juncture where the Pont-au-Change meets the Ile de la Cité. The tower, forming one corner of the Palais de Justice (cf. D.-W. 19; S. 34 A&B) whose buildings stretch along the Quai des Orfèvres, is a major landmark in the center distance of *La Galerie Notre-Dame* (cat. nos. 5 and 6). This is a straightforward and masterly rendition of the clock tower, Palais de Justice, the Pont-au-Change, the crowd crossing the bridge with sunlight resting on the hay wagons, and the subtly expressed shadows on

the buildings.

The third, fourth, and fifth states of this etching were printed by Meryon. The sixth state was published in an edition of 600 in *L'Artiste* (vol. V, no. 9, October 1858). Delâtre printed states vi-ix. States viii to x, retouched by Meryon about 1861, feature two strong beams of light streaming from the windows of the Palais de Justice.

There are three study drawings for this print: one at the Metropolitan Museum of Art, New York; one dated *1852* in the Toledo Museum of Art; and a complete drawing in the Bibliothèque Nationale, Paris.

The impression illustrated is an early one of the fifth state, printed in black ink on cream-colored laid paper.

9

Tourelle, Rue de la Tixéranderie, Paris (House with a Turret, Weavers' Street, Paris), (D.-W. 29; S. 24). 1852.

The subject of this print was drawn just before its demolition. The turreted old house stood at the corner of the rue de Coq which was demolished in 1851. In *Notre-Dame de Paris*, Victor Hugo mentioned this street as one of the informal and interesting areas of the city.

The etching gives a very beautiful, warm effect of sunlight on the picturesque old house, with the lower part of the turret wreathed in foliage. At the far right the medieval knight-in-armor with plumes and the nude woman standing with the little girl in the doorway at right center are enigmatic elements of the scene.

There are several preliminary drawings for this print: a detail of the turret is in the Bibliothèque Nationale, Paris; a pencil study on several pieces of paper glued together, with touches of red and blue to indicate shadows, is in the Carnegie Museum of Art, Pittsburgh; and a complete study is in the Art Institute of Chicago.

The impression illustrated is a brilliant third state in black ink on buff-colored Japan wove paper. The warm tone of the paper emphasizes the bright, sunny effect of the light. This state was printed by Meryon with great care to provide the desired delicate quality of light defined by the colors of ink and paper.

10

Saint-Etienne-du-Mont, Paris (Church of St.

Stephen of the Mount, Paris), (D.-W. 30; S. 25). 1852.

The facade of the west front of Saint-Etienne-du-Mont shows its gracious Renaissance portal, its Rose window and Gothic gable with its ancient Gothic tower, all bathed in sunlight. To the left is part of the Collège de Montaigu (later destroyed) and at the right is a corner of the Panthéon. In 1851-1852, Meryon lived on the rue Nouvelle Saint-Etienne-du-Mont, very near this site.

This print gives a beautiful effect of sunlight with the architectural details of the church rendered with exquisite clarity. The people on the steps of the church, the little figures of the workmen on the scaffolding of the Panthéon, the soldiers, and the stately nuns make the print lively and interesting.

There are two preliminary study drawings for this print and a final preparatory drawing, all in the Toledo Museum of Art.

The impression illustrated is a rare third state before trimming of the plate, which removed the top of the knob surmounting the cupola. It is printed in black ink on buff-colored, Japan wove paper.

11

La Pompe Notre-Dame, Paris (The Notre Dame Pump, Paris), (D.-W.31; S.26). 1852.

This pump, originally built in 1670, provided water from the Seine for the city. It was demolished in 1858. The view is from the water level, showing the pump with its square tower containing a reservoir, and its picturesque piles. To the right, beyond the buildings on the quay, are the high towers of Notre Dame. Meryon's precision and modelling in light and shade are well exemplified in this plate. As Philip G. Hamerton remarks, the arrangement of the carpentry is expressed with a keen sense of construction.[94] This present author agrees with Campbell Dodgson that the eye delights in the intricate lines, alternately light and dark, of the two wooden structures that rise from the water.[95] In a letter to Paul Mantz of June 4, 1853, Meryon admitted that the towers of Notre Dame are a little higher than one could see them in reality:

This etching of 'La Pompe Notre-Dame' gives as nearly as possible a faithful view of this structure which it is said is shortly to be demolished. Nevertheless I have permitted myself a certain freedom in depicting it, as I desired to minimize its

heavy appearance by modifying certain details. Thus the towers of 'Notre-Dame' stand slightly higher above the houses than they do in reality; but I consider these licenses permissible since it is, so to speak, in this way that the mind works as soon as the actual objects which have arrested its attention have disappeared from sight.[96]

A preparatory drawing for the print is in the Bibliothèque Nationale, Paris. The etching closely follows the drawing, with the exception of the boat at the right, which in the etching is pointed downstream. A drawing in the Museum of Fine Arts, Boston, shows one of the arches of the Pont Notre-Dame and is dated 1852 by Meryon.

12

Le Pont Neuf, Paris (The New Bridge, Paris), (D.-W. 33; S. 30). 1853.

This etching is the ninth of the set as Meryon numbered it and features the oldest bridge in Paris, begun in 1578, and remodelled in 1843-1853. It connects the right bank with the Ile de la Cité. Pictured are the last three piers and arches of the bridge with semicircular boutiques on the street level above. Delâtre printed impressions of the fifth state on both ivory-colored and pale green papers; all impressions of the sixth state are on greenish paper. Meryon reworked the plate in 1861 for states ix and x, removing the chimneys and smoke. In these later states, too, the houses in the background were burnished out and re-etched on a smaller scale.

This print is a solid, masterly piece of architectural etching. The light impinging on the truncated turrets of the bridge and reflecting on the surface of the river is very subtly expressed.

Two study drawings for this print are in the Toledo Museum of Art and the Bibliothèque Nationale, Paris. A finished drawing in reverse, the location unknown, was in the B. B. Macgeorge collection.

The impression illustrated, at one time in the John W. Wilson collection, is a rich fifth state in dark brown ink on pale green, laid paper.

13

Le Pont-au-Change, Paris (The Exchange Bridge, Paris), (D.-W. 34; S. 40). 1854.

This print depicts again at the right, from a point near the Pont Neuf on the Ile de la Cité, the Tour de l'Horloge and the Palais de Justice. Beyond the bridge in the center is the tower of the Notre Dame pump. In the distance, on either side of the river, are dwellings. In the foreground a bather stretches out his arms to a nearby boat in which the occupants are looking in the opposite direction.

This plate is imbued with air and light. It renders admirably the shimmering water and the atmosphere. In its sky effects, it is the most beautiful of all of Meryon's prints. In the first state the print shows the caretaker's lodge, the bridge and the river, while the sky is entirely blank. In subsequent states up to the fifth, the plate was finished and the added details give it life and brilliance. The first and fifth states are the best. In later states the plate deteriorates as a result of Meryon's retouching and bizarre additions.

The print is remarkable for the many alterations made in the sky in successive states. In states ii to vi a balloon floats in the sky at the left, inscribed *SPERANZA*. In state vii the balloon is effaced and in state viii, at the left, two flocks of birds are in the sky. The lower flock appears to be ducks, whereas the upper flock, with longer wings and hooked beaks, looks like birds of prey or perhaps seagulls. In state xi most of the birds on the left have disappeared and a new flock wheels about the Tour de l'Horloge. Five small balloons are in the sky at the left. In state xii several new balloons are visible in the sky including a large one bearing the inscription *[VAS] CO DE GAMA PAR [IS]*. Below the title is: *A. DELATRE IMP. R.S. JACQUES 203*. The multitude of changes seem pointless; the extensive alterations were introduced after Meryon's mental condition had deteriorated.

In a letter of January 8, 1860, Baudelaire comments on this plate in a letter to his publisher, Poulet-Malassis:

In one of his large plates, he substituted a flock of birds of prey for a small balloon, and when I remarked to him that it was unusual to put so many eagles in a Parisian sky, he replied that this was not groundless, since those people (the government of the Emperor) often released eagles to study omens after the rite, and that this had been put into print in the newspapers, even *Le Moniteur*.

I should say that he does not conceal in any way his regard for all superstitions, but he interprets them poorly and sees intrigue everywhere.[97]

A preliminary study of the whole scene was in the B. B. Macgeorge collection, current location unknown. An on-the-spot sketch, annotated "A," is in the Bibliothèque Nationale, Paris. A small study showing the profile of the bridge and studies of the bathhouse is in the Art Institute of Chicago. A complete, detailed drawing is in the Sterling and Francine Clark Art Institute, Williamstown, Massachusetts.

The impression illustrated is a magnificent, fresh fifth state in brownish-black ink, with plate tone and inky plate edges, on ivory-colored laid paper.

14

La Morgue, Paris (The Mortuary, Paris), (D.-W. 36; S. 42). 1854.

The old morgue, situated on the Ile de la Cité, was constructed in 1568, and was formerly an abattoir. Burty's description of the print reveals that he had a strong appreciation for Meryon's active imagination:

In the eyes of some amateurs, this piece is perhaps the most remarkable of all his works. It would be impossible to extract a more moving treatment of a corner of houses, which, in reality, were far from producing a similar impression on the soul. These bizarre, superimposed roofs, these colliding angles, this blinding light which renders the contrasts of the masses of shadow so striking, this monument which acquires a vague resemblance to an antique tomb under the burin of the artist, offers to the spirit some unknown enigma about which the characters speak a sinister word; the massed crowds hanging on the parapet of the quai look upon a drama which unfolds on the bank: a corpse has just been dragged from the Seine; a little girl sobs; a woman turns her back, distraught, choked by despair; the policeman gives the order to the sailors to carry this derelict of misery or debauchery to the Morgue.[98]

La Morgue is granted by many connoisseurs the first rank among all of Meryon's etchings. The plate combines a wonderful chiaroscuro effect and an impressive treatment of the chimneys, roofs, and windows which ascend in a succession of levels from the river's edge. Dodgson notes that it features a motive of poignant human interest in the dramatic group that bears the body of a drowned young man from the Seine towards the old morgue at the right.[99] This print is an unforgettably great piece, noble in design; in it is clearly visible Meryon's power of instilling poetry and mystery into uninteresting subject matter. It is a moving evocation of ancient Paris. The solid lines of the stone buildings are rendered with certainty of style and the effect has been concentrated with great skill. The shadows from the sunlight are unerringly defined; the fenestration is faultlessly observed with some windows being occupied by viewers of the human drama. As Malcolm Salaman observed, the whole place seems tenanted and alive.[100] Martin Hardie's description of the plate is noteworthy:

The buildings, we are told, were dull and uninteresting in actual fact; but see how Meryon has woven into his sinister design the crude shapes and angles of the roofs, the clash of blazing light and massed shadow, the whirling lurid smoke from the chimneys, as though Hell itself were belching there. Look at the dramatic arrangement of the figures, the callous spectators leaning over the parapet, and watching the *sergent de ville* as he directs the removal to the mortuary of a sodden victim of despair or debauch. Look at the agonized frenzy of the woman—the sobbing child. It is of the theatre, this scene, with washer women working quietly below, while the hot sun illuminates, like limelight, the tragic group. But there is no melodrama in the scene; it is all grim tragedy, in which the very houses seem to play their part. And did anyone ever make an empty window more dramatic than Meryon? His windows are like human eyes, with depths of haunting sorrow dwelling underneath their lids.[101]

A preparatory drawing, annotated "*A,*" in the Bibliothèque Nationale, Paris, outlines the composition, but omits the figures.

The impression illustrated, which once belonged in the Loys Delteil collection, is a wonderfully rich, fourth state in black ink on ivory-colored wove paper.

15

L'Abside de Notre-Dame de Paris (The Apse of Notre Dame, Paris), (D.-W.38; S.45). 1854.

Philippe Burty's excellent description of this great print bears repeating:

The towers of the Cathedral, seen from the foot of the Pont de la Tournelle, dominate the nave and its buttresses. To the left the three arches of the Pont aux Choux span the river, and beyond are seen the ancient buildings of the Hôtel Dieu. This view of Notre Dame is strikingly majestic. The Cathedral, which inspired a poet to write one of the most beautiful

works of our generation, appears to have exercised a great influence over Méryon's dreamy spirit, and to it we owe his loveliest plate. It is also the one which has called for the exercise of the greatest amount of knowledge of drawing, of composition, and of taste. For it must be remembered that photography had not then placed in the hands of artists reductions of views, whereby they could obtain either tracings or valuable hints. Note well how Méryon has preserved in his drawing of this Gothic building all the vastness and elegance of proportion which are the characteristic types of that branch of French architecture.[102]

Meryon was very pleased with the reference to Victor Hugo and wrote: "I am most honored by this comparison which the author makes of my work with one of the great names of our era, but only in accepting it with the humility due from my past."[103]

In this print, Notre Dame, with its long high roof, its flying buttresses and pinnacles, its transepts and rose-windows with great twin towers, is indeed impressive. It is admired for its harmony and beauty among lovers of etching throughout the world.[104]

The composition of this plate, the lighting of the sky and of the majestic cathedral, the towers and high-pitched roof set against the insignificant array of buildings along the Seine combine to produce an effect of unrivalled dignity and charm. Dodgson notes the stark contrast of the splendid architecture of the cathedral with the squalid foreground, where heaps of sand are being shovelled into carts, and barges are moored along the shore.[105]

The inspiration for this beautiful etching was likely the large drawing, c. 1848-1849, of Notre Dame with the north side of the Ile de la Cité (Yale University Art Gallery). The print may also derive from a painting of an almost identical view by Johan Barthold Jongkind done in Paris in 1848-1849 (Private Collection, Paris).[106] Nine studies of individual details as well as a finished pencil drawing are in the Bibliothèque Nationale, Paris. There is also a superb finished drawing in a private New York collection.

16
La Rue des Toiles, à Bourges (Street of Textiles, Bourges), (*D.-W. 55; S. 31*). 1853.

Having visited Bourges and been fascinated with the city and its ancient buildings, Meryon projected a series of etchings on the same plan as his album on Paris. He had made loose leaves and two drafts for the title, but the project was not completed. This etching from 1853 features old, gabled houses, some timbered, with quaint doorways and windows. The narrow road and sidewalk sloping down from the houses are animated. A young woman is assisting a man with a wooden leg, and a beautiful young woman is conversing with a pikeman who could have stepped out of the 16th century.

This print, though not in the Paris set, must be numbered among the most powerful and striking plates by Meryon and is equal to the finest pieces of *Eaux-fortes sur Paris*. It is similar in certain respects to *Tourelle, Rue de la Tixéranderie* (cat. no. 9). Early impressions of this print are beautifully printed. Burty wrote: "A dark and winding street, whose houses are in the purest 14th and 15th century styles."[107]

Meryon's letter of June 20, 1853, to his father describes his work on this print:

The composition of this piece has cost me much more pain than one could ever have believed as I have never made use of a Daguerreotype until now, [sic] for many reasons, the acquisition of the necessary materials has demanded of me both time and work. Add to this that all the lower parts of the houses were modern and by consequence strongly dissimilar to the upper parts which date from many centuries.[108]

He indicated to Burty that he had combined details from various houses for this subject in order to achieve a true medieval character. "All the upper portions of the houses are true to nature; the lower parts had, however, been so disfigured by modern restorations, that I obtained from other quarters of the town details which would best accord with the upper stories."[109]

A finished drawing, done on the spot, and inscribed: *à M. Neil, dessin fait sur*

place à Bourges en '52, is in the Art Institute of Chicago. The final drawing for the print, in reverse, from the B. B. Macgeorge collection, is also in Chicago.

The print illustrated is a rich impression of the rare fifth state in black ink on cream-colored laid paper. The ninth state of this print was published in a large edition in 1864 to accompany Philip Hamerton's first appreciation in English of Meryon's prints.[110]

James Burke's beautiful tribute provides a fitting close to these comments on Meryon's prints:

> He was a gentle person, extremely oversensitive and humble, a deeply introspective artist who had created and preserved on paper a special vision that still has power to affect us today. It is a fragile old world of medieval streets and civic pride, destroyed and built by the Second Empire. The remarkable lucidity of his images, so striking in their faithfulness to nature, are filled with mystery and tension. This heightened intensity is combined with deep over-contrasts of light and shadow to portray an immense city in which tiny incidental dramas are played out amidst masses of humans. It is a world of unseen forces, fascinating and mystical; a spirit that would continue later in the art of Bresdin, Redon and Ensor, and extend into the works of the Surrealists in our century.[111]

Jean-François Millet (1814-1875)

Millet was born October 4, 1814, in the small hamlet of Grunchy, in the parish of Gréville, near Cherbourg, on the Normandy coast. Grunchy is a few hundred yards from the sea by the high granite cliffs of the Hague overlooking the stormy waters of Cherbourg Roads. A fertile country, the area had sustained generations of Millet's family, rooted in the poor French peasantry. According to early biographers William Ernest Henley and Alfred Sensier, Millet came of excellent stock on both sides of his family. His paternal grandmother, Louise Jumelin, widow of Nicolas Millet, was a woman of great depth and strength of character. Robust and energetic, very religious, intelligent, and decisive, she came from a family of siblings who were also exceptional. Millet's father was pious, cheerful, serious of temper and mind, and an artist at heart. He was fond of music and served as choir director for the

Grunchy church. He modeled in clay and carved in wood; he loved to instruct Jean-François in the beauty and charm he saw in the surrounding landscape and to make him feel "the wonder and the mystery in the changing seasons," in the fruiting of the wheat, in the majesty of the nearby woods, and in the growth of the grass and flowers. Millet's mother, Aimeé-Henriette-Adélaïde Henry, though not mystical and imaginative like her mother-in-law and her husband, was intelligent and rich in sentiment and emotional capacity as her letters to her son attest. She bore nine children, the eldest a girl and the second child, the artist.[112]

Millet was christened Jean, after his father, Jean-Louis-Nicolas, and François, after Francis of Assisi, his grandmother's patron saint. Because his mother tended the fields, Louise Jumelin took care of François, who is said to have been indebted to her for his strong principles of right and morality. His uncle, the Abbé Charles Millet, also profoundly affected his life. Careful guidance by these relatives exerted a powerful influence on his life and character and the boy grew up in an environment of toil, sincerity, and devotion. Henley's description of his early life is instructive:

> He was fostered upon the Bible and the great book of nature. He dwelt between the eternal majesty of the sea and the solemn beauty of the wide champaign. From the first he was familiar with the spectacle of the generous strife of man and the elements. When he woke, it was to the lowing of cattle and the song of birds; he was at play all day among the sights and sounds of the open landscape; and he slept with the murmur of the spinning-wheel in his ears, and the memory of the evening prayer in his heart. In a little while he learned to read and write, and he was then able to search the Scriptures for himself, and, in time, to study the men of Port-Royal. He combined the religious ardor of his grandmother with the tenderness of his mother. He learned Latin from the parish priest and from his uncle Charles; and he soon came to be a student of Virgil, who was one of his idols always. While he was yet young in his teens he began to follow his father out into the fields; and thenceforward, as became the eldest boy in a large family, he worked hard at grafting and ploughing, sowing and reaping, scything and shearing and planting, and all the many duties of husbandmen.[113]

While at home, Millet read voraciously. *The Lives of the Saints,* the *Confessions of Saint*

Meryon and Millet

Augustine, Saint Francis of Sales, the *Letters of Saint Jerome,* and the religious philosophers of Port Royal-Bossuet and Fénelon are among the books recorded. He read and re-read Virgil and his Bible, always in Latin.[114]

While still young, he began to become interested in art. Some old engravings in the Bible caught his attention and he began to draw them. The landscape outside became a subject for study. Subsequently, he drew the garden, the stables, the fields, and often animals which wandered by.[115] His skill in drawing increased rapidly and he was enthusiastically encouraged by his father to sketch scenes and people about him. His father replied to the 18-year-old Millet, who had indicated a desire to become a painter:

My poor François, I see you are troubled by the idea. I should gladly have sent you to have the trade of painting taught you, which they say is so fine, but you are the oldest boy, and I could not spare you; now that your brothers are older, I do not wish to prevent you from learning that which you are anxious to know. We will soon go to Cherbourg and find out whether you have talent enough to earn your living by this business.[116]

The young man prepared two drawings to be shown as proof of his proficiency to Mouchel, a Cherbourg artist and pupil of the school of Jacques-Louis David. One of these was a composition of a peasant coming out of a cottage and giving some bread to another man under a starry sky. Under the drawing Millet had written in Latin the words of St. Luke's Gospel: "Though he will not rise and give him, because he is his friend, yet because of his importunity he will rise and give him as many as he needeth."[117] In later years, Millet remarked that this drawing anticipated all his art. He and his father showed the two drawings to Mouchel, who initially disbelieved that the drawings had been done by the young peasant before him. Finally convinced, he declared to Millet's father: "Well, you will go to perdition for having kept him so long, for your child has the stuff of a great painter." Mouchel then agreed to accept Millet as a pupil. The student stayed with Mouchel only two months, doing much as he pleased. Mouchel advised him: "Draw what you like, choose what you please

here, follow your own fancy—go to the museum."[118]

On November 29, 1835, Millet's father died of brain fever. On his deathbed he charged François "never to execute a work of impiety, and that all his desires should be to praise God by thought, word and deed."[119] Subsequently, Millet was prepared to become the chief supporter of the family, but his mother and grandmother would not hear of it. The two women worked to allow François to carry out his father's desire for him to become an artist. They insisted that he return to Cherbourg for further training. Doing so, he entered the studio of Langlois, a pupil of Antoine-Jean Gros. As with Mouchel, François received little direction and supervision from Langlois and was left to do as he wished. In Cherbourg he continued to read extensively. Besides French authors, such as Victor Hugo and Chateaubriand, he favored Shakespeare, Byron, Sir Walter Scott, Goethe's *Faust,* and James Fenimore Cooper. In addition, he studied Montaigne and Augustine, Jerome and Pascal. The scope of his reading widened to the end of his life.[120]

While in Cherbourg, Millet diligently copied paintings in the town gallery, creating studies after works by Philippe de Champaigne, Van Loo, Schedone, Van der Mol, and Jacob Jordaens. On Langlois' recommendation, the Municipal Council voted Millet a yearly allowance of 400 francs to support his art studies in Paris. A stipend of 600 francs from the Council General of La Manche supplemented this amount, but it was not long continued.[121]

The Millet family shared in François' excitement when he departed for Paris in January 1837. Mother and grandmother cautioned him about the seductions of this new Babylon. "Remember the virtues of your ancestors," his grandmother said. "Remember that at the font I promised for you that you should renounce the devil and all his works. I would rather see you dead, dear son, than a renegade, and faithless to the command of God."[122] Millet arrived in Paris with letters of introduction to the studio of Paul Delaroche. With a few hundred francs in his pocket he was received into the home of a man for whom he had letters of introduction from friends in Cherbourg. He gave all his money to his

hostess to keep for him and dole out to him as needed. The lady fell in love with Millet, and finding that he did not reciprocate her affection, confiscated his whole deposit, leaving him almost penniless. He left the house immediately and having secured a garret to live in, he entered into the studio of Delaroche. According to Henley, his fellow students were scornfully amused with his rusticity and the unconventional way he had of working. They called him the "wild man of the woods."[123] Meanwhile, Millet visited the Luxembourg and the Louvre, studying the works of Mantegna, Michelangelo, Fra Angelico, Filippo Lippi, Ribera, Murillo, and Nicolas Poussin. But the artificial prettiness of Watteau and Boucher gave him no pleasure. He was a pupil of Paul Delaroche, but could not adopt the academic formality of his teacher.[124] Though he was a simple peasant, he was far from being an ignorant one. His letters show that he was a man of keen intellect and refinement.

Millet was not impressed with Romanticism. He possessed the virtues of sincerity and strength; he had been reared on the Scriptures and was familiar with heroic literature. He much preferred dignity to effect, and truth to falsehood. His ambitions were lofty and he took life very seriously. He turned aside, discontented and surprised, from the affectation of Romanticism with its vulgarity and trickiness. He cherished a life-long admiration for Eugène Delacroix, but the barrenness and insincerity of painters like Boulanger and Delaroche were painfully apparent to him, for he said:

Let no one think that they can force me to *prettify* my types; I would rather do nothing than express myself feebly. Give me sign-boards to paint; give me yards of canvas to cover by the day, like a house-painter—but let me imagine and execute my own work in my own way.[125]

Thus he soon left the studio of Delaroche and together with his friend Louis-Alexandre Marolle rented a little attic studio. Here he painted portraits at five francs each and produced sham Watteaus and Bouchers which his friend Marolle, son of a varnish manufacturer, peddled to dealers. When the dealers tired of Watteau and Boucher there was nothing to do but return to Cherbourg and secure work there; this he did.[126]

When his paintings did not readily sell, Millet accepted commissions for signs which he painted life-size. These include *The Little Milk-girl*, created for a dry-goods shop; *A Scene of Our African Campaigns*, for a tumbler, who paid him 30 francs; a horse, for a veterinary surgeon; and a sailor, for a sail-maker.[127]

At this time, Millet was a strong, handsome young man twenty-seven years old. His first wife, Pauline Ono, whom he married in November 1841, was very delicate and died after two years and five months of marriage. In late 1845, he married Cathérine Lemaine, the mother of his nine children and a devoted companion, who remained with him until his death.[128]

In December 1845, Millet returned to Paris, and, with his wife, endured four years of severe poverty. In the winter of 1848, a friend found them in a room that was freezing cold. When 100 francs were given to Millet, he said: "Thank you; it comes in time. We have not eaten for two days, but the important thing is that the children have not suffered. Until today they have had food."[129] His pictures sold for very low amounts, they were hung badly at exhibitions, and most of the critics snubbed or ignored him. The Paris Salon refused to admit several of his paintings, and those which were accepted found few admirers or purchasers. Indeed, it was a time of effort and meditation.

In this period, he learned from Michelangelo the mystery of gesture, expression, and emotion. Millet wrote:

But when I saw a drawing of Michael Angelo's—a man in a swoon—that was another thing! The expression of the relaxed muscles, the planes and modeling of the figure weighed down by physical suffering, gave me a succession of feelings: I was tormented by pain, I pitied him, I suffered with that very body, those very limbs. I saw that he who had done this was capable, with a single figure, to personify the good or evil of all humanity. It was Michael Angelo—that says all.[130]

Several other sources inform the paintings and etchings of Millet. According to Sensier, from studying Nicolas Poussin, Millet learned style, dignity in design, breadth and symmetry in composition, nobility in conception, and reticence and grandeur in execution. Of this

artist Millet remarked: "...Poussin was the prophet, the sage, and the philosopher, while also the most eloquent teller of a story. I could pass my life face to face with the work of Poussin, and never be tired."[131] From the work of Correggio he mastered the art of modelling, which absorbed Millet in his early studies of the nude.

His work at this time consisted mainly of sketches of the nude since this subject matter sold more easily than other works. Artists called him "*le maître du nu*." According to Millet's biographer, one day he overheard a conversation between two young men who were looking at one of his nudes (*Baigneuses*) in the shop window of Deforge: "Do you know the author of this picture?" one asked. The other replied: "yes, it's a fellow called Millet who paints only nude women." Cut to the quick, Millet returned home, told his wife the story and said: "If you consent, I will do no more of that sort of picture. Living will be harder than ever, and you will suffer, but I will be free to do what I have long been thinking of." His wife replied: "I am ready; do according to your will." After this resolve Millet gradually turned his attention to rustic subjects—sketches and studies of life in the streets and suburban fields and villages.[132]

When cholera broke out in Paris, Millet and Charles Jacque, an etcher and friend, decided to leave the city. Furnished with 1,800 francs, they moved their families on June 13, 1849, to the little inn of François Ganne at Barbizon, a hamlet of Chailly, at the edge of the forest of Fontainebleau. There Millet found already established the artists Narcisse Diaz, Claude Aligny, and Théodore Rousseau, who became his life-long friend, neighbor, and champion. Though intending to spend only a month or two in Barbizon, Millet prolonged his stay to twenty-six years, living in a rented cottage till the end of his days.[133] In a dismal, damp, barnlike studio Millet worked for five years. There was no chimney and the only means of warmth in the winter was by burning straw on the stone floor. Yet in this comfortless workshop Millet produced some of his greatest works.[134] Five years later, his landlord converted a barn across the garden into an *atelier* (Fig. 1) which Millet used to the end of his life.

Millet's development in art was gradual and steady. It was only after he devoted himself at Barbizon to the delineation of peasant life that his masterpieces of painting, drawing, and etching were forthcoming. As Sensier noted, there he drew and painted the rustic scenes

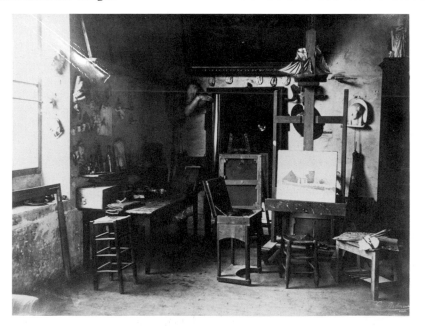

Fig. 1. Karl Bodmer, Photograph of Millet's Studio, Albumen Print. S.P. Avery Collection, Miriam & Ira D. Wallach Division of Art, Prints and Photographs, The New York Public Library, Astor, Lenox and Tilden Foundations.

he loved—sawers at work, wood-gatherers, charcoal-burners, quarrymen, poachers, stone-breakers, road laborers, and men plowing, harrowing, and cutting wood.[135] Several of his contemporaries recognized the greatness of his work. Among these were Rousseau, Jacque, and the American painter William Morris Hunt.[136] Jacque, then engaged in making his charming etchings, became a passionate admirer of Millet's talent.[137] Meryon also recognized the greatness of Millet's etched work for he had begged to see Millet's etchings and expressed a desire to buy some of them. In a letter to Sensier of December 4, 1860, Millet spoke of Meryon: "Since M. Meryon is really so amiable, let him choose any of the plates which he likes to have."[138] Sensier writes that: "Meryon, who has had such success since with his etchings, had a great opinion of Millet's, and took the trouble to print some proofs in his own press, in order to study their qualities."[139]

Millet was thoroughly original in his etching style. A consummate draftsman, he avoided prettiness and "finish," and sought the essentials of a subject. There is "no coquetry, no superficial adroitness" in his work; instead there is honesty and transcendent ability. His perspective is revealed in a letter to an intimate friend: "To paint well and naturally, I think an artist should avoid the theater. The human side of art is what touches me most; the gay side never shows itself to me."[140]

Millet's struggles repeat the sad story of so many men of original genius: first neglect, then opposition, violent controversies, serious consideration, and finally taking their place among the immortals. When at last much-deserved renown came to Millet, it was too late. The strong, vigorous man was now worn out by years of neglect, poverty, deprivation, and deep disappointment. No strength remained to gather the harvest and so after an extended illness, he died at 6:00 a.m. on January 20, 1875, in the 61st year of his life.[141] Millet was buried by the side of Théodore Rousseau on January 23, at Chailly under the shadow of the church tower which appears against the sunset sky in his *Angelus*. A bronze relief panel bearing their profiles, side by side, is attached to one of the great rocks in the forest of Fountainbleau near the Porte des Vaches.[142]

Alfred Sensier filled an important role in Millet's life, having been an intimate friend and champion for twenty-eight years, since 1847. He recognized Millet's talent early and frequently purchased the paintings, drawings, and pastels which Millet was happy to sell at any price. As a dealer for Millet's paintings, he often guaranteed to reimburse the purchaser the cost if later the buyer became dissatisfied with the picture. The result was that many pictures were returned to Sensier, who then had to buy them back.[143] Sensier's biography, *La Vie et l'Oeuvre de J.-F. Millet*,[144] is a poignant account of Millet's life struggle and work. After the artist's death, Sensier sold his large collection of Millet's works at public auction at an immense profit. The story then arose that Sensier had unmercifully exploited Millet, taking ill advantage of him. But this charge is false. Rather, Millet and Sensier had a very close relationship. The latter wrote that Millet once told him: "Friends get tired or leave us, in the hard moments of life. Some die or disappear. You have remained. You have always helped, sustained, encouraged and understood me."[145] On being questioned about this charge of exploitation, Charles Millet, the artist's son, stated that his father always gratefully recognized the sympathy and aid of Alfred Sensier. And Millet's eldest daughter, Madame Saignier, who was an adult before her father's death, declared that Millet taught his children to love and esteem Alfred Sensier "next after le bon Dieu."[146]

Millet's Etched Work

Millet's entire etched work consists of twenty prints. Of these, seven are minor sketch plates which the French call *griffonnements*, or experimental scribblings, done on a copper plate with an etching needle or the drypoint and not intended for publication. They are trials in the etching process and are of little interest except to students of the etching technique. Thus they are merely practice plates, "tuning up" as it were for the real music which was to follow. These first essays in etching were prompted by Charles Jacque, Millet's close friend and neighbor.[147]

Thirteen plates may be considered as finished works. Millet's etchings were done when this art was not yet popular; therefore

some of his finest prints are rare and some states are unique. However, for many years it was his custom to give a proof of every plate he printed himself to his friend Alfred Sensier. His own early printing methods were relatively primitive. Without printing press or ink, he would fill the plate with some dark color from his palette; then he would fold a sheet of paper about the plate and take an impression by rubbing the paper with the rounded back of a soup-spoon. Millet's first print, *Le Petit Navire*, was printed by this method. Such proofs were carefully preserved by Sensier, after whose death they passed into the collection of Alfred Lebrun.[148] In 1886, the Lebrun collection of Millet etchings was sold to the New York dealer, Frederick Keppel, and now is in the Art Institute of Chicago.

Whereas Rembrandt rarely etched a subject which he had painted, or painted one that he had etched, Millet's practice was quite the opposite. When a composition pleased him, he frequently used it in its various media. Several of his works were first etched and the design later repeated, in watercolor or pastel or oils.

Mrs. Schuyler Van Rensselaer, a connoisseur of Millet's etched work, in discussing this subject, wrote:

In etching a subject which he had previously painted Millet did not try to reproduce the painting; he merely tried to give fresh expression, with a different artistic method, to a conception already once expressed with paint. Each etching stands on its own merit as an etching, as frankly and simply as though no painting of the same subject were in existence.

Millet's truly artistic nature shows itself in the fact that he went thus about his work. And the breadth and versatility of that nature is convincingly proved by the intrinsic excellence of these etchings in conjunction with the intrinsic excellence of the corresponding pictures. A man who had given his whole life to etching only, who had never thought of painting, and had never cared for those effects proper to painting and not to etching, could not have been more truly and markedly a born etcher than Millet showed himself to be—few though were the plates and many though were the canvases he worked upon. To depend upon lines, not tones, for expression; to make every line "tell" and to use no more lines than are absolutely needed to tell exactly what he wants to say; to speak strongly, concisely

and to the point; to tell us much while saying little; to suggest rather than to elaborate, but to suggest in such a way that the meaning shall be very clear and individual and impressive—these are the things the true etcher tries to do. And these are the things that Millet did with a more magnificent power than any man, perhaps, since Rembrandt. Other modern etchings have more charm than his—none have quite so much feeling. Others show more grace and delicacy of touch—none show more force or certainty, and none a more artistic "economy of means." Compare one of these prints with the corresponding picture, and you will feel, more deeply than ever before, how much more important was the intellectual than the technical side of Millet's art. Its technique is always admirable, whatever may be the process chosen; if it were not, the intellectual message would not be told so clearly.[149]

Millet's etchings and drypoints are characterized by masterly draftsmanship, richness of effect, and great economy and power of line.[150] They are creations of a conscious power which places them on a level with his paintings as perfect expressions of his genius.

Millet, in his handling of the medium, was at once bold and simple, like his designs. Broad planes and essential lines, rather than tones, were used to develop his compositions. He used no strokes beyond those necessary to express exactly his meaning. He omitted details he considered unnecessary, for, according to Roger Passeron, his object was to render the inner life of his subject.[151] He suggested his ideas rather than elaborated them in detail, with the result that his meaning is unfettered, strong and individual.[152] He once wrote, "I have been reproached for not observing *detail*; I see it, but I prefer to construct the *synthesis* which as an artistic effort is higher and more robust. You reproach me with insensibility to charm; why, I open your eyes to that which you do not perceive, but which is none the less real: the dramatic."[153] John Taylor Arms, who was an admirer of Millet's etched work, wrote:

There exists not a passage, not a single line, in all the etched work of Jean-François Millet that could be called "pretty," clever, or trivial. Rather are his prints veritable epics, born of knowledge and of the humility that goes with great knowledge, a perfect blending, in both their spiritual and technical aspects, of those qualities of heart and of intellect which form the foundations on which human life

in its truest and most rudimentary attributes is built. Indeed was his a great spirit, in which his works are most clearly mirrored.[154]

Millet's habit of drawing even at the dinner table developed a precision and sureness of touch that is reflected in all his etchings. His superb and elegant draftsmanship lends distinction to the humblest figure. His peasant figures are presented with a rugged directness and possess a formal but homely sobriety. The theme of all Millet's work is: "Man goes forth to his labor until the evening" and "In the sweat of thy face shalt thou eat bread." Of the weary toil of the peasants he wrote: "But, nevertheless, to me it is true humanity and great poetry."[155] He understood the dignity of labor and knew by bitter experience the secrets of the poor. The pathetic side of human life held an especial attraction for him. As Arms states, Millet pondered long upon his peasants and drew them on the copper after he had drawn from them their essence, without superfluous detail or decoration. Thus they are the result of *reasoning* rather than simple *seeing*. As a consequence, Arms concludes that Millet was not merely depicting peasants involved in daily toil, but rather the epic of labor and hardship as manifestations of real life.[156] As A. Hyatt Mayor claimed, he etched his peasant laborers with the force of truth in revolt against the artificiality of official art.[157] When he viewed peasant life, he saw it as sometimes pathetic and always grave and serious. "He was by birth and temperament a man of the soil, virile in feeling and powerful in expression." Thus, his work has been described as: "The Poem of the earth."[158] He interpreted peasant life with sympathy and understanding. Finally, it is his bond of affinity with his fellow men that gives to his etchings their intensely human and universal character. "His best etchings are full of melancholy and mystery, they encourage and inspire for they are the expressions of a heroic mind and soul. The influence of his art is thus elevating and ennobling and his work radiates an impressive solemnity."[159]

Thomas Moran, the distinguished 19th-century American painter and printmaker, in speaking of Millet's etchings said: "I admire his etchings still more than I admire his paintings. When Millet was painting he was thinking of his color, but when he was etching he was thinking of his drawing."[160] Millet's friend, the Barbizon painter Jules Dupré, once

wrote: "The painters did paintings on their good days and their bad days, but they did etchings only on their good ones."[161] This comment applies well to Millet's work.

The subjects of several of Millet's plates already existed as paintings, which in turn, had been studied in many preliminary drawings. Thus, when he came to create these etched interpretations of peasant life, he was able to express with a directness and knowledge precisely what he wished to say. Consequently, his etchings manifest a concentration on the essentials of his theme and an elimination of extraneous detail—these factors are responsible for their simplicity, strength, and poetry.

Millet's finest prints, such as *La Baratteuse* (cat. no. 26), *Le Paysan Rentrant du Fumier* (cat. no. 27), *Les Glaneuses* (cat. no. 28), *Les Bêcheurs* (cat. no. 29), *La Cardeuse* (cat. no. 31), *La Grande Bergère* (cat. no. 34), and *Le Départ pour le Travail* (cat. no. 35), will take their place among the permanent icons of graphic art as worthy companions to the great prints of Dürer, Schongauer, Rembrandt, Piranesi, Goya, Meryon, and Whistler. In the nobility of their conception, in their powerful execution, and in the breadth of their influence, Millet's prints assure him a rank among the world's great printmakers.[162] His etchings have exerted a profound influence on subsequent artists, particularly van Gogh, who though not copying literally, painted variations on Millet's themes. Like van Gogh, Millet evoked a new understanding of the lives of those who lived close to the soil. Millet once said that "he heard the cry of the earth." His work is for the ages and is certain to exercise influence in the future.[163]

A word of caution is in order about the quality of impressions taken from Millet's plates. His prints should be judged only by well-printed, life-time impressions. His plates were usually deeply bitten, permitting them to be reprinted after his death. Most of the posthumous impressions published by Frederick Keppel shortly after 1900, using the services of the English printer Frederick Goulding, are not of excellent quality because of fatigue of the plates, and should be avoided despite Keppel's claim that the Goulding proofs "are unquestionably the finest that Millet's plates ever yielded—although they are the

latest."[164] Even lifetime impressions are sometimes dull, muddy, and lifeless. But this is not due to any fault in the plates themselves. When the plates were printed by such a master printer as Auguste Delâtre, the results are harmonious, luminous—even glorious. These are the impressions that one should collect.[165]

The following are comments on impressions in the exhibition:

17

Moutons Paissant (Sheep Grazing), (D.5; M.5; L. & K.2), is an early drypoint and was dated by Alfred Lebrun to 1849, perhaps on the basis of information from Charles Jacque.[169] In style and character this print precedes all the Barbizon plates. At the top left is the signature, *Ch. Jacque*, and at the bottom left the inscription, *Jackson invenit et fecit*. Lebrun indicated that "The signature of Charles Jacque was added in jest, and was not intended to insure the sale of the print. The plate was done one evening at the corner of a table, in the house of the plate-printer, Delâtre." Delâtre told Lebrun that Jacque was present when Millet did this drypoint.[170]

18

La Planche aux Trois Sujets (The Plate with Three Subjects), (D.2; M.2; L. & K.8), 1854-1855, is another of Millet's early etching trials and foreshadows the wealth of material in his rural subjects. The central part of this plate is based on a drawing created during Millet's visit to his native Grunchy in 1854,[171] and shows a woman hanging out clothes. To her right is a seated peasant with crossed arms while at the extreme right is a small panel showing a peasant resting on the handle of his spade. The earth is turned up in a furrow and to the left a figure walks away, followed by a cow. In the lower right corner is a third subject of a seated peasant leaning on his left arm and looking into the distance. The plate is much obscured with roulette work. According to Lebrun only ten life-time impressions on old laid paper were pulled. The impression owned by Lebrun (detail of the *Woman Hanging out Clothes*) was printed by Millet with painter's pigment rather than with printer's ink.

19

Les Deux Vaches (The Two Cows), (D.4; M.4; L. & K.3), 1850-1852, another trial sketch plate, shows a woman standing between two grazing cows. This print suggests an artist ill at ease with etching, for the drawing is in short, straight strokes bitten deeply into the plate.[172] The fourth state illustrated, showing strong roulette marks and heavy plate tone, is printed in black ink on antique, pale green paper. The fifth state with the angles of the plate trimmed represents posthumous alterations.

20

La Planche aux Croquis (The Plate with Sketches), (D.6; M.6; L. & K.6), 1854-1855, is etched on the back of a plate which bears the stamp of *M. Juéry, 27 Rue de la Huchette, Paris* and though only a trial sketch, has some very fine drawing in it. A woman knitting is seen leaning against a hillock. She wears a kerchief, a cloak with a hood, and a skirt falling to her sabots. In front of her is sketched what appears to be a large tree. To the left is a drawing of a forearm. Further down the plate is a sketch of the head and shoulders of a man, and beside him written backwards: *Diaz delineavit*. A sketch of the trunk of a tree with one branch and a small figure of a man walking toward the tree is also visible. At the lower left is a small sketch of a nude figure standing. There are random strokes throughout the plate. According to Lebrun, this plate was also printed in an edition of ten. The impression illustrated is printed in black ink on old, cream-colored laid paper.

21

La Tricoteuse (Woman Knitting), (D.7; M.7; L.&K.7), 1854-1855 (?), is an extremely rare sketch plate in drypoint, known in only two impressions. Lebrun considered this print a separate printing of the central figure in *The Plate with Sketches* (Delteil 6), but it is a different print, though similar in design. This print appears to be a preliminary study for *La Grande Bergère* (cat. no. 34). As in *The Plate with Sketches*, this print was also done on the reverse of a plate which bore the address of the metal planer: *M. JUÉRY / 27, RUE DE LA / HUCHETTE / PARIS*. This impression, formerly in the collections of Hector Giacomelli, Jules Gerbeau and H. H. Benedict, is the one

illustrated in Loys Delteil's 1906 catalogue raisonné. It is in warm-black ink with burr and platetone, on pale buff laid paper.

22
Ramasseurs de Varech (Kelp Collectors), (D.8; M.8; L. & K.5), 1854-1855, another trial sketch plate, pictures a scene at the foot of the cliffs of Gréville. It depicts a man on the seashore seen from the rear, his right foot resting on a rock. He is pulling sea weed from the sea by means of a boat-hook. In the left background is a small figure of a man stooping towards the water. Roulette marks cross the body of the smaller figure and are also in other areas of this print. According to Lebrun only ten life-time impressions of this print were pulled. The print illustrated is printed in black ink on old, thin, white laid paper with a faint green tint.

23 and 24
L'Homme Appuyé sur sa Bèche (The Man Leaning on His Spade), (D.3; M.3; L. & K.4), 1854-1855, is Millet's earliest complete subject. It features a small but beautifully drawn figure of a man whose head is bent forward in an attitude of reflection. In this etching one can feel the deep-seated weariness of the peasant; it is as profound as a Michelangelo sculpture. This print is based on a pencil drawing on light brown paper in the Ashmolean Museum, Oxford. One of the impressions exhibited is only lightly toned (cat. no. 23) and printed in warm-black ink on antique, ivory-colored laid paper. The other (cat. no. 24) is printed with strong plate tone on antique, ivory-colored laid paper with an Arms of Amsterdam watermark.

25
La Couseuse (The Seamstress), (D.9 ii/iii; M.9 ii/iii; L. & K.12 ii/iii), 1855-1856. In late 1855, at the urging of his friend Alfred Sensier, Millet began a series of etchings intended for commercial publication. Sensier's purpose was to make Millet's work better known and to produce badly needed funds for the artist. *La Couseuse* is one of this series of prints. It is a little jewel among Millet's work and belongs to his Dutch-inspired subject matter. The light falls from a window glazed with antique diamond-shaped panes onto the figure of a woman sewing, seated in profile. Women at needlework was one of Millet's

favorite themes for which he did several drawings, pastels, and paintings. A study drawing in black conté crayon with white chalk is in the Museum of Art, Rhode Island School of Design. In posthumous impressions of this print (state iii), the light drypoint strokes in the upper left corner have disappeared, as well as the vice mark in the lower right corner. The impression illustrated is a beautiful life-time impression of state ii in warm-black ink on *Chine collé* laid over thick, white wove paper.

26
La Baratteuse (Woman Churning), (D.10 i/iii; Melot 10 i/iii; L. & K.13 i/iii), 1855-1856, is one of the finest of Millet's etchings, and is derived from his painting of 1848-1851 (Museum of Fine Arts, Boston). It depicts a robust and comely young peasant woman in the act of making butter with a primitive, old-fashioned churn. She wears a plain kerchief about her head, her arms are bare to the elbows, and her apron falls to her sabots. Her cat, with tail erect, expresses general contentment by affectionately rubbing against her petticoats. This print is drawn in sober, expressive lines and magically evokes a sense not only of the scene shown, but of the woman's surroundings and her labor-burdened life. The lines of this print are wonderfully expressive and the lighting of the woman is masterly.[173] Millet later repeated this subject both in oils and watercolors. A study drawing in pencil and black conté crayon on tracing paper is in the Museum of Fine Arts, Boston. There is also a drawing of this subject in black conté crayon in the Museum of Fine Arts, Budapest, and a related pastel and black crayon drawing in the Musée du Louvre, Paris. Paintings of the same subject are in the Museum of Fine Arts, Boston, and in the Malden Public Library, Malden, Massachusetts.

The print illustrated is a luminous impression of the extremely rare first state in black ink on thick, old, white Dutch wove paper. This is the impression from the Alexis Rouart collection that Loys Delteil used to develop his catalogue description of the first state. It was printed either by Millet himself or under his close supervision, so that it expresses well his idea of how this print should look.

27

Le Paysan Rentrant du Fumier (Peasant with a Wheelbarrow), (D. 11 iii/iv; M.11 iii/iv; L. & K.14 iii/iv), 1855-1856, presents an image well-developed in earlier drawings and paintings. Examples are the study drawings in black conté crayon in the Museum of Fine Arts, Boston, and in the Cabinet des Dessins, Museé du Louvre, Paris (three drawings), and the oil painting in the Indianapolis Museum of Art.

The print features a peasant wearing a hat with face in profile. His muscular arms are covered with knitted sleeves. He pushes a loaded wheelbarrow through an opening in a stone wall. In the right background hazel nut trees raise their straight trunks behind the rustic well.[174] In this print the droop of the shoulders, the muscular action of the arms that bear the weight, and the legs that furnish propulsion to the heavy load are rendered very effectively. Though completely covered by clothing, these members are as clearly modelled to the stress and strain they are supporting as if drawn in the nude. John Taylor Arms wrote: "Only one thoroughly familiar with human anatomy and able to render it truthfully and forcefully in any pose could so convincingly have filled those loose sleeves of the peasant's shirt, and the legs of his trousers, with the living flesh and bones within as has Millet in this typical example of his superb powers as a draughtsman."[175] Millet has rendered the solid figure and spaces of this garden scene so as to bring the subject to life.[176] In this print, Millet's drawing is direct, powerful, expressive, and lacking in non-essential detail. This print is not just an objective rendering of one particular peasant pushing one particular wheelbarrow, but it is also a symbol of all humble laborers engaged in all forms of toil and it is an eloquent expression of the basic relationship between the two.[177] The impression illustrated is state iii/iv, in warm-black ink on ivory-colored laid paper, printed with even plate tone.

28

Les Glaneuses (The Gleaners), (D. 12 ii/ii; Melot 12 ii/ii; L.& K.15 iii/iii), 1855-1856, is probably the most famous subject in Millet's etched oeuvre. Its theme is central to the Biblical story of Ruth and Boaz.[178] Sensier said that this subject represented autumn.[179] Unlike many of Millet's prints which reproduce his paintings, this composition was first developed as an etching and later done as a painting (Museé du Louvre, Paris). He worked from the study drawing now in the Baltimore Museum of Art, creating details directly on the copper plate. Essential components of the print are also seen in his vertical study drawing (1852-1853) in black conté crayon in the Museum of Fine Arts, Boston, and in the drawing in black conté crayon in the Museé Gobet-Labadié, Marseille.[180] This print features three women in the arid stubble-field walking in a very fatiguing bent position, collecting one by one the ears of grain that the modern Boaz no longer orders his servants to leave on purpose.[181] The rhythmic forms and strength of the bent backs constitute a very powerful image.[182] The mounted figure in the right background is the *garde champètre* (field warden) who insured that laws of local usage were observed and the rights of gleaning were not abused.

Some have seen a strong social element in this print. The three women are in isolation from the prosperity of the harvest in the background; they toil under the hot sun to glean a little from what the harvesters have overlooked so that they can keep body and soul together through the dark days of winter. But this author believes Millet would deny a social commentary, for he did not consider himself a revolutionary. No subversive idea troubled his brain. He would not listen to socialistic doctrines and he considered all revolutionary principles distasteful. He said: "My program is work. 'Thou shalt gain thy bread in the sweat of thy brow' was written centuries ago. Immutable destiny, which none may change! What every one ought to do is to find progress in his profession, to try to do better, to be strong and clever in his trade, and be greater than his neighbor in talent and conscientiousness in his work. That for me is the only path. The rest is dream or calculation."[183]

The impression illustrated is a life-time impression, printed with plate tone and inky plate edges in brownish-black ink on buff-colored wove paper. It bears the inscription in Millet's hand: "*Souvenir de J. F. Millet/ Son vieil ami Alfred Sensier.*"

29

Les Bêcheurs (The Diggers),[184] (D. 13 iii/iv; M. 13 iii/iv; L. & K.16 iii/iv), 1855-1856, like the preceding etching, was created before the pastel of the same subject, *Two Men Turning over the Soil*, of 1866, and the unfinished painting in the Tweed Gallery, University of Minnesota.

The scene is again the plain about Barbizon. In the extreme distance, dimly seen, are trees and the roofs of a remote village. In the foreground, two men are digging. The elder and nearer thrusts in his spade, laboriously and strenuously, setting his whole body to the stroke, as if the effort were too much for him. The younger is emptying his blade of clods just turned. His action is large and free, and it is evident that to him effort comes easily. Their hats lie on the ground nearby. In the left background, the smoke of burning dry grass rises in spirals, and the hour is still remote when the two will be able to return to the village half hidden in the trees.[185]

Cultivating the earth—breaking up the hard-packed soil in preparation for the annual sowing—has been a prototype for man's fate since Genesis. Millet saw in these labors the fulfillment of the Creator's words to Adam: "By the sweat of thy brow shalt thou eat thy daily bread."[186] This theme of two men laboring at the back-breaking monotonous task of cultivating the soil for planting had attracted Millet's attention before he left Paris for Barbizon in 1849. His archetypal peasants are the descendants of the medieval portrayals of the labor of the months, a theme which was also treated by the Netherlandish printmakers of the 16th and 17th centuries.[187] The theme of labor is rich in opportunity for the portrayal of gesture, and, as Henley notes, the sentiment of motion and action is one of the most striking features of Millet's work.[188]

A series of drawings, resolving the spatial relationships of the two working figures and studying each man separately, preceded this etching.[189] These include a pastel in the Museum of Fine Arts, Boston, two drawings in private collections in Paris, a drawing in a private collection in Lugano, and a work in the British Museum, London. A very closely related drawing, done in charcoal heightened with white (24 x 35 cm.), was offered for sale by the Jill Newhouse Gallery, London.[190]

Tackling a composition to be produced as a print was relatively new to Millet. Edward Wheelright wrote about Millet's use of etching as a way of creating original work:

During the winter I was with him, Millet made frequent visits to Paris to learn the art of etching. The process of painting, he said, was so slow that he should never live long enough to paint all the pictures he had already in his mind. He had therefore resolved to try his hand at some more expeditious process by which to express a part of what he had to tell. On a table in his atelier I used to see the implements of this new method—sheets of copper covered with black varnish, etching-needles, bottles of acid—and during my stay he completed and had printed four or five plates. One of these was a reproduction of the picture of two men digging, already mentioned; another, of which he presented me with a copy, represented a woman churning. Fourteen years afterward he painted identically the same subject, which I saw in the salon of 1870, under the title of *La Baratteuse.*[191]

In both this etching and in *The Gleaners*, (cat. no. 28) Millet employed strokes and dots to suggest a range of different materials and textures. The pitting in the lower left corner resulting from an improperly grounded plate is incorporated into the design with toning that heightens the appearance of the newly opened soil. The spaces and figures are left open and light in early impressions of fine quality.[192] Millet preferred lightly inked impressions that displayed well his beautiful line. He once complained of Delâtre's tendency to ink his plates too heavily.[193]

The impression illustrated is a rich one of state iii/iv, in black ink on thin, white tissue laid over heavy, white paper and printed with light plate tone.

The Gleaners and *The Diggers* are among the most important and beautiful of Millet's graphic oeuvre. In each the wasting effect of the sun is expressed with terrible energy. Both express the long hours of fatiguing labor carried out without grumbling or complaint, it seems. The figures of these humble laborers are drawn with a touching simplicity; there is nothing vulgar either in their pose or in their clothes. In a way, they become identified with the soil which they water with their perspiration.[194]

30

La Veilleé (The Vigil), (D.14; M.14; L. & K.10), of about 1855. This etching pictures two women bent over their mending by the

flickering light of an antique lamp suspended from a pole by the side of a curtained bed. The room is dark. The light falls on the head, chest, and hand of the woman at the left. The hands of the other woman are in half-light. The masses of surrounding shadow enhance the effect of mystery created by the feeble, flickering light. The flatness of the hand of the seamstress at the right and her crumpled sewing suggest that Millet was not yet able to modulate adequately the light and dark necessary for this subject.[195] A related drawing in black conté crayon on tracing paper and a painting of 1853-1854 are in the Museum of Fine Arts, Boston.

The zinc plate for this print was left too long in the acid bath so that in places the lines run together. Millet was dissatisfied with this print, finding it too dark for his taste. Only a few impressions were pulled, after which the plate was destroyed.[196] Burty comments on this print:

Either because the varnish was badly prepared or because the acid was too violent, the metal was attacked so deeply that in printing it gave only a heavy image and was cancelled after a few trial proofs.[197]

31

La Cardeuse (The Woman Carding Wool), (D.15; M.15; L. & K.11), 1855-1856, though an overbitten plate (the plate was inadvertently left in the acid bath overnight), is a monumental print. We see a powerful, large-scale figure of a woman seated at the left and turned to the right. Her head is covered with a kerchief knotted in front. She dominates the collection of accessories which surround her. With a low viewpoint and a light source to the right beyond the subject area, Millet has given the figure great plasticity and sculptured effect.[198] Alexandra R. Murphy writes:

Throughout the print, the masterful placement of large areas of light and dark, which draw the viewer's eye around the image and back to the woman's tired gaze, is complemented by an inventive range of needlestrokes conveying the heavy, nubby material of her costume as convincingly as the soft, free wool in the basket at her side.[199]

Both Philippe Burty and Alfred Lebrun, two early cataloguers of Millet's prints, mention that Millet was unhappy with this etching and considered withholding it from publication.[200] Preliminary study drawings for this subject

are in the Musée du Louvre, Paris, the Art Institute of Chicago (in reverse), and in a private collection in Tokyo. In 1863 at the Salon in Paris, Millet exhibited an oil painting of this same subject (89.5 x 73.5 cm.; collection George Weil, Washington, DC; exhibited Hayward Gallery, London, 1976, no. 86).

The impression illustrated, at one time a part of the T. G. Arthur collection, Glasgow, is a brilliant, early impression in black ink on old, French laid paper of a grayish-cream tint.

32

La Gardeuse d'Oies (The Goosegirl), (D.16; M.16; L. & K.9), about 1855. Millet's only drypoint among his mature prints, it was drawn in strong outline directly on the plate with a sharp needle. The drawing is loose and open, with extensive areas of white to convey the sunshine of this outdoor scene. This charming print is based on a larger, unfinished drawing in black conté crayon on paper (current location unknown).[201] Early impressions show rich burr on the strokes shading the ground below the tree, on the girl's feet, and on the neck of the goose at the lower right. Lebrun described this print as "très rare." The one exhibited is a rich, early impression in black ink with burr on old, thick, ivory-colored laid paper.

33

La Bouillie (The Woman Feeding Her Child), (D.17 ii/v; Melot 17 ii/v; L. & K.17 ii/v), 1861. After publishing the series of prints of 1855-1856, Millet did not etch again until 1861, when all subsequent etchings were done in response to specific commissions. *La Bouillie* shows a young mother carefully cooling food in a spoon by blowing on it, before offering it to the eager child who lies across her lap. Madame Heymann (Millet's daughter) and her baby served as models for this subject. Philippe Burty commissioned the work to illustrate an article and catalogue of Millet's prints written for the *Gazette des Beaux-Arts*.[202] The print is based on a drawing in the same direction done in black conté crayon on laid paper in the Museum of Fine Arts, Boston. There is an oil painting of the same subject in the Musée des Beaux-Arts, Marseille.

When the plate was bitten, Burty accompanied Millet to the studio of Félix Bracquemond, one of the most technically

expert etchers of that day. He records the biting and printing process:

10 June 1861.—This morning at 10:30, J.-F. Millet who, nevertheless, had forewarned me by a letter, came to me to look for Blanche Street.... We went to Bracquemond's, in order to have the plate bitten that he had engraved in the manner of one of his paintings of the Salon, the young woman who feeds her child. The copper plate was very boldly attacked. It was well bitten the first time. The background was re-covered, and the piece was bitten again. Finally, Millet himself had to put two drops of pure acid on the head of the woman and her child. As soon as the brush had touched, Bracquemond quickly threw drops of water. We went to Delâtre's. A worker pulled us some proofs. On the third, Millet covered with the drypoint a great highlight on the neck of the woman, put some strokes on the shadow of the cap, some specks on the wrist that supports the child. We had pulled 19 in all, of which two were retouched. Bracquemond is going to add the signature there. There are only three which had the sketch below, the printer effacing them or making them come to his liking. I burnished them myself on the plate.[203]

The impression exhibited is the second state before Millet signed the plate in the lower left margin, but after removal of the marginal sketches of Delteil's first state. It is printed in brownish-black ink on *Chine collé* over thick, cream-colored laid paper. Lebrun and Delteil both described this state as "*très rare*."

34

La Grande Bergère (The Shepherdess Knitting), (D.18; M.18; L. & K.18), 1862, is an etching of exquisite beauty. The young shepherdess stands in the shade knitting a stocking, her back against a hillock on which young trees are growing. In the middle distance her black sheepdog watches over the flock; a few of the sheep are merely outlined in the background. In the distance a village is indicated. There is half-light in the foreground and full light in the background; the contrast is soberly, but powerfully rendered. As indicated by Roger Passeron, the composition is masterly and the linework is executed with economy of means.[204]

The major related drawing for this etching is a study in black conté crayon in the Museum of Fine Arts, Boston. There is also a painting of this subject in the Art Institute of Chicago. In the etching, Millet created a pattern of vigorous strokes that captures the essence of

the drawing. As Murphy puts it, the hatching patterns that define the sheepdog and the shepherdess's skirt and cape are bold and arresting; the irregular soil bank is established convincingly by chaotic strokes of varied density.[205]

This plate was originally intended for publication by the Société des Aqua-fortistes, but the publisher, Cadart, asked Millet to withdraw it. Millet objected and then resigned from the Society.

The impression exhibited is a rich, life-time printing in dark brown ink on antique, ivory-colored laid paper.

35

Le Départ pour le Travail (Peasants Going to Work), (D.19 ii/vii; M.19 iib/vii; L. & K.19 ii/viii), 1863, features a young peasant couple going to work in the fields. The woman shades her head from the sun with a basket; the sunlight penetrates the wicker-work and illuminates her face. She carries a jug filled with water or perhaps cider. The man wears a straw hat and is dressed in a blouse and pantaloons; his feet are in sabots and he carries a pitchfork on his shoulder and a hoe slung through his arm. They plod along, their steps weighed down by their wooden shoes, padded with straw to keep their feet comfortable during the long hours of toil. In the background, the Barbizon plain is flooded with light. In the distance, the backs of the houses which form the main street of the village are seen. In the fields, there is a plow towards which a laborer approaches with two horses, riding the one on the left.

This plate was commissioned in 1862 by a group of ten friends and patrons (Société des Dix) who paid 50 francs each and were entitled to a certain number of impressions on Chinese paper, laid paper, and vellum. Alfred Sensier had the idea of forming this society of print lovers to commission Millet to etch a plate of which the ten members would enjoy co-ownership. Ten impressions of the first state bore the autographic signature and personal dedication by Millet and the name of the subscriber. The group of ten patrons were: Philippe Burty, Michel Chaissaing, Charles Forget, Moureau, Jules Niels, Théodore Rousseau, Alfred Sensier, Théodore Sensier, Henri Tardiff, and Charles Tillot.[206] The impressions inscribed to Théodore Rousseau

and to Michel Chaissaing are now in the Art Institute of Chicago.

Millet began work on this print in late November 1863, requesting from Sensier 1,000 francs to support the work.

On November 3, Sensier responded:

Push ahead with the etching. I am counting a lot on it, a lot. I should like really everyone to want it and to have it exhibited as a criterion of your talent.[207]

Six days later Sensier again wrote:

Let me know when the etching is done. The Dix are counting on seeing your etching turn up by the end of the month.[208]

On November 16, Millet wrote to Sensier:

Today I am beginning to trace my composition for the etching onto my plate.[209]

A large number of related drawings exist, among them, the study in black conté crayon in the Musée du Louvre, Paris, the drawing in black chalk in the Art Institute of Chicago, and the study in black conté crayon in the Musée National des Beaux-Arts, Algiers. He also printed several trial proofs of details of the plate (Davison Art Center, Wesleyan University, Middletown, Connecticut),[210] showing the care with which he approached his task. He finished the plate on November 23, 1863, and therein wrote to Sensier:

I may have to have some things bitten again. Does Delâtre know how to re-varnish a plate? If he does it, let him try to have on hand everything needed for this. I shall also have some spots to be removed, and we may perhaps need the help of an engraver who is really clever in his profession.[211]

The print's large size and the implied slow, deliberate movement dignify the couple. As described by Esther Thyssen, the calm and unity the couple project suggest familial harmony and a resigned but graceful acceptance of the laws of the land.[212] Below them, at the lower left edge, is a curious sketch of a standing nude figure, designed perhaps to amuse the original patrons. In the bottom foreground, within the foliage, below the woman's left foot, is also a tiny nude figure.

Probably the most important of Millet's etchings, it was printed in eight states, the last three representing posthumous alterations. The fifth Delteil state with the three dots at the lower right has been unmercifully exploited since the death of Millet. Large numbers of impressions have been printed from the worn plate and these impressions retain little of the original beauty of the plate.

The impression exhibited is a rich one of the second state (with Millet's signature in the plate) in warm-black ink with light plate tone on thin, beige-colored wove paper. Lebrun and Delteil both describe this state as "rare."

36

La Fileuse Auvergnate (Shepherd-Girl Spinning), (D.20 v/v; M.20 v/v; L. & K.20 v/v), 1868, Millet's last etching, shows a goatherd spinning threads of wool while walking. Her head is covered with a straw hat, like that worn by the peasant women of Auvergne, and a distaff is attached to her side. She twists the thread with the fingers of her raised left hand while her right arm holds a spindle. In the middle and far distances, goats look toward her or to the grass, where many are busily feeding.

This etching was published in Alphonse Lemerre's *Sonnets et Eaux-fortes* of 1869. Millet developed an image which had no relationship to the sonnet by Albert Mérot that Burty had selected for him to illustrate. The sonnet was about a drawing that Millet had made for Gavet of two young peasant girls watching a flight of storks across the sky. Instead of proceeding with a drawing of the girls and storks, Millet returned to a subject of his visits to Vichy. On November 8, 1868, Millet wrote to Sensier:

I have had a letter from M. Albert Mérot in which he sends me a sonnet already printed. He thinks that I have done or am supposed to do the etching on the same subject. I am going to tell him that that is not the case and to explain to him what I am doing. His letter is perfectly pleasant. I am working at my etching and, at the present moment, the copper plate is half incised. If my migraine does not interfere too much you will find it at Martinmas [November 11].[213]

Then on November 11 he wrote again:

I am leaving today at two o'clock to go to Paris to have my etching bitten. If I do not see you this evening I shall see you tomorrow before going to Burty's.[214]

Sensier relates that forty-one artists who contributed etchings to *Sonnets et Eaux-fortes,* such as Bracquemond, Corot, Daubigny, Seymour Haden, and Jules Jacquemart, had

consented to destruction of their plates after 350 impressions had been pulled. Millet refused to understand how, when a plate has been etched by an artist, it can enter the mind of anyone to spoil the plate in order to prove to purchasers that no further impressions can be printed. He therefore vigorously objected to the destruction of his plate. In a letter to Sensier of January 9, 1869, Millet wrote:

The publisher Lemerre first wrote to me about the destruction of my plate. I did not reply. Then Burty wrote in his turn, and gave a whole pile of reasons, good and bad, in order to make me consent to the proposed destruction. As I do not wish to ask favours, or to be treated differently from others, I wrote to Burty, three days ago, begging him to treat my plate exactly as they treated the rest. It seemed to me that they might raise endless difficulties if I took any other course, and it was better to have done with them.[215]

Even after giving his consent to destruction of his plate he was still remonstrating about it when he wrote again to Sensier on January 24, 1869:

...I have consented to the destruction of my plate, in spite of my desire to keep it. Between ourselves, I considered this destruction of plates the most brutal and barbarous of proceedings. I am not strong enough on commercial questions to understand the use of it, but I know that if Rembrandt and Ostade had each made one of these plates, they would have been annihilated.[216]

There are four drawings related to this print: a black conté crayon drawing in a private collection, Paris; a pastel with black conté crayon in the Johnson Collection at the Philadelphia Museum of Art; one in black conté crayon in a private collection in Japan; and a compositional study, squared for transfer, in black conté crayon in a private collection in Paris. An impression of the etching, colored with watercolor, is in the Museum of Fine Arts, Boston.[217]

The impression illustrated, from the Alfred Beurdeley collection, Paris, is a fifth state in black ink on ivory-colored laid paper.

ACKNOWLEDGEMENT.

The author is grateful to Frank Raysor II of New York City for carefully reading the manuscript and making helpful suggestions. He also appreciates the loan of reference materials and of two of Mr. Raysor's Meryon etchings to the exhibition. In addition, he thanks the New York Public Library for the loan of three prints by Millet and of the photograph of Millet's Barbizon studio. He also thanks Robert Keil and Bonita Lei of Great Modern Pictures, New York for helpful information about Millet's prints. Finally, he is grateful to Dr. William Eiland, Patricia Phagan, Bonnie Uter, Patricia Wright, and other members of the Georgia Museum of Art for their efforts in bringing this exhibition to fruition.

Endnotes

1. Joseph Pennell, *Etchers and Etching*, fourth edition (New York: The Macmillan Co., 1936), p. 40.

2. Frederick Wedmore, *Etchings* (London: Metheun & Co., 1911), p. 44.

3. E. S. Lumsden, *The Art of Etching* (New York: Dover Publications, 1962), p. 274.

4. See A. Hyatt Mayor, *Prints & People: A Social History of Printed Pictures* (New York: The Metropolitan Museum of Art and the New York Graphic Society, 1971), no. 674, for his interesting remarks.

5. Philippe Burty, "L'Oeuvre de M. Charles Meryon I," *Gazette des Beaux-Arts XIV* (June 1863), p. 520; Philippe Burty and Marcus B. Huish, *Charles Meryon Sailor, Engraver, and Etcher. A Memoir and Complete Descriptive Catalogue of his Works* (London, 1879), p. 1.

6. Dora Wilcox, "Charles Meryon," *The Home* (Sydney, Australia) V, no. 3 (July-August 1924), pp. 30, 58, 60, 62.

7. Burty and Huish, p. 1.

8. Léon Delaunay, *Nouvelles Archives de l'Art Français* V, 1877, p.393.

9. Burty, "Charles Meryon I," p. 520; Burty and Huish, p. 3.

10. Wilcox, p. 62.

11. Burty, "Charles Meryon I," p. 520; Delaunay, p. 382.; Burty and Huish, p. 3; Sinclair H. Hitchings, "Meryon's Voyage and Vision of the Pacific," *Print Collector's Newsletter* 1, no. 5 (1970), pp. 102-104.

12. Jean Vallery-Radot, "Quand Meryon était Marin," *Gazette des Beaux-Arts* LVII (May-June 1961), pp. 358-368; Burty and Huish, p. 4.

13. Loys Delteil and Harold J. L. Wright, *Catalogue Raisonné of the Etchings of Charles Meryon* (New York: Winfred Porter

Truesdell, 1924).

14 Richard S. Schneiderman, with the assistance of Frank W. Raysor, II, *The Catalogue Raisonné of the Prints of Charles Meryon* (London: Garton & Co. with the Scolar Press, 1990).

15. Burty, "Charles Meryon I," p. 521; Burty and Huish, p. 6.

16. A portion of the letter is reprinted in Jean Ducros, *Charles Meryon, Officier de Marine, Peintre-Graveur, 1821-1868*, exhibition catalogue (Paris: Musée de la Marine, 1968-1969), no. 366.

17. See Delteil and Wright, p. 2, note 2.

18. Burty and Huish, p. 8; Hugh Stokes, *Etchings of Charles Meryon* (London: George Newnes Ltd. and New York: Charles Scribner's Sons, 1906), pp. 15-16.

19. Burty and Huish, pp. 9-10; Stokes, p. 16.

20. Ducros, no. 398.

21. Burty and Huish, p. 11.

22. Philippe Burty, "Charles Meryon," *La Nouvelle Revue II* (1880), p. 122; Ducros, no. 400.

23. Ducros, no. 405.

24. Burty, "Charles Meryon," 1880, p.125.

25. Quoted in Winfred Porter Truesdell, "Charles Meryon," *The Print Connoisseur 2* (March 1922), p. 234.

26. Burty and Huish, pp. 11-12.

27. Stokes, pp. 17-18.

28. Henri Béraldi, *Les Graveurs du XIXe Siecle*, vol. 10 (Nogent-le-Roi: Jacques Laget, 1981), pp. 36-37; quoted in Delteil and Wright, p. 5.

29. Martin Hardie, *Charles Meryon and His Eaux-Fortes Sur Paris* (London: The Print Collectors' Club, 1931), p. 11.

30. Truesdell, p. 236.

31. Burty and Huish, p. 15.

32. Hardie, p. 28.

33. *Ibid.*, p. 13.

34. Frederick Keppel, *The Golden Age of Engraving* (New York: The Baker & Taylor Co., 1910), pp. 157-158.

35. Quoted in Delteil and Wright, no. 27.

36. Burty and Huish, p. 17.

37. Edmond and Jules de Goncourt, *Journal des Goncourt, mémoires de la vie littéraire*, I (Paris 1887-1888), pp. 147-148; quoted in James D. Burke, *Charles Meryon, Prints & Drawings* (New Haven: Yale University Art Gallery, 1974), p. 7.

38. Burty and Huish, pp. 17-18.

39. *Ibid.*, p. 19; Burty, "Charles Meryon," 1880, p. 131-132; Ducros, no. 438.

40. Burty and Huish, p. 29.

41. *Ibid.*, p. 19; Burty, "Charles Meryon," 1880, p. 132.

42. Y. G. Le Dantee, ed., *Baudelaire, Oeuvres Complètes* (Paris, 1961), pp. 1083-1084; quoted by Burke, p. 8.

43. Jacques Crépet, ed., *Charles Baudelaire, Etude biographique d'Eugène Crépet* (Paris, 1919), p. 378; quoted by William Aspenwall Bradley, "Meryon and Baudelaire," *Print Collector's Quarterly* 1 (1911), p. 592.

44. Burty, "Charles Meryon I," p. 522; Burty and Huish, p. 22.

45. Stokes, p. 20.

46. Seymour Haden, *About Etching*, fourth edition (London: The Fine Art Society, 1879), pp. 50-51.

47. Burty, "Charles Meryon," 1880, p. 131; Ducros, no. 444-447.

48. F. F. Gautier and Y. G. LeDantec, *Oeuvres complètes de Charles Baudelaire. Correspondence I: 1841-1863* (Paris, 1933), p. 311, letter of March 9, 1860; quoted by Bradley, p. 605.

49. Burty, "Charles Meryon," 1880, pp. 133-134.

50. Ducros, no. 453.

51. Philippe Burty, "Charles Meryon II," *Gazette des Beaux-Arts XIV* (July 1863), p. 512, no. 4.

52. Charles Meryon, *Mes Observations sur l'article de la Gazette des Beaux-Arts (Livraison du I^{ER} Juin 1863)*, original manuscript in the Toledo Museum of Art. Published in *Gazette des Beaux-Arts* 102 (December 1983), pp. 221-236 [transcribed, introduced and extensively annotated by Philippe Verdier].

53. Burty and Huish, pp. 23-26.

54. Burty and Huish, p. 27; Burty, "Charles Meryon," 1880, pp. 137-138.

55. Burty and Huish, pp. 27-28.

56. Loÿs Delteil, *Meryon* (London: John Lane, The Bodley Head Ltd., 1928), p. 51.

57. Burty and Huish, pp.15-16.

58. *Ibid.*, p. 16.

59. Burty, "Charles Meryon II," 1863, p. 75.

60. Burke, p. 28.

61. Letter of August 5, 1850, to his father,

61. cited in Ducros, no. 711.

62. Burty, "Charles Meryon II," 1863, p. 79; Burty and Huish, p. 57.

63. Burke, p. 28.

64. Burty, "Charles Meryon," 1880, p. 137; Burty and Huish, p. 23.

65. Ducros, no. 711.

66. Burty, "Charles Meryon II," 1863, p. 76; Burty and Huish, p. 50.

67. P. D. Cate, "Meryon's Paris," *The Print Collector's Newsletter*, II (September-October 1971), p. 77.

68. Victor Hugo, *Notre-Dame de Paris*, vol. 1 (Paris, 1836), pp. 296-297.

69. Beaumont Newhall, *The History of Photography from 1839 to the Present Day*, revised edition (New York, 1964), pp. 30-31.

70. Delteil, p. 21.

71. Ducros, no. 710.

72. William Aspenwall Bradley, "Charles Meryon, Poet," *Print-Collector's Quarterly* 3 (1913), p. 343.

73. Delteil and Wright, no. 23.

74. Hardie, p. 17.

75. Burke, p. 35.

76. Quoted in Frederick Wedmore, *Meryon and Meryon's Paris* (London, 1892), pp. 44-45. See also Stokes, p. 24.

77. Burke, p. 37.

78. Ducros, no. 711.

79. Burty and Huish, p. 56.

80. Hardie, p. 12.

81. Eugène Crepet, ed., *Charles Baudelaire, Oeuvres Posthumes et correspondences inédites* (Paris, 1887), p. 193; quoted by Burke, p. 40.

82. Burty, "Charles Meryon II," 1863, p. 79.

83. Meryon, *Mes Observations*, no. 37; Burty and Huish, p. 57.

84. Victor Hugo, *Notre-Dame de Paris*, pp. 296-297.

85. Burty, "Charles Meryon II," 1863, p. 79; Burty and Huish, p. 58.

86. Quoted in Hardie, pp. 19-20.

87. Burty, "Charles Meryon I," 1863, p. 522; Burty and Huish, p. 22.

88. Malcolm Salaman, *Charles Meryon (Modern Masters of Etching*, vol. 14) (London: The Studio, 1927), p.4.

89. Burty, "Charles Meryon II," 1863, p. 80; Burty and Huish, p. 59.

90. Salaman, p. 4.

91. *Ibid.*

92. Burty and Huish, pp. 18-19.

93. Campbell Dodgson, *The Etchings of Charles Meryon* (London: "The Studio", Ltd., 1921), p. 10.

94. Philip G. Hamerton, *Old Paris. Twenty Etchings by Charles Meryon* (Liverpool: Henry Young & Sons, Ltd., 1914), pp. 16-17.

95. Dodgson, p. 15.

96. Quoted in Delteil and Wright, no. 31.

97. Quoted in Burke, p. 63.

98. Burty, "Charles Meryon II," 1863, p. 83; quoted in Burke, p. 69.

99. Dodgson, pp. 15-16.

100. Salaman, p. 7.

101. Hardie, p. 23.

102. Burty, "Charles Meryon II," 1863, pp. 83-84; Burty and Huish, p. 70, no. 52.

103. Meryon, *Mes Observations*, no. 50; quoted by Burke, p. 75.

104. Delteil, p. 24.

105. Dodgson, p. 18.

106. Burke, p. 76.

107. Burty, "Charles Meryon II," 1863, p. 85; Burty and Huish, p. 76.

108. Ducros, no. 744; quoted in Burke, p. 91.

109. Quoted in Burty and Huish, p. 76.

110. Philip G. Hamerton, "Modern Etching in France," *The Fine Arts Quarterly Review* II (January-May 1864), pp. 89-93.

111. Burke, p. 10.

112. William Ernest Henley, *Jean-François Millet. Twenty Etchings and Woodcuts* (London: The Fine Art Society, 1881), pp. 2-4; Alfred Sensier, *Jean-François Millet, Peasant and Painter* (Boston: James R. Osgood and Co., 1881), p. 17-20.

113. Henley, pp. 4-5.

114. Sensier, *Jean-François Millet*, p. 35.

115. *Ibid.*

116. Sensier, *Jean-François Millet*, p. 40; *Alfred Lebrun's Catalogue of the Etchings, Heliographs, Lithographs, and Woodcuts done by Jean-François Millet* (New York: Frederick Keppel & Co., 1887), p. 6.

117. *Luke* 11:8.

118. Henley, p. 5; Sensier, *Jean-François Millet*, pp. 40-42.

119. Charles Sprague Smith, *Barbizon Days: Millet-Corot-Rousseau-Barye* (New York: A. Wessels Co., 1903), p. 49.

120. Henley, pp. 5-6.

121. *Ibid.*, pp. 6-7.

122. Sensier, *Jean-François Millet*, p. 45.

123. Henley, p. 9.

124. *Ibid.*, pp. 8-9; *Lebrun's Catalogue*, p. 6.

125. Sensier, *Jean-François Millet*, p. 124.

126. Henley, p. 8.

127. Sensier, *Jean-François Millet*, p. 61.

128. Henley, p. 11; *Lebrun's Catalogue*, p. 7.

129. Sensier, *Jean-François Millet*, 1881, *op. cit.*, p. 74.

130. *Ibid.*, p. 50.

131. *Ibid.*, p. 51.

132. Henley, pp. 11-12; Sensier, *Jean-François Millet*, p. 78; Smith, pp. 50-51.

133. Henley, pp. 13-14.

134. Smith, pp. 52-53; Robert J. Wickenden, "A Jupiter in Sabots," *Print Collector's Quarterly* VI (1916), p. 142.

135. Sensier, *Jean-François Millet*, p. 83.

136. *Lebrun's Catalogue*, p. 9.

137. Sensier, *Jean-François Millet*, p. 73.

138. Julia Cartwright, *Jean-François Millet. His Life and Letters* (London: Swan Sonnenschein & Co., Lim'd, 1896), p. 211.

139. Sensier, *Jean-François Millet*, p. 143.

140. *Lebrun's Catalogue*, pp. 9-10.

141. Frederick Keppel, *The Golden Age of Engraving* (New York: Baker and Taylor Co., 1910), p. 115.

142. Wickenden, p. 156.

143. Sensier, *Jean-François Millet*, pp. 102, 105.

144. Alfred Sensier, *La Vie et l'Oeuvre de J.-F. Millet* (Paris: A. Quantin, 1881).

145. Sensier, *Jean-François Millet*, p. 215.

146. Frederick Keppel, "The Etchings of J. F. Millet," in Charles Holmes ed., *Corot and Millet* (London: "The Studio," 1902), p. mxviii.

147. Robert J. Wickenden, "The Art and Etchings of Jean-François Millet," *Print Collector's Quarterly* II (1912), p. 238.

148. *Lebrun's Catalogue*, p. 10.

149. Schuyler Van Rensselaer, *Jean-François Millet, Painter Etcher* (New York: Frederick Keppel & Co., 1902), pp. 5-9.

150. Malcolm C. Salaman, *Whitman's Print-Collector's Handbook* (London: G. Bell and Sons, Ltd., 1918), p. 36.

151. Roger Passeron, *Impressionist Prints* (Secaucus, NJ: Wellfleet Press, 1974), p. 24.

152. S. William Pelletier, "Jean François Millet, the Bard of Peasant Life," in Bonita Y. Lei and Robert Keil, *The Complete Etchings of Jean-François Millet* (New York: Great Modern Pictures [forthcoming]).

153. Quoted in Arsène Alexander, "Jean-François Millet," in *Corot and Millet*, 1902, pp. ix-x.

154. John Taylor Arms, "Peasant with a Wheelbarrow," *Print Collector's Quarterly* XXXIX (1948), p. 41.

155. Sensier, *Jean-François Millet*, p. 93; Smith, pp. 76-77.

156. Arms, p. 40.

157. Mayor, no. 674.

158. Arms, p. 40; Smith, p. 67.

159. Pelletier, "Millet, the Bard of Peasant Life."

160. Quoted in Keppel, p. 120.

161. Quoted in Passeron, p. 24.

162. Pelletier, "Millet, the Bard of Peasant Life."

163. Paul J. Sachs, *Modern Prints and Drawings* (New York: Alfred A. Knopf, 1954), pp. 8-9.

164. Keppel, pp. 122-123.

165. Pelletier, "Millet, the Bard of Peasant Life."

166. Loys Delteil, *Le Peintre-graveur illustré* (XIXe et XXe Siècles), vol. 1, *J. F. Millet, Th. Rousseau, Jules Dupré, J. Barthold Jongkind* (Paris: Chez l'Auteur, 1906).

167. Michel Melot, *L'Oeuvre gravé de Boudin, Corot, Daubigny, Dupré, Jongkind, Millet, Théodore Rousseau* (Paris: Arts et Métiers Graphiques, 1978).

168. Lei and Keil (forthcoming).

169. Alfred Lebrun, "Catalogue de l'Oeuvre Gravé de J.-F. Millet," in Alfred Sensier and Paul Mantz, *La Vie et l'Oeuvre de J.-F Millet* (Paris: A. Quantin, 1881), p. 371; *Lebrun's Catalogue*, p. 20, no. 6.

170. *Lebrun's Catalogue*, p. 20, no. 6.

171. Alexandra R. Murphy, *Jean-François Millet* (Boston: Museum of Fine Arts, 1984), p. 87.

172. Murphy, p. 87.

173. W. P. Robins, *Etching Craft. A Guide for Students and Collectors* (London: The

Bookman's Journal & Print Collector, 1922), p. 133.

174. Philippe Burty, "Les Eaux-fortes de M. J.-F. Millet," *Gazette des Beaux-Arts*, 11 (September 1, 1861), p. 265.

175. Arms, p. 41.

176. Murphy, p. 100.

177. Arms, p. 41.

178. *Ruth*, chapter 2.

179. Sensier, *Jean-François Millet*, p. 94.

180. *Jean-François Millet* (Paris: Grand Palais, 1975) p. 146, no. 101.

181. Burty, "Les Eaux-fortes," 1861, p. 264.

182. *Impressionist and Modern Masters* (London: William Weston Gallery, 1989), no. 35.

183. Sensier, *Jean-François Millet*, p. 111.

184. The *bêche* is a spade, a shallow-bladed shovel with which the men are working.

185. Burty, "Les Eaux-fortes," 1861, p. 264.

186. *Genesis* 3:19.

187. Esther Thyssen, *Natural and pastoral themes by Barbizon printmakers* (Middletown, CT: Davison Art Center, Wesleyan University, 1985), p. 15.

188. Henley, no. IV.

189. Murphy, p. 105.

190. *Selected Drawings* (Catalogue X) (London: Jill Newhouse, Autumn 1989), no. 15 (illustrated).

191. Edward Wheelwright, "Personal Recollections of Jean-François Millet," *Atlantic Monthly* 38 (September 1876), p. 271.

192. Murphy, p. 105.

193. Alfred Sensier, letter to Millet of December 26, 1863, about *Going to Work: "Burty finds, like you, that the second state is too heavy and too oily. He complains a good deal about this printing or rather about the new means of Delâtre to push all his prints to blackness and heaviness."*

194. Burty, "Les Eaux-fortes," 1861, p. 264.

195. Murphy, p. 106.

196. Burty, "Les Eaux-fortes," 1861, p. 263; Lebrun, "Catalogue de l'Oeuvre Gravé de J.-F. Millet," 1881, 374, no. 15; *Lebrun's Catalogue*, p. 30, no. 15.

197. Burty, "Les Eaux-fortes," 1861, p. 263.

198. Weston, no. 34.

199. Murphy, p. 109.

200. Burty, "Les Eaux-fortes," 1861, p. 263; Lebrun, "Catalogue de l'Oeuvre Gravé de J.-F. Millet," 1881, p. 374; *Lebrun's Catalogue*, p. 31.

201. Murphy, p. 109.

202. Burty, "Les Eaux-fortes," 1861, pp. 261-267.

203. Maurice Tourneux, *Revue retrospective*, 1892; quoted by Loys Delteil, *Le Peintre-graveur*, 1906, no. 17.

204. Passeron, p. 26.

205. Murphy, p. 135.

206. Melot, p. 288; *19th Century French Prints, Drawings, & Bronzes* (Chicago: R. S. Johnson International, April 1985), no. 100.

207. Quoted in Michel Melot, *Graphic Art of the Pre-Impressionists* (New York: Harry N. Abrams, Inc., 1978), p. 290.

208. *Ibid.*, p. 290.

209. *Ibid.*, p. 290.

210. Thyssen, p. 32, no. 58.

211. Quoted in Melot, *Graphic Art*, p. 290.

212. Thyssen, p. 16.

213. Quoted in Melot, *Graphic Art*, p. 291.

214. *Ibid.*

215. Cartwright, p. 313.

216. Sensier, *Jean-François Millet*, pp. 193-194; *Lebrun's Catalogue*, p. 39, footnote.

217. Murphy, pp. 204-205.

Catalogue of the Exhibition

S. William Pelletier

I. Charles Meryon

1
Titre des Eaux-fortes sur Paris
Title Page to the "Etchings of Paris"

1852
Delteil-Wright 17, only state; Schneiderman 22 i/ii
Etching

Inscription on plate:	*EAUX-FORTES/SUR/PARIS/par/C. MERYON./MDCCCLII.*
Inscriptions and marks on sheet:	On recto: *LXI 36790* (graphite); *6¾ × 5⅛* (graphite) On verso: stamp of S. W. Pelletier in reddish-brown ink (1977; 9 · 12 · 49)
Platemark:	166 x 124.5 mm. (6¹⁷⁄₃₂ x 4²⁹⁄₃₂ in.)
Sheet:	266 x 238 mm. (10¹⁵⁄₃₂ x 9⅜ in.)
Provenance:	[Craddock & Barnard, London, September 12, 1977].
Description:	Black ink on ivory-colored wove paper. Rare.

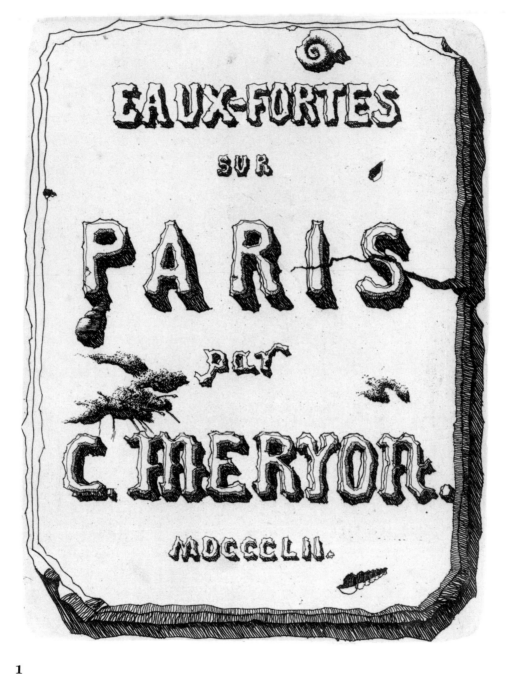

1

2 and cover
Le Stryge
The Vampire

1853
Delteil-Wright 23 iv/viii; Schneiderman 27 v/x
Etching

Inscription on plate:	On wall of chimney stack: *C.M.*
Inscriptions and marks on sheet:	On recto: *FW 7¹/LD 23ᴵⱽ* (graphite); *Le Stryge, Paris* (graphite); *Colln. A.C.J. Wall/Colln. J.H.W. Rennie* (graphite); *10⅜ x 14¾* (graphite); *c 4255* (graphite); *15* (graphite) On verso: stamp of S. W. Pelletier in black ink (1971; 8·17·3)
Platemark:	169 x 129 mm. (6²¹⁄₃₂ x 5³⁄₃₂ in.)
Sheet:	261 x 194 mm. (10⁹⁄₃₂ x 7⅝in.)
Provenance:	A. C. J. Wall; Major J. H. W. Rennie; [Craddock & Barnard, London, August 17, 1971].
Description:	Dark brown ink on old, pale green paper. By comparison, this impression is finer than the fourth state in the collection of the British Museum. *(S. W. Pelletier).*
Literature:	*Modern Etchings (Nineteenth and Twentieth Centuries).* London: Craddock & Barnard, cat. 123, p. 23, no. 314.
	"Masterpieces of European Printmaking: 15th-19th Centuries," *Georgia Museum of Art Bulletin* 9, nos. 2-3 (Winter-Spring 1984), no. 72 (p. 39).
Exhibited:	*Prints and Processes.* Birmingham, England: City Museum & Art Gallery, May 8-June 13, 1954.
	Masterpieces of European Printmaking: 15th-19th Centuries. Athens, Georgia: Georgia Museum of Art, September 21-December 31, 1983.
	The Gargoyle Image in Prints. Athens, Georgia: Georgia Museum of Art, June 16-September 2, 1984.

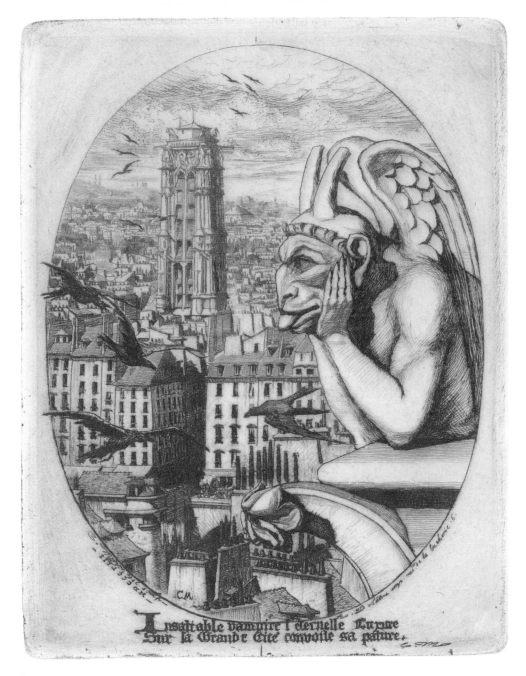

Insatiable vampire l'éternelle Luxure
Sur la Grande Cité convoite sa pâture.

2

3
Le Petit Pont, Paris
The Small Bridge, Paris

1850
Delteil-Wright 24 iv/vii; Schneiderman 20 v/ix
Etching and drypoint

Inscription on plate:	In upper right corner: *C.M.*
Marks on sheet:	On verso: two S. W. Pelletier stamps in black ink (1976; 4 · 8 · 4)
Platemark:	258 x 186 mm. (10$\frac{5}{32}$ x 7$\frac{5}{16}$ in.)
Sheet:	427 x 319.5 mm. (16$\frac{13}{16}$ x 12$\frac{19}{32}$ in.)
Provenance:	[Kennedy Galleries, Inc., New York, April 8, 1976].
Description:	Warm, black ink on thick, cream-colored wove paper. Meryon printed the first four Delteil states himself. The horizontal scratches in the lower left blank margin, which are strong in state iii, are still visible.
Literature:	"Masterpieces of European Printmaking: 15th-19th Centuries," *Georgia Museum of Art Bulletin* 9, nos. 2-3 (Winter-Spring 1984), no. 72 (pp. 38-39).
Exhibited:	*Masterpieces of European Printmaking: 15th-19th Centuries.* Athens, Georgia: Georgia Museum of Art, September 21-December 31, 1983.
	The Gargoyle Image in Prints. Athens, Georgia: Georgia Museum of Art, June 16-September 2, 1984.

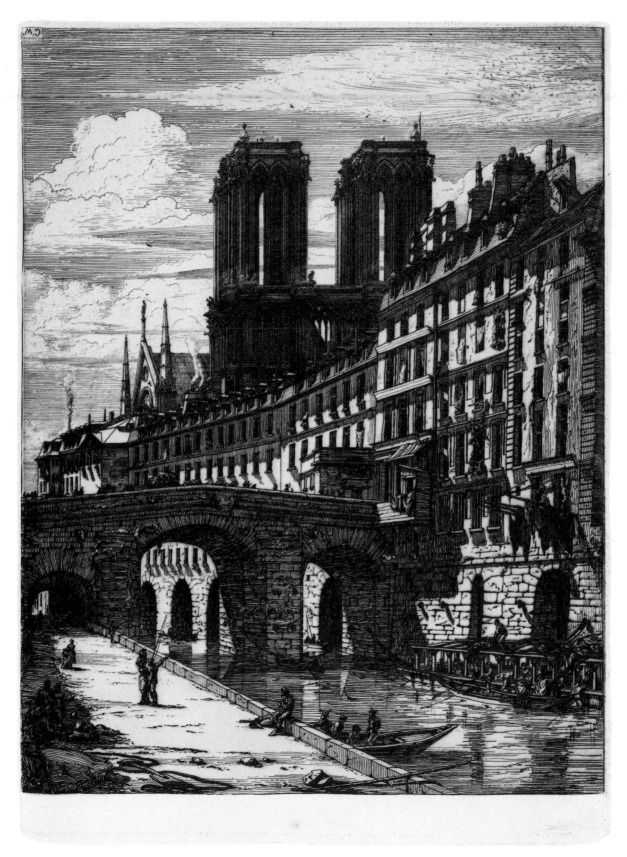

3

4
L'Arche du Pont Notre-Dame, Paris
The Arch of the Notre Dame Bridge, Paris

1853
Delteil-Wright 25 iv/vii; Schneiderman 28 iv/vii
Etching

Inscriptions on plate:	Below image: *C. Meryon del. sculp. —imp. Rue Ne St. Etienne du Mont 26.; Paris 1853*
Inscriptions and marks on sheet:	On recto: *L.D. 25* (graphite); *L.D. & W. 25IV/ L'Arche du Pont N Dame* (graphite); *13½ x 15* (graphite); *c. 15707* (graphite) On verso: *B20128* (graphite); *PCX* (graphite); two S. W. Pelletier stamps in reddish-brown ink (1977; 9 · 14 · 51)
Platemark:	153 x 193 mm. (6⅟32 x 7¹⁹⁄32 in.) 208 x 244 mm. (8³⁄16 x 9¹⁹⁄32 in.)
Provenance:	[P. & D. Colnaghi, London]; Harry Katz, New York; [Paul McCarron Fine Prints, Brooklyn, New York, September 14, 1977].
Description:	A strong, evenly printed impression, with plate tone, in black ink on pale green laid paper.
Literature:	*Catalogue, Summer 1976.* Brooklyn: Paul McCarron Fine Prints, no. 24 (illustrated).

4

5
La Galerie Notre-Dame, Paris
The Gallery of Notre Dame, Paris

1853
Delteil-Wright 26 iii/v; Schneiderman 29 iv/vi
Etching

Inscriptions on plate:	Below image: *C. Meryon del. sculp 1853–; Imp– Rue № S! Etienne-du-Mont 26*
Inscriptions and marks on sheet:	On recto: *23* (graphite) On verso: *A 97002* (graphite); *MG-89-57-RIMF4* (graphite); stamp of S. W. Pelletier in reddish-brown ink (1992; 10 · 13 · 24); unidentified collector's stamp ("B" and reverse "B" within circle) in black ink; Dowdeswell stamp in black ink (Lugt 690)
Platemark:	282 x 175 mm. (11³⁄₃₂ x 6⅞ in.)
Sheet:	312 x 248 mm. (12⁹⁄₃₂ x 9¾ in.)
Watermark:	HUDELIST
Provenance:	C. W. Dowdeswell, London (Lugt 690); [Christie's, New York, May 10, 1989]; [Paul McCarron, New York, October 13, 1992]; unidentified collector.
Description:	Dark brown ink on ivory-colored laid paper.
Literature:	*Prints (Part II). American and Modern Prints and Illustrated Books.* New York: Christie's, May 10, 1989, lot 675 (illustrated).

C. Meryon del. sculp 1853. Imp. rue N.º S.t Etienne du Mont 26

5

6
La Galerie Notre-Dame, Paris
The Gallery of Notre Dame, Paris

1853
Delteil-Wright 26 iv/v; Schneiderman 29 v/vi
Etching

Inscriptions on plate:	Upper left corner: *M*; lower margin: *LA GALERIE N₊ ⁺ ₊D₋*

Inscriptions on plate: Upper left corner: *M*; lower margin: *LA GALERIE* $N_+\ ^+\ _+D_-$

Inscriptions and marks on sheet: On verso: *4* (graphite); *La Galerie ND* (graphite); *To Katherine S. Dreier/New York Christmas 1926/Marcel Duchamp/(print from the Victor Hugo Collection)* (graphite); stamp of S. W. Pelletier in reddish-brown ink (1988; 6 · 16 · 2); unidentified collector's stamp (double "M" surmounted by "R" on its side)

Platemark: 281 x 177 mm. (11¹⁄₁₆ x 6³¹⁄₃₂ in.)

Sheet: 496 x 327 mm. (19¹⁷⁄₃₂ x 12⅞in.)

Provenance: Victor Hugo, Paris; Marcel Duchamp, New York; Katherine S. Dreier, New York; [Sotheby Parke Bernet, New York, June 22-23, 1977, no. 216]; private collection in Geneva; [Galerie Kornfeld-Bern, Bern, Switzerland, June 16, 1988]; unidentified collector.

Description: Black ink on ivory-colored laid paper.

Literature: *Nineteenth and Twentieth Century Prints, Americana, Old Master Prints*, Sale no. 4013. New York: Sotheby Parke Bernet, Inc., June 22-23, 1977, no. 216.

 Charles Meryon; David Young Cameron. Geneva: Cabinet des Estampes, Musée d'art et d'histoire, April 3-May 31, 1981, p. 51, no. 13 (illustrated on p. 15, pl. no. 13).

 Moderne Kunst (Auktion 198, Teil II). Bern: Galerie Kornfeld-Bern, June 15-17, 1988, lot 725.

Exhibited: *Charles Meryon; David Young Cameron.* Geneva: Cabinet des Estampes, Musée d'art et d'histoire, April 3-May 31, 1981.

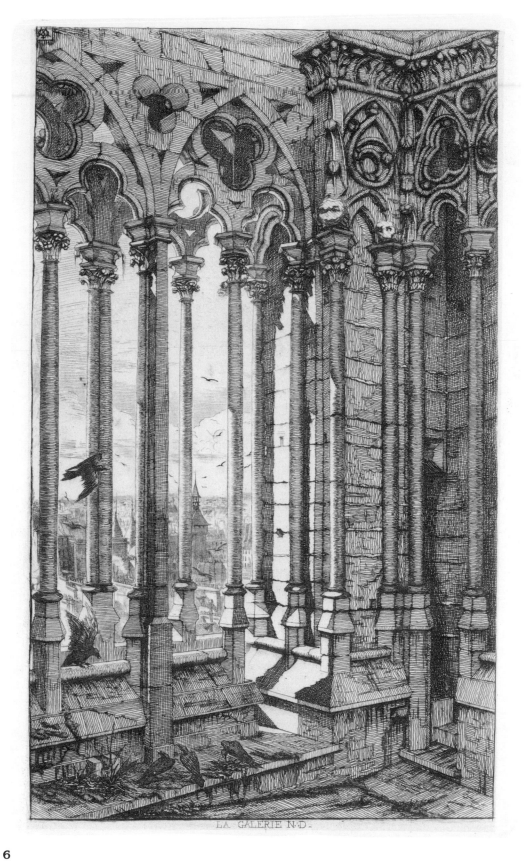

LA GALERIE N·D·

6

7
La Rue des Mauvais Garçons, Paris
The Street of the Bad Boys, Paris

1854
Delteil-Wright 27 iii/iii; Schneiderman 38 iii/iii
Etching

Inscriptions on plate:	On rock at bottom left: *C.M.* (in reverse); running vertically along right edge: *Meryon Imp. Rue N^e St. Etienne-du-Mont 26-*
Inscriptions and marks on sheet:	On recto: *12. Juin 1854./3606. Je certifie que le tirage est uniforme/à la présente épreuve/C. Meryon/Rue N^e St Etienne-du-Mont 26* (all in dark brown ink)
	On verso: stamp of S. W. Pelletier in reddish-brown ink (1981; 8 · 4 · 21)
Platemark:	126 x 99 mm. (4³¹⁄₃₂ x 3²⁹⁄₃₂ in.)
Sheet:	249 x 214 mm. (9¹³⁄₁₆ x 8⁷⁄₁₆ in.)
Watermark:	Fancy letters
Provenance:	Charles H. Watkins, Middletown, Massachusetts; [Childs Gallery, Boston, August 4, 1981] .
Description:	Brownish black ink on thin, beige-colored laid paper.

12. Juin 1854.

3666. *Je certifie que le tirage est conforme*
à la présente épreuve

C. Meryon

Rue n° St Étienne-du-Mont 26.

8
La Tour de l'Horloge, Paris
The Clock Tower, Paris

1852
Delteil-Wright 28 v/x; Schneiderman 23 v/x
Etching

Inscription on plate:	Upper right corner: *C.M.*
Mark on sheet:	On verso: stamp of S. W. Pelletier in black ink (1973; 11 · 5 · 7)
Platemark:	260 x 183 mm. (10¼ x 7⁷⁄₃₂ in.)
Sheet:	282 x 205 mm. (11³⁄₃₂ x 8¹⁄₁₆ in.)
Provenance:	[H. Schickman Gallery, New York, November 5, 1973].
Description:	Black ink on cream-colored laid paper. There is a small rust spot in the lower margin outside the platemark.

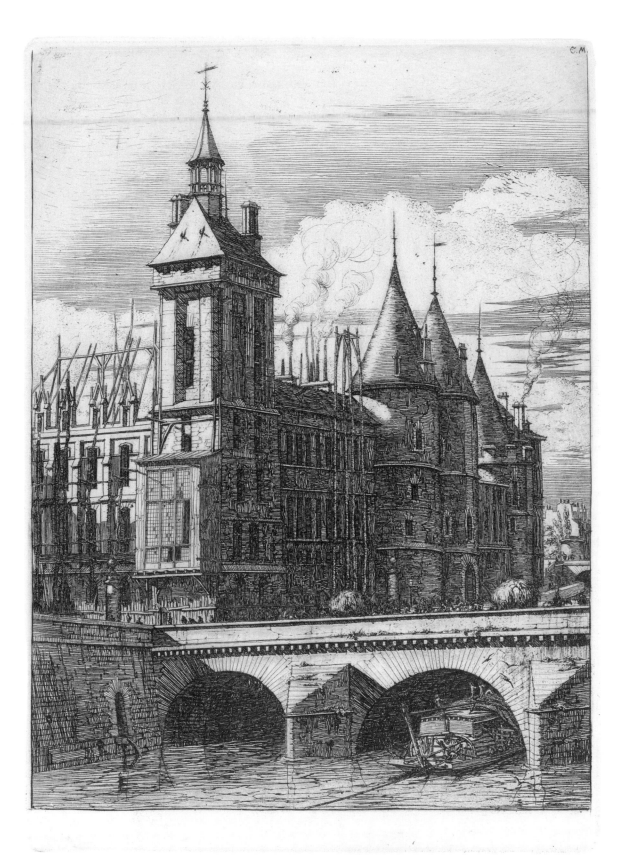

9
Tourelle, Rue de la Tixéranderie, Paris
House with a Turret, Weavers' Street, Paris

1852
Delteil-Wright 29 iii/v; Schneiderman 24 iii/iv
Etching

Inscription on plate:	Upper right corner: *C.M.*
Inscriptions and marks on sheet:	On recto, lower margin: *Meryon* (graphite) On verso: *L.D. 29II* (graphite); *Vues de Paris* (graphite); *c.8301* (graphite); *Zu 9275* (graphite); *14* (graphite); stamp of S. W. Pelletier in black ink (1974; 2 · 28 · 1); "C. Weisböck" in brown ink; "P. Davidsohn" in black ink; illegible signature in graphite; stamp of Gottfried Eissler in brown ink (Lugt 805b)
Platemark:	245 x 132 mm. (9²¹⁄₃₂ x 5³⁄₁₆ in.)

Platemark: 245 x 132 mm. (9$^{21/32}$ x 5$^{3/16}$ in.)

Sheet: 255 x 136 mm. (10$^{1/32}$ x 5$^{11/32}$ in.)

Provenance: Carl Weisböck, Vienna (Lugt 2576); Paul Davidsohn, Grunewald-Berlin (Lugt 654); Dr. Gottfried Eissler, Vienna (Lugt 805b); [C. G. Boerner, Düsseldorf, February 28, 1974]; unidentified collector.

Description: Black ink on buff-colored, Japan wove paper. The warm tone of the Japan paper emphasizes the shimmering effect of the light.

Literature: *Print Collector's Bulletin* II, no. 1, M. Knoedler & Co., Inc., New York (1931), p.22.

 Alte und Neuere Graphik und Zeichnungen (Neue Lagerlist Nr. 63). Düsseldorf: C. G. Boerner, October 2-23, 1973, no. 96 (illustrated).

Exhibited: *Alte und Neuere Graphik und Zeichnungen.* Düsseldorf: C. G. Boerner, October 2-23, 1973.

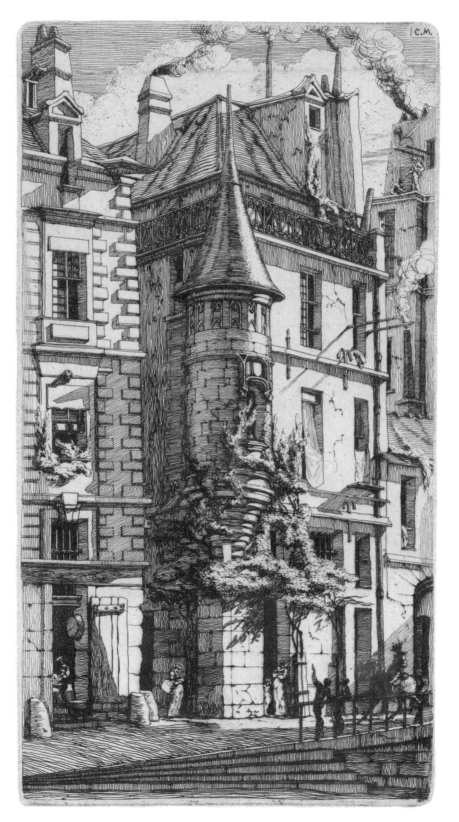

9

10
Saint-Etienne-du-Mont, Paris
Church of St. Stephen of the Mount, Paris

1852
Delteil-Wright 30 iii/viii; Schneiderman 25 iii/viii
Etching

Inscriptions and marks on sheet:	On verso: *mO* (graphite); *Haden* (graphite); stamp of S. W. Pelletier in reddish-brown ink (1981; 8 · 3 · 20)
Platemark:	251 x 130 mm. (9⅞ x 5⅛ in.)
Sheet:	256.5 x 134 mm. (10³⁄₃₂ x 5⁹⁄₃₂ in.)
Provenance:	Seymour Haden, London; [Kennedy Galleries, Inc., New York, August 3, 1981].
Description:	Black ink on buff-colored, Japanese wove paper. This extremely rare third state of eight is recorded only in the collections at the Museum of Fine Arts, Boston (BMFA), the Art Institute of Chicago (AIC), the Detroit Institute of the Arts (DIA), the British Museum (BM), and the Toledo Museum of Art (TMA).

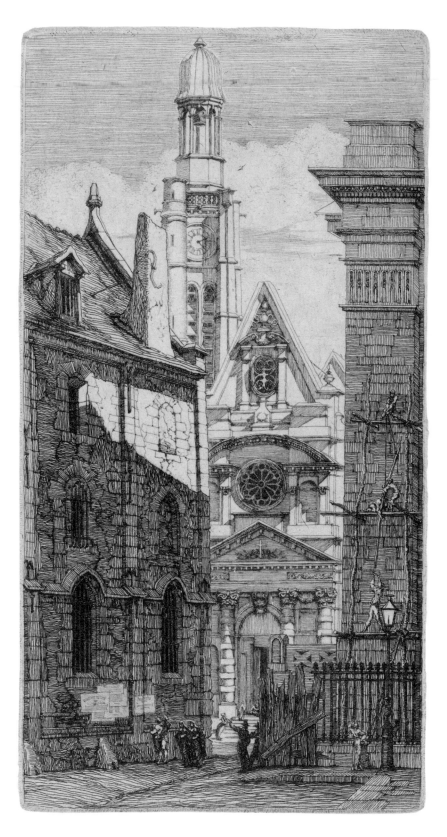

10

11
La Pompe Notre-Dame, Paris
The Notre Dame Pump, Paris

1852
Delteil-Wright 31 v/ix; Schneiderman 26 vi/x
Etching

Inscriptions on plate:	Below image: *C. Meryon ft Imp. R. Nᵉ Sᵗ Etienne-du-Mont 26; 1852*
Inscriptions and marks on sheet:	On verso: *tchc* (graphite); indecipherable stamped mark (a circle with the letters "EXPO" clearly visible) in a violet-colored ink.
Platemark:	170 x 251 mm. (6¹¹⁄₁₆ x 9⅞in.)
Sheet:	218 x 262 mm. (8¹⁹⁄₃₂ x 10⁵⁄₁₆ in.)
Description:	Dark brown ink on thin, ivory-colored laid paper.

On loan, courtesy of Frank W. Raysor II, New York City.

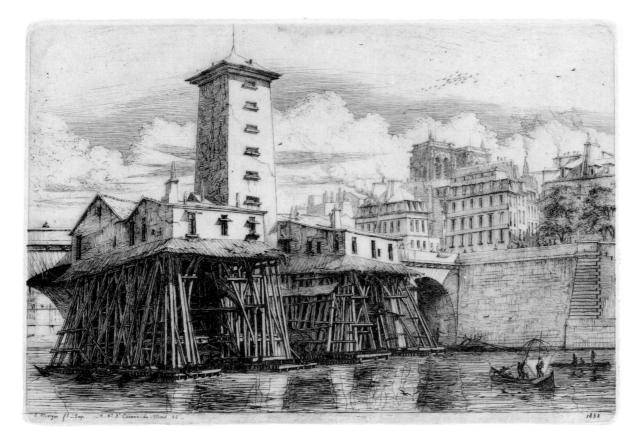

C. Meryon f.t. Imp. R. N. 3.ᵉ Étienne-du-Mont 26. 1852

11

12
Le Pont Neuf, Paris
The New Bridge, Paris

1853
Delteil-Wright 33 v/x; Schneiderman 30 v/xi
Etching

Inscriptions on plate:	Below image: *C. Meryon Del. sculp. 1853– Imp. A. Delâtre Rue de la Bacherie n°6.*
Inscriptions and marks on sheet:	On recto: *5237* (graphite); *R.18* (graphite); W 33 - 5th *state of 10* (graphite); *<A19559>* (graphite); *Le Pont Neuf, Paris* (graphite); *4285* (graphite); *D. 33 V/X* (graphite); *26* (graphite); dry stamp of John Waterloo Wilson (Lugt 2581) On verso: *3944* (graphite); *FVXV* (graphite); *oSe* in circle (graphite); *a59322* (crossed out, graphite); stamp of S. W. Pelletier in black ink (1976; 4 · 8 · 3)
Platemark:	180 x 182 mm. (7³⁄₃₂ x 7⁵⁄₃₂ in.)
Sheet:	251 x 240 mm. (9⅞ x 9⁷⁄₁₆ in.)
Provenance:	John Waterloo Wilson, Haarlem, Brussels, and Paris (Lugt 2581); [Kennedy Galleries, Inc., New York, April 8, 1976].
Description:	Dark brown ink on pale green laid paper. Delâtre printed impressions of this state on both ivory and greenish papers. This state bears Meryon's name and date and Delâtre's address, but is before the verses were added in the lower margin.
Literature:	*An Exhibition; One Hundred Fine Prints in Celebration of our Hundredth Year as Fine Print Dealers, 1874-1974.* New York: Kennedy Galleries, Inc., July 1974, p. 27, no. 53 (illustrated).
Exhibited:	*An Exhibition; One Hundred Fine Prints in Celebration of our Hundredth Year as Fine Print Dealers, 1874-1974.* New York: Kennedy Galleries, Inc., July 1974.

12

13
Le Pont-au-Change, Paris
The Exchange Bridge, Paris

1854
Delteil-Wright 34 v/xii; Schneiderman 40 v/xii
Etching and drypoint

Inscriptions on plate:	On recto: below image, in lower left: *C. Meryon del. sculp. mdcccliiii-*; in lower right: *Imp. R. Neuve St. Etienne-du-Mont. 26.*
	S
Inscriptions and marks on sheet:	On verso: CS 1(graphite); *a46880* (graphite); stamp of S. W. Pelletier in reddish brown ink (1991; 2 · 19 · 4)
Platemark:	155 x 333 mm. (6³⁄₃₂ x 13⅛ in.) image: 140 x 322 mm. (5½ x 12¹¹⁄₁₆ in.)
Sheet:	291 x 442.5 mm. (11¹⁵⁄₃₂ x 17¹³⁄₃₂ in.)
Watermark:	Crown over shield over fleur-de-lis.
Provenance:	[Kennedy Galleries, Inc., New York, 1967]; [Linda Papaharis, Birmingham, Alabama, February 19, 1991].
Description:	Brownish black ink, with strong plate tone, on ivory-colored laid paper. Printed with inky plate edges. This state was printed by Meryon himself.

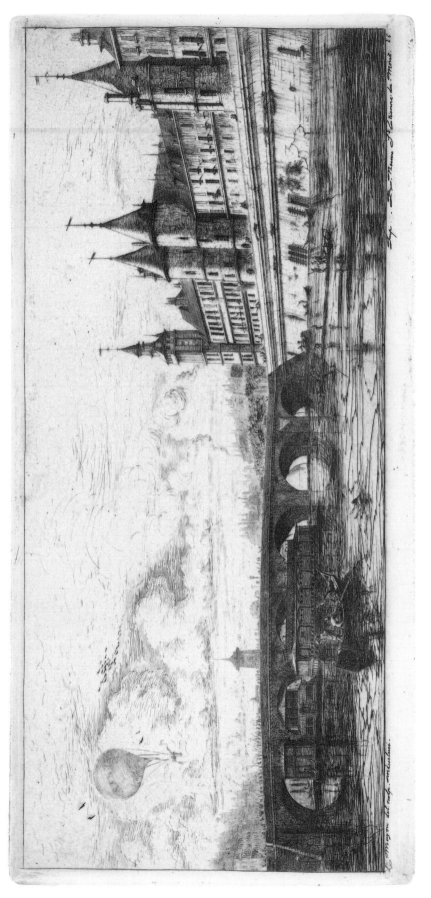

13

14
La Morgue, Paris
The Morgue, Paris

1854
Delteil-Wright 36 iv/vii; Schneiderman 42 iv/vii
Etching and drypoint

Inscriptions on plate:	Below image: *C. Meryon del. sculp. mdcccliv– ; Imp. Rue neuve S.ᵗ - Etienne-du-Mont-Nᵒ 26.–.*
Inscriptions and marks on sheet:	On verso: *B9536* (graphite); *NCX* (graphite); stamp of S. W. Pelletier in reddish brown ink (1992; 4 · 27 · 5); stamp of Loys Delteil in black ink
Platemark:	231 x 204.5 mm. (9³⁄₃₂ x 8¹⁄₁₆ in.) image: 212 x 187.5 mm. (8¹¹⁄₃₂ x 7³⁄₈ in.)
Sheet:	317.5 x 250.5 mm. (12½ x 9⅞ in.)
Watermark:	*J WHA[TMAN] / Turke[y Mill] / 18 []*
Provenance:	Loys Delteil, Paris (Lugt 773); [William P. Carl, Boston, April 27, 1992].
Description:	Black ink on ivory-colored wove Whatman paper. With very minor staining and discoloration in the wide margins. This dramatic impression is cited in the Delteil-Wright catalogue raisonné.
	The old morgue stood on the Ile de la Cité, on the Quai de Marché-Neuf, between the Pont Saint-Michel and the Petit Pont. The building, constructed in 1568, was formerly an abattoir, a fact that may have influenced Meryon's feelings about it.
Literature:	*Selected Fine Prints.* Boston: William P. Carl, April 1992, p. 11 (illustrated).

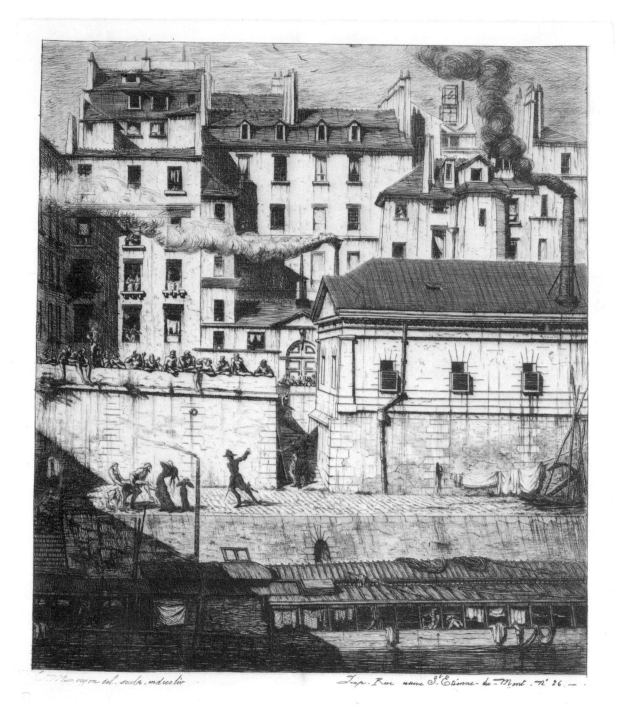

C. Meryon del. sculp. mdccclii.

Imp. Rue neuve St Etienne du Mont. n° 26.

14

15

L'Abside de Notre-Dame de Paris
The Apse of Notre Dame, Paris

1854 (state iv dated 1854; D. W. state vi and S. state vii dated 1853)
Delteil-Wright 38 iv/viii; Schneiderman 45 iv/ix
Etching

Inscriptions on plate:	Below image: *C. Meryon–del. sculp mdcccliv; Imp Rue neuve St Etienne-du-Mont 26–*
Inscriptions on sheet:	On recto: *(ix.yy.o/L.L.O.)* (graphite) On verso: *C.L. 7/5/1929 Lot 285/£400* (graphite); stamp of C. W. Dowdeswell in black ink
Platemark:	164 x 296 mm. (6^{15}⁄$_{32}$ x 11^{21}⁄$_{32}$ in.)
Sheet:	266 x 431 mm. (10^{15}⁄$_{32}$ x 16^{31}⁄$_{32}$ in.)
Provenance:	C. W. Dowdeswell, London (Lugt 690).
Description:	Black ink on ivory-colored laid paper, printed with plate tone.

On loan, courtesy of Frank W. Raysor II, New York City.

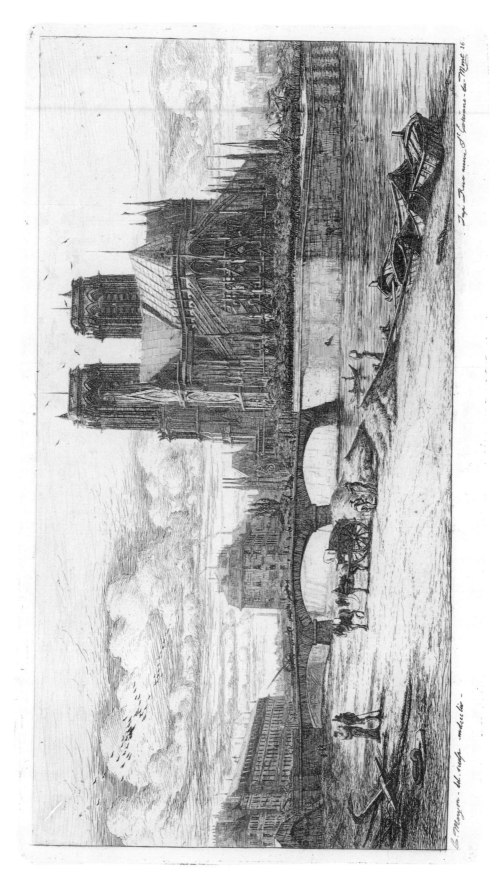

C. Meryon. Del. Sculp. MDCCLII. — Tye Hue near St Catherine-le-Mont. 16.

16
La Rue des Toiles, à Bourges
The Street of Textiles, Bourges

1853
Delteil-Wright 55 v/ix; Schneiderman 31 v/ix
Etching

Inscriptions on plate:	Below image: *C. Meryon del. sculp. –1853; Rue Nᵉ Sᵗ.* *Etienne-du-Mont 26* (with a horizontal line drawn through both inscriptions)
Inscriptions and marks on sheet:	On verso: *58.35 –Rue des toiles à Bourges/Epreuve avant le titre, avec le chien/et avec 1853 sur la cheminée*; stamp of S. W. Pelletier in reddish brown ink (1991; 6 · 20 · 9)
Platemark:	217.5 x 120.5 mm. (8⁹⁄₁₆ x 4¾in.)
Sheet:	322.5 x 224 mm. (12¹¹⁄₁₆ x 8¹³⁄₁₆ in.)
Watermark:	*[] & C BLAUW*
Provenance:	[Galerie Kornfeld-Bern, Bern, Switzerland, June 20, 1991].
Description:	Black ink on cream-colored laid paper. In this state the date on the chimney is partially effaced, and there are lines through the plate inscriptions. There is no borderline along the top yet. The little dog still remains at the lower left. Very rare in this state.
Literature:	*Moderne Kunst* (Auktion 206, teil II). Bern: Galerie Kornfeld-Bern, June 1921, 1991, lot 639.

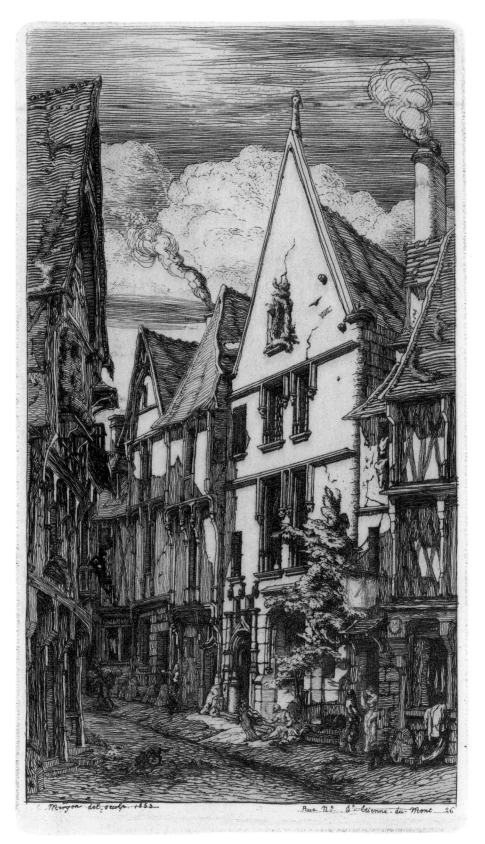

Méryon del. sculp. 1852 Rue N^e S^t Etienne du Mont 26

16

II. Jean-Francois Millet

17
*Moutons Paissant**
Mouton Paissant (Lebrun, Beraldi)
A Sheep Grazing (Keppel)
Sheep and Cow Grazing (Keppel)
Sheep Grazing (Melot)

1849 (Delteil)
c. 1849 (Lei & Keil)
1850 (Melot)
MEZAC, Delteil 5, only state; Lebrun 6 i/ii; Lei & Keil 2, only state; Melot 5, only state
Drypoint with roulette

Inscription on plate: Top left: *Ch. Jacque*. At bottom: *Jackson invenit et fecit*

Platemark: 48 x 117 mm. (1⅞ x 4⅝ in.)

On loan from the S. P. Avery Collection, Miriam & Ira D. Wallach Division of Art, Prints and Photographs, The New York Public Library, Astor, Lenox and Tilden Foundations.

* Many authors have given varying titles to Millet's prints. The differing titles are given here chronologically, as they were published.

17

18
La Planche aux Trois Sujets
Croquis Femme étendant du Ligne; Petit Bêcheur au Repos; Un paysan
 assis (Lebrun)
Sketches of Three Subjects (Keppel)
Femme étendant du ligne sur une haie; Petit Bêcheur au
 repos, tourné vers la droite; Croquis d'un paysan assis,
 appuyé sur le bras gauche (Beraldi)
Trial Sketches (Keppel)
Sketches of Three Subjects: Woman Hanging out Clothes;
 Man Leaning on His Spade; A Peasant Seated (Keppel)
Plate with Three Subjects: Woman Hanging up Washing; Small
 Digger Resting; Seated Peasant (Melot)
Three Sketches: Woman Laying Out Wash; Man Leaning on a Spade;
 and Seated Peasant (Murphy)

Before 1848 (Melot; The New York Public Library)
1854-1855 (Lei & Keil)
c. 1855 (Murphy)
MEZAC, Delteil 2, only state; Lebrun 2, 3, and 7, only state; Lei & Keil 8,
only state; Melot 2, only state
Etching with roulette

Platemark: 91 x 151 mm. (3⁹/₁₆ x 6 in.)

On loan from the S. P. Avery Collection, Miriam & Ira D.
Wallach Division of Art, Prints and Photographs, The New
York Public Library, Astor, Lenox and Tilden Foundations.

18

19
Les Deux Vaches
The Two Cows (Keppel; Melot)
Woman with Two Cows (Murphy)

Before 1848 (1847 ?) (Melot)
1850-1853 (Lei & Keil)
c. 1855 (Murphy)
Delteil 4 iv/v; Lebrun 5 iv/iv; Lei & Keil 3 iv/v; Melot 4 iv/v
Etching, roulette, and drypoint

Inscription on plate:	*J. F. Millet*
Inscriptions and marks on sheet:	On recto: *8001* (brown ink) On verso: *81* (brown ink); *235* (graphite); stamp of S. W. Pelletier in reddish brown ink (1985; 2 · 6 · 1)
Platemark:	91 x 151 mm. (3¹⁹/₃₂ x 5¹⁵/₁₆ in.)
Sheet:	220 x 344 mm. (8²¹/₃₂ x 13¹⁷/₃₂ in.)
Provenance:	[Craddock & Barnard, London, February 6, 1985].
Description:	Black ink on antique, green laid paper. Printed with strong plate tone. This state is recorded in BMFA, AIC, BN, TMA, and the New York Public Library (NYPL).
Literature:	*Engravings & Etchings (Fifteenth to Twentieth Centuries)* (Catalogue 149). London: Craddock & Barnard, December 1984, no. 256.

19

20

La Planche aux Croquis
Various Sketches (Keppel)
Croquis Divers (Lebrun)
Feuille de croquis (Beraldi)
Trial Sketches (Keppel)
Various Sketches on One Plate (Keppel)
La Planche aux Croquis ou à la Tricoteuse (Delteil)
Plate with Sketches or Woman Knitting (Melot)

Before 1848 (1847 ?) (Melot)
1854-1855 (Lei & Keil)
c. 1855 (Murphy)
Delteil 6, only state; Lebrun 8, only state; Lei & Keil 6, only state;
Melot 6, only state Etching and drypoint

Inscriptions and marks on plate:	At upper left, in reverse: *M. JUERY/27, RUE DE LA/ HUCHETTE/PARIS.* At lower right, inscribed in reverse: *Diaz delineavit.*
Marks on sheet:	On verso: stamp of S. W. Pelletier in reddish brown ink (1986; 6 · 19 · 2)
Platemark:	190.5 x 118.5 mm. (7½ x 2 x 4²¹⁄₃₂ in.)
Sheet:	220 x 139 mm. (8²¹⁄₃₂ x 5¹⁵⁄₃₂ in.)
Provenance:	[Galerie Kornfeld-Bern, Bern, Switzerland, June 19, 1986].
Description:	Early impression with burr, in black ink on old, cream-colored laid paper. Printed with plate tone. Only 10 impressions were pulled in the original edition, according to Lebrun. Impressions of this print are recorded in AIC, NYPL, BN, and the Victoria and Albert Museum.
Literature:	*Moderne Kunst des Neunzehnten und Zwanzigsten Jahrhunderts* (Auktion 192). Bern: Galerie Kornfeld-Bern, June 18-20, 1986, p. 131, lot 572.

20

21
La Tricoteuse
Woman Knitting (Melot; Lei & Keil)
Before 1848 (1847?) (Melot); 1854-1855 (Lei & Keil).

Delteil 7, only state; Lebrun (not listed); Lei & Keil 7,
only state; Melot 7, only state.
Drypoint

Inscriptions on plate:	At lower left in reverse: *M JUERY / 27, RUE DE LA / HUCHETTE/ PARIS.*
Inscriptions and marks on sheet:	On recto: stamp of Hector Giacomelli in pink ink; stamp of Jules Gerbeau in red ink. On verso: stamp of H. H. Benedict in black ink; stamp of S. W. Pelletier in reddish brown ink (1992; 12 · 15 · 92); *241088* (graphite).
Platemark:	107 x 75 mm. (4 $^7/_{32}$ x 2 $^{15}/_{16}$ in.).
Sheet:	167.5 x 126 mm. (6 $^{19}/_{32}$ x 4 $^{31}/_{32}$ in.).
Watermark:	Tail or letter *S* (?).
Provenance:	Hector Giacomelli, Paris and Versailles (Lugt 1311); Jules Gerbeau, Paris (Lugt 1166); Henry Harper Benedict, New York (Lugt 2936); [Arsène Bonafous-Murat, Paris, December 1986]; [Artemis Fine Arts, Ltd., London, December 15, 1992].
Description:	A rich impression with burr in warm black ink on pale buff laid paper with tone. Only two impressions of this rare drypoint are known. This is the one illustrated in the Loys Delteil catalogue raisonné as no. 7. This print is similar to the drawing of the *Shepherdess Knitting* in the Museum of Fine Arts, Boston. This drawing and *La Tricoteuse* appear to be preliminary studies which eventually evolved into Millet's large *La Grande Bergère (cat. no. 34)*.
Exhibited:	*Prints and Drawings by Jean-François Millet.* Brooklyn, New York: Brooklyn Museum, May 14-July 6, 1937.

21

22
Ramasseurs de Varech
The Seaweed Gatherers (Keppel)
The Kelp Gatherers (Melot)

Before 1848 (1847 ?) (Melot)
1854-1855 (Lei & Keil)
Delteil 8, only state; Lebrun 9, only state; Lei & Keil 5,
only state; Melot 8, only state
Etching, roulette, and drypoint

Inscriptions and marks on sheet:	On verso: *bert* [?] (graphite); stamp of S. W. Pelletier in reddish brown ink (1986; 6 · 19 · 3)
Platemark:	100 x 124 mm. (3¹⁵⁄₁₆ x 4⅞ in.)
Sheet:	165 x 222 mm. (6½ x 8¾ in.)
Provenance:	[Galerie Kornfeld-Bern, Bern, Switzerland, June 19, 1986].
Description:	Impression with rich burr, in black ink on old, thin, white (with faint green tint) laid paper. Only 10 impressions were pulled in the original edition, according to Lebrun. Life-time impressions are recorded in AIC and NYPL.
Literature:	*Moderne Kunst des Neunzehnten und Zwanzigsten Jahrhunderts* (Auktion 192). Bern: Galerie Kornfeld-Bern, June 18-20, 1986, p. 131, lot 573.

22

23

L'Homme Appuyé sur sa Bêche
Digger Resting (Keppel)
The Man Leaning on his Spade (Keppel; Wickenden)
Man Leaning on Spade (Melot)
Man Leaning on a Spade (Murphy)

Before 1848 (1847 ?) (Melot)
1854-1855 (Lei & Keil)
c. 1855 (Murphy)
Delteil 3, only state; Lebrun 4, only state; Lei & Keil 4, only state; Melot 3, only state
Etching

Inscriptions and marks on sheet:	On recto, in lower margin: *L.D.3. only state. Early proof* (graphite); *(From the P. M. Robinow collection)/Hamburg* (graphite); *original etching/J. F. Millet Bêcheur appuyé* (graphite); *French 1814-1875* (graphite) On verso: *om* (graphite); *PM-77-14-REE* (graphite); two S. W. Pelletier stamps in reddish brown ink (1977; 9 · 14 · 50); stamp of Paul M. Robinow in red ink
Platemark:	85 x 69 mm. (3¹¹⁄₃₂ x 2²³⁄₃₂ in.)
Sheet:	207 x 155 mm. (8⁵⁄₃₂ x 6³⁄₃₂ in.)
Watermark:	*Crown with shield* (fragment)
Provenance:	Paul M. Robinow, Hamburg (Lugt 2102); Edward F. Miller, Spencerville, Ohio; [Paul McCarron Fine Prints, Brooklyn, New York, September 14, 1977].
Description:	Early impression in warm black ink on antique, ivory-colored, laid paper. Printed with light plate tone and rough, uneven inky plate-edges. Lugt cites the Robinow collection of Millet prints as: *"une série de très belles épreuves des eaux-fortes de Millet."* Lifetime impressions of this print are recorded in BMFA, AIC, NYPL, BN, and the Walters Art Gallery in Baltimore (WAGB).
Literature:	*Jean François Millet 1814-1975.* Brooklyn: Paul McCarron Fine Prints, September 1977, no. 1.

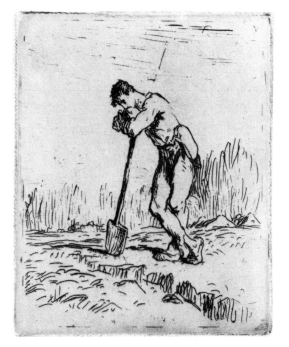

23

24

L'Homme Appuyé sur sa Bèche
Digger Resting (Keppel)
The Man Leaning on his Spade (Keppel; Wickenden)
Man Leaning on Spade (Melot)
Man Leaning on a Spade (Murphy)

Before 1848 (1847 ?) (Melot)
1854-1855 (Lei & Keil)
c. 1855 (Murphy)
Delteil 3, only state; Lebrun 4, only state; Lei & Keil 4,
only state; Melot 3, only state
Etching

Mark on sheet:	On verso: stamp of S. W. Pelletier in reddish brown ink (1984; 3 · 16 · 1)
Inscriptions on old mat:	On recto, lower margin: *To T. H. Lewis Esq./ with best wishes for a happy/ and prosperous new year/ Dec. 31. 1885./R Guéraut* (in brown ink)
Platemark:	85 x 68 mm. (3¹¹⁄₃₂ x 2¹¹⁄₁₆ in.)
Sheet:	196.5 x 140 mm. (7¾ x 5½ in.)
Watermark:	*Arms of Amsterdam*
Provenance:	Robert Guéraut, Glasgow (cf. Lugt 2210 and 2210 suppl.); T. H. Lewis, Esq.; [Craddock and Barnard, London, March 16, 1984].
Description:	Early impression in warm black ink on antique, ivory-colored laid paper. Printed with plate tone and rough, uneven inky plate edges. Some light staining. Lifetime impressions of this print are recorded in WAGB, BMFA, AIC, NYPL, and BN.

Robert Guéraut was a Glasgow print publisher responsible for the publication of many etchings by Alphonse Legros.

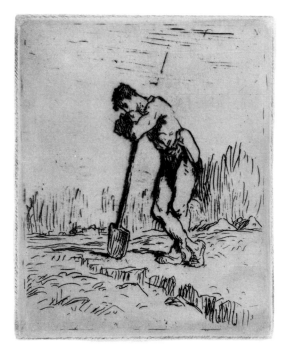

24

25
La Couseuse
Sewing (Henley)
Woman Sewing (Keppel, Melot)
A Woman Sewing (Keppel; Wickenden)
Woman Sewing beside a Window (Murphy)

1855 (Delteil)
1855-1856 (Lei & Keil; Melot; Murphy)
Delteil 9 ii/iii; Lebrun 10, only state; Lei & Keil 12 ii/iii; Melot 9 ii/iii
Etching

Inscriptions and marks on sheet:	On verso: *E670* (graphite); *260* (graphite); stamp of S. W. Pelletier in reddish brown ink (1989; 8 · 30 · 9)
Platemark:	106 x 74 mm. (4³⁄₁₆ x 2²⁹⁄₃₂ in.)
Sheet:	282 x 200 mm. (11³⁄₃₂ x 7⁷⁄₈ in.)
Provenance:	Albert Elliott McVitty, Princeton, New Jersey (Parke-Bernet, 1949, November 28-29, lot 251); [Linda M. Papaharis Gallery, Bronxville, New York, August 30, 1989].
Description:	Luminous impression of the second state printed in brownish black ink on cream-colored *Chine collé* over thick, white wove paper. Delteil described this state as *"rare."* This state is recorded in BMFA, AIC, BN, the Metropolitan Museum of Art (MMA), and the Davison Art Center, Wesleyan University, Middletown, Connecticut (DAC).

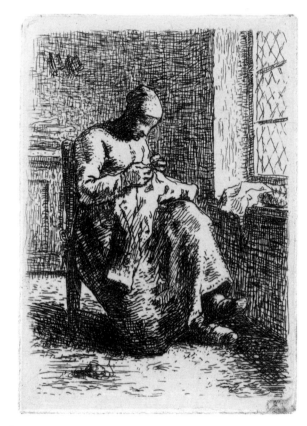

25

26

La Baratteuse
La Femme qui bat le beurre (Burty; Lebrun)
Churning (Henley; Keppel)
A Woman Churning (Keppel; Wickenden)
Woman Churning (Melot)
Woman Churning Butter (Murphy)

1855 (Lebrun; Delteil)
1855-1856 (Lei & Keil; Melot; Murphy)
Delteil 10 i/iii; Lebrun 11 i/ii; Lei & Keil 13 i/iii; Melot 10 i/iii
Etching

Inscriptions and marks on sheet:	On recto: stamp of George M. Adams in magenta ink. On verso: *First state. Probably unique* (graphite); *A78849* (graphite); *HCO* (graphite); *Ex. collection A. Rouart* (graphite); two S. W. Pelletier stamps in reddish brown ink (1977; 8 · 16 · 41A); stamp of George M. Adams in magenta ink; stamp of Albert W. Scholle
Platemark:	179 x 118 mm. (7¹/₁₆ x 4²¹/₃₂ in.)
Sheet:	310 x 218 mm. (12⁷/₃₂ x 8¹⁹/₃₂ in.)
Provenance:	Alexis Hubert Rouart, Paris (cf. Lugt 2187ᵃ); [Frederick Keppel & Co., New York, February 9 - March 6, 1915]; Albert W. Scholle, New York (Lugt 2923ᵃ); George M. Adams, New York (Lugt 59); [Associated American Artists, New York, August 16, 1977].
Description:	Luminous impression of the exceedingly rare first state in black ink on thick, old, white, Dutch wove paper. A printed label on the mat from the 1915 Keppel exhibition catalogue reads: "The Churner. (Delteil No. 10)/ First state, before the horizontal lines on the floor/ in front of the bench, and before the oblique lines/ to the right of the duster on the wall. Splendid/ luminous proof in black ink on Dutch paper. From/ the collection of Alexis Rouart. Of the greatest/ rarity, probably unique. This is the print which/ Loys Delteil saw when he made his catalogue of/ Millet's etchings and upon which he based his first/ state." Delteil described this state as *"de toute rareté."* This is the impression illustrated as the first state in the Delteil catalogue. Impressions of this state are recorded in BMFA, BN, and Yale University Art Gallery (YALE).
Literature:	*Catalogue of an Exhibition of Etchings and Drawings by J. -F. Millet.* New York: Frederick Keppel & Co., February 9-March 6, 1915, p. 6, no. 9.
	The Discerning Eye. New York: Associated American Artists, August 10-September 10, 1977, no. 115.
Exhibited:	*Catalogue of an Exhibition of Etchings and Drawings by J.-F. Millet.* New York: Frederick Keppel & Co., February 9-March 6, 1915.
	The Discerning Eye. New York: Associated American Artists, August 10-September 10, 1977.

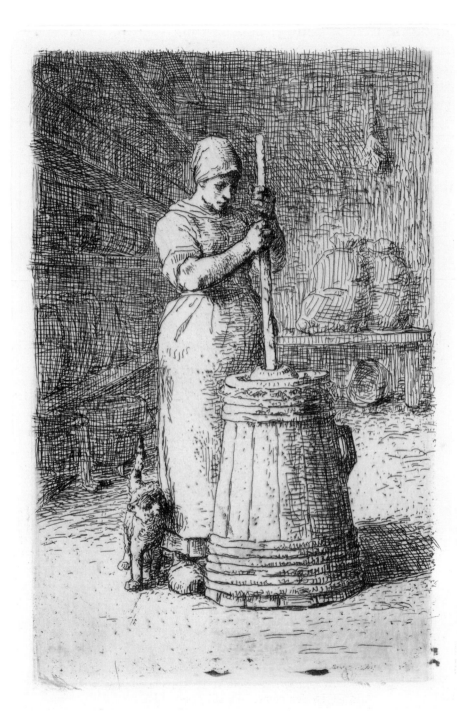

26

27

Le Paysan Rentrant du Fumier
L'Homme à la brouette (Burty; Beraldi)
Paysan rentrant du Fumier (Lebrun; Beraldi)
Peasant with a Wheelbarrow (Keppel; Wickenden)
Hauling (Henley)
Man with a Wheelbarrow (Keppel)

1855 (Lebrun; Delteil)
1855-1856 (Lei & Keil; Melot; Murphy)
Delteil 11 iii/iv; Lebrun 12 ii/ii; Lei & Keil 14 iii/iv; Melot 11 iii/iv
Etching

Inscription on plate:	In lower right corner: *J. F. Millet.*
Mark on sheet:	On verso: stamp of S. W. Pelletier in reddish brown ink (1992; 2 · 18 · 1)
Platemark:	165 x 131.5 mm. (6½ x 5³⁄₁₆ in.)
Sheet:	260 x 189 mm. (10¼ x 7⁷⁄₁₆ in.)
Watermark:	*C & I Honig.* (Similar to Heawood 3346 and 3348).
Provenance:	[Sotheby's, New York, February 14, 1992]; [Great Modern Pictures, New York, February 18, 1992].
Description:	A strong impression in brownish black ink on medium weight, ivory-colored laid paper. Printed with strong, even plate tone. Faintly light-struck. This state is recorded in AIC (2 impressions), DIA, YALE, and the Fogg Museum of Art at Harvard University (FMA).
Literature:	*19th & 20th Century Prints.* New York: Sotheby's, February 14, 1992, no. 176 (illustrated; miscatalogued as fourth and final state).

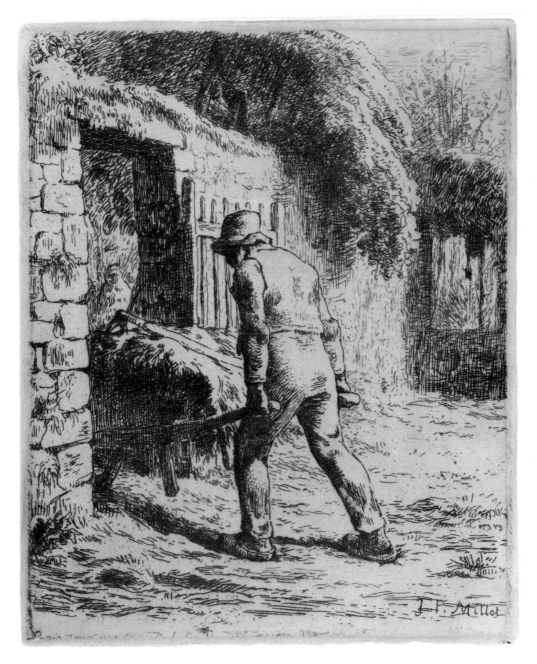

27

28
Les Glaneuses
Gleaning (Henley; Keppel)
The Gleaners (Keppel; Wickenden; Melot)
Gleaners (Murphy)

1855-1856 (Lei & Keil; Melot; Murphy)
Delteil 12 ii/ii; Lebrun 13 ii/ii; Lei & Keil 15 iii/iii; Melot 12 ii/ii
Etching

Inscriptions on plate:	At lower right: *Pars [sic] Imp par Aug. Delâtre. Rue st. Jacque 171 171* (faint)
Inscriptions and marks on sheet:	On recto: *79* (graphite); inscribed by artist in graphite in the lower margin: *Souvenir de J. F. Millet/Son vieil ami Alfred Sensier* On verso: *L. D. 12II* (graphite); stamp of S. W. Pelletier in reddish brown ink (1980; 11 · 12 · 26); stamp of Max Gotthilf Kade
Platemark:	190 x 154 mm. (7^{15}⁄$_{32}$ x 6^1⁄$_{16}$ in.)
Sheet:	303 x 407 mm. (11^{15}⁄$_{16}$ x 16^1⁄$_{32}$ in.)
Provenance:	Alfred Sensier, Paris; Max Gotthilf Kade, New York (Lugt 1561a); [Kennedy Galleries, New York, November 12, 1980].
Description:	Sharp impression in brownish black ink on buff-colored wove paper. Printed with plate tone and inky plate edges. On verso there are the remains of glue along the margins. This impression is cited in the Delteil catalogue: *"Sensier, 2e état, 68 fr."* Impressions of this state are recorded in WAGB, AIC (3 impressions), NYPL, and BN.

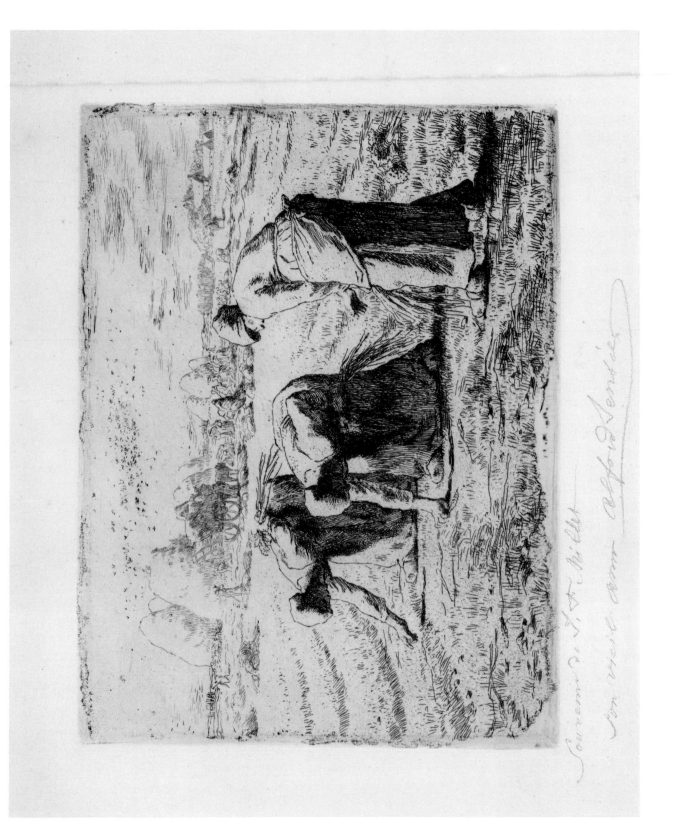

28

29
Les Bêcheurs
Les Terrassiers (Burty)
Delving (Henley)
Two Men Digging (Keppel; Wickenden)
The Diggers (Wickenden; Melot)
Two Men Turning over the Soil (Murphy)

1855-1856 (Lei & Keil; Melot; Murphy)
Delteil 13 iii/iv; Lebrun 14 iii/iv; Lei & Keil 16 iii/iv; Melot 13 iii/iv
Etching

Inscriptions and marks on sheet:	On recto: *L.↑526* (graphite); *(From Sir J. C. Day coll.* (graphite); *George M. Adams collection* (graphite); blind stamp of Sir John Charles Frederic Sigismund Day; stamp of George M. Adams in bluish green ink; *c 9997* (graphite); *L.D. 13ᴵᴵᴵ Les Bêcheurs J. F. Millet* (graphite) On verso: stamp of S. W. Pelletier in black ink (1973; 1 · 26 · 1)
Platemark:	232 x 333 mm. (9⅛ x 13⅛ in.)
Sheet:	329 x 434 mm. (12¹⁵⁄₁₆ x 17³⁄₃₂ in.)
Provenance:	Sir John Charles Frederic Sigismund Day, London (Lugt 526); [Christie's sale, London, May 17-18, 1909]; George M. Adams, New York (Lugt 59); [M. Knoedler & Co., New York, January 26, 1973].
Description:	Black ink on thin, white tissue laid over heavy, white paper. Printed with light plate tone. Delteil described this state as *"rare."* An impression of this state is recorded in the AIC.
Literature:	"Masterpieces of European Printmaking: 15th-19th Centuries," *Georgia Museum of Art Bulletin* 9, nos. 2-3 (Winter-Spring 1984), no. 68 (pp. 37-38).
Exhibited:	*Masterpieces of European Printmaking: 15th-19th Centuries.* Athens, Georgia: Georgia Museum of Art, The University of Georgia, September 21-December 31, 1983.

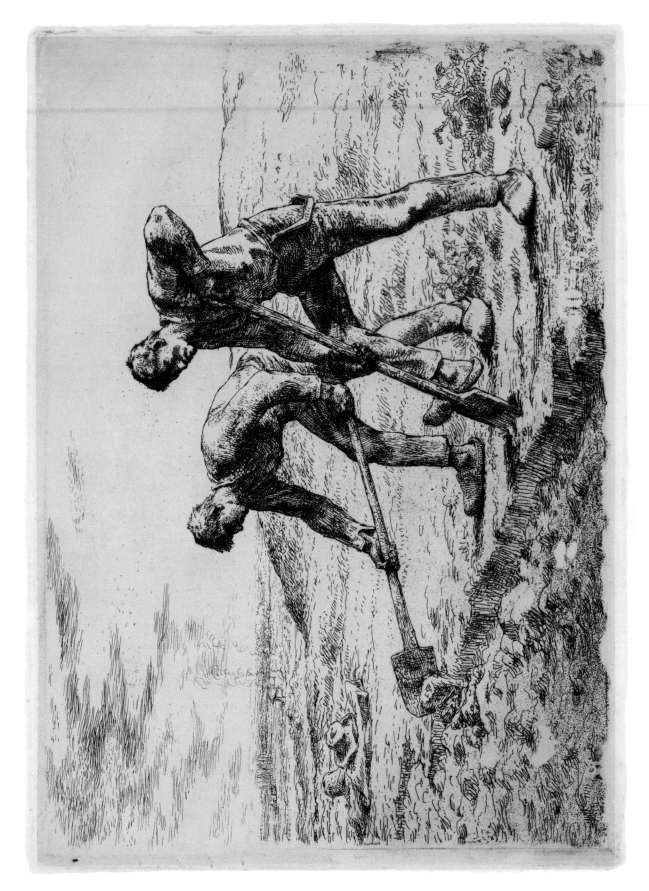

29

30
La Veillée
The Watchers (Keppel)
The Vigil (Keppel; Wickenden; Melot)
Woman Sewing by Lamplight (Murphy)

c. 1855 (Lei & Keil)
1855-1856 (Melot; Murphy)
1856 (Delteil; The New York Public Library)
MEZAC, Delteil 14 ii/ii; Lebrun 15, only state; Lei & Keil 10 ii/ii; Melot 14 ii/ii
Etching

Platemark: 151 x 110 mm. (5⁵⁄₁₆ x 4⁵⁄₁₆ in.)

On loan from the S. P. Avery Collection, Miriam & Ira D.
Wallach Division of Art, Prints and Photographs, The New
York Public Library, Astor, Lenox and Tilden Foundations.

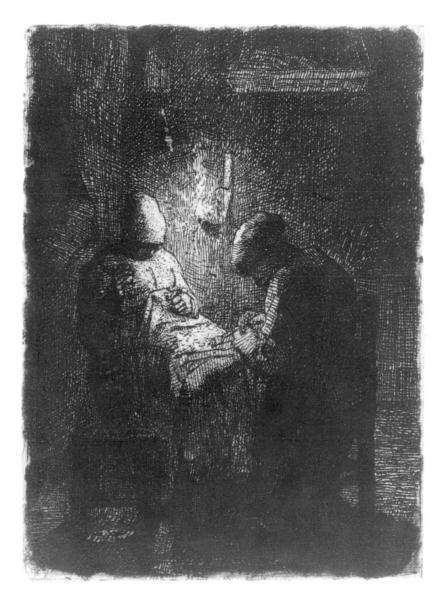

30

31

La Cardeuse
La Cardeuse de laine (Burty)
Carding (Henley)
Carding Wool (Keppel; Wickenden)
The Woman Carding Wool (Keppel; Wickenden)
The Wool-Carder (Keppel)
Woman Carding (Melot)
Woman Carding Wool (Murphy)

1855-1856 (Lei & Keil; Melot; Murphy)
Delteil 15, only state; Lebrun 16, only state; Lei & Keil 11, only state;
Melot 15, only state
Etching

Inscriptions and marks on sheet:	On recto: Inscribed in pencil in lower margin by Harold Wright of P. & D. Colnaghi, London: *L.D. 15/only state/La Cardeuse (Early proof) (From the T. G. Arthur collection, Glasgow/1913)* (graphite); *c 26429. A 9291* (graphite; crossed out); *39* (graphite) On verso: stamp of S. W. Pelletier in reddish brown ink (1983; 6·1·3)
Platemark:	256 x 176 mm. (10³⁄₃₂ x 6¹⁵⁄₁₆ in.)
Sheet:	329.5 x 226.5 mm. (12³¹⁄₃₂ x 8²⁹⁄₃₂ in.)
Provenance:	Thomas Glen Arthur, Glasgow (cf. Lugt 129); [Craddock & Barnard, London, June 1, 1983, cat. 146, no. 212].
Description:	Early impression in black ink on old, French laid paper of a slightly grayish cream tint. Printed with light, uneven plate tone. Impressions of this print are recorded in WAGB (3), BMFA, AIC (2), MMA, NYPL, BN (2), TMA (2), YALE, the Brooklyn Museum, the Herbert F. Johnson Museum of Art at Cornell University, and the National Gallery of Art in Washington, D.C.
Literature:	*Engravings & Etchings (Fifteenth to Twentieth Centuries)* (Catalogue 146). London: Craddock & Barnard, June 1983, no. 212 (illustrated in pl. VI). "Masterpieces of European Printmaking: 15th-19th Centuries," *Georgia Museum of Art Bulletin* 9, nos. 2-3 (Winter-Spring 1984), no. 67 (p. 37).
Exhibited:	*Masterpieces of European Printmaking: 15th-19th Centuries.* Athens, Georgia: Georgia Museum of Art, The University of Georgia, September 21-December 31, 1983.

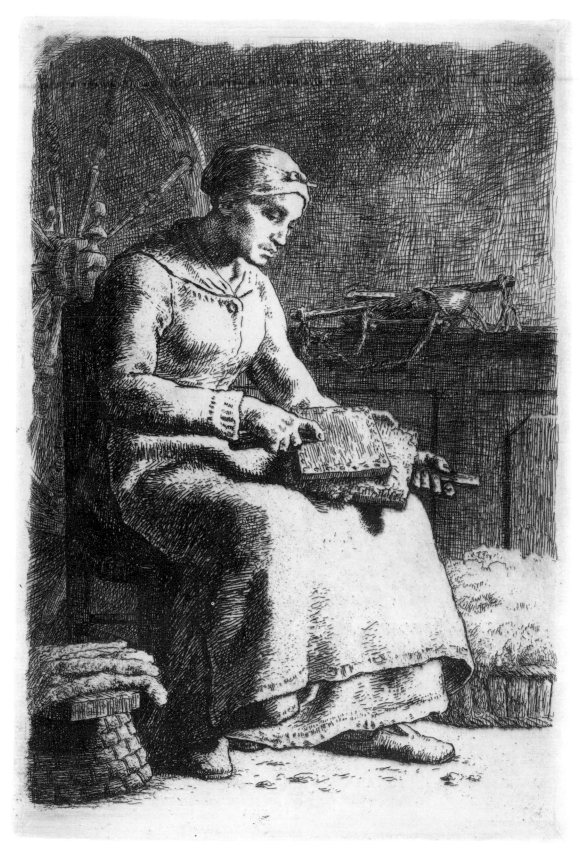

31

32
La Gardeuse d'Oies
A Girl Minding Geese (Keppel)
Goosegirl (Wickenden)
The Goosegirl (Melot)
Young Woman Tending Geese (Murphy)

1855-1856 (Lei & Keil; Murphy)
Delteil 16, only state; Lebrun 17, only state; Lei & Keil 9,
only state; Melot 16, only state
Drypoint

Inscriptions and marks on sheet:	On recto in lower margin: *L.D 16/only state/La gardeuse d'oies by J. F. Millet/(Early proof). Rare* (graphite); *TX* over *04* (graphite) On verso: *MG-83-13-RIEP* (graphite); stamp of S. W. Pelletier in reddish brown ink (1983; 11 · 30 · 4)
Platemark:	143 x 121 mm. (5⅝ x 4¾ in.)
Sheet:	220 x 164 mm. (8²¹⁄₃₂ x 6¹⁵⁄₃₂ in.)
Provenance:	[Paul McCarron, New York, November 30, 1983].
Description:	Early impression in black ink on old, thick, ivory-colored laid paper. With burr on the lines and light plate tone. Lebrun stated that only a few proofs were printed on China paper and on old, laid paper and described this print as *"très rare."* Impressions are recorded in BMFA, FMA (from the canceled plate), AIC (2), NYPL, BN, and TMA.
Literature:	*Catalogue 6.* New York: Paul McCarron, no. 36 (illustrated).

32

33

La Bouillie
La Femme faisant manger son Enfant (Burty; Lebrun; Beraldi; Melot)
La Soupe (Keppel)
The Woman Feeding her Child (Keppel; Wickenden)
Gruel: Woman Feeding Her Child (Melot)
Woman Feeding a Child (Murphy)

1861 (Lebrun; Delteil; Lei & Keil; Melot; Murphy)
Delteil 17 ii/v; Lebrun 18 ii/iv; Lei & Keil 17 ii/v; Melot 17 ii/v
Etching

Inscriptions and marks on sheet:	On recto: signed by artist: *J. F. Millet* (graphite); *3958* (graphite)
	On verso: *FNX²ⁿᵈ* (graphite); *A 19102* (graphite); stamp of S. W. Pelletier in reddish brown ink (1974; 5·1·3)
Platemark:	214 x 159 mm. (8⁷⁄₁₆ x 6¼ in.) image: 155 x 130 mm. (6³⁄₃₂ x 5⅛ in.)
Sheet:	292.5 x 205 mm. (11¹⁷⁄₃₂ x 8¹⁄₁₆ in.)
Watermark:	Unidentified
Provenance:	[Frederick Keppel, New York, 1930]; [Kennedy Galleries, New York, May 1, 1974].
Description:	A strong, early impression in brownish black ink on *Chine collé* over thick, cream-colored laid paper. An old Kennedy & Co. label on mat (inv. no. 80777) reads: *"First State. Very rare."* A penciled note on mat says: "Sold by Keppel 1930 $120." Lebrun and Delteil described this state as *"très rare."* Madame Heymann (Millet's daughter) with her baby modeled for this etching.
	This is the state before the addition of Millet's name, but after removal of the marginal sketches of Delteil's first state. Delteil knew of only one impression of this second state in a Paris collection (J. Gerbeau). Impressions of this state are recorded in AIC (2), DAC, and NYPL.
Literature:	*An Exhibition. One Hundred Fine Prints in Celebration of our Hundredth Year as Fine Print Dealers 1874-1974.* New York: Kennedy Galleries, July 1974, no. 52 (illustrated).
Exhibited:	*An Exhibition. One Hundred Fine Prints in Celebration of our Hundredth Year as Fine Print Dealers 1874-1974.* New York: Kennedy Galleries, July 1974.

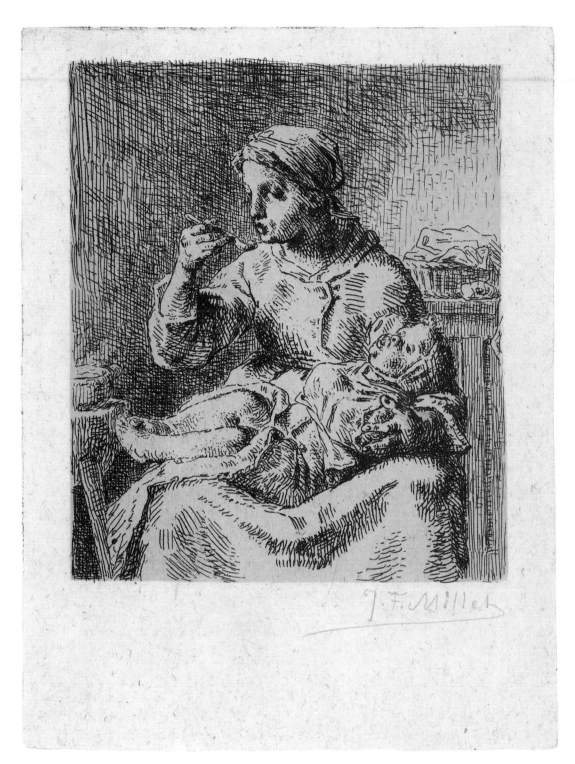

33

34
La Grande Bergère
Knitting (Henley)
The Shepherdess Knitting (Keppel; Wickenden)
The Large Shepherdess (Melot)
Shepherdess Knitting (Murphy)

1862 (Lebrun; Delteil; Lei & Keil; Melot; Murphy)
Delteil 18, only state; Lebrun 19, only state; Lei & Keil 18,
only state; Melot 18, only state
Etching

Inscriptions on plate:	In lower left corner, signed: *J. F. Millet.*
Inscriptions and marks on sheet:	On verso: *NX.* (graphite); *C 45249* (graphite); *Δ a 60609* (graphite); *A* (graphite); stamp of S. W. Pelletier in reddish brown ink (1991; 12 · 3 · 10) On back of mat is a label reading: *C 45270*
Platemark:	320 x 236.5 mm. (12^{19}⁄$_{32}$ x 9^{5}⁄$_{16}$ in.) (outside dimensions of beveled platemark)
Sheet:	417.5 x 304 mm. (16^{7}⁄$_{16}$ x 11^{31}⁄$_{32}$ in.)
Watermark:	*IW[]TA*
Provenance:	[Catherine E. Burns, Oakland, California, December 3, 1991].
Description:	Life-time impression in dark brown ink on old, medium weight, ivory-colored laid paper. Printed with light plate tone and inky plate corners. On verso is a seam in paper (not visible on recto). Impressions of this print are recorded in WAGB, BMFA, AIC (2), NYPL (2), BN (2), TMA, YALE, and Smith College.
Literature:	*European and American Prints* (List No. 11). Oakland, California: Catherine E. Burns. *19th and Early 20th Century Fine Prints and Drawings*, September 1991, p. 3.

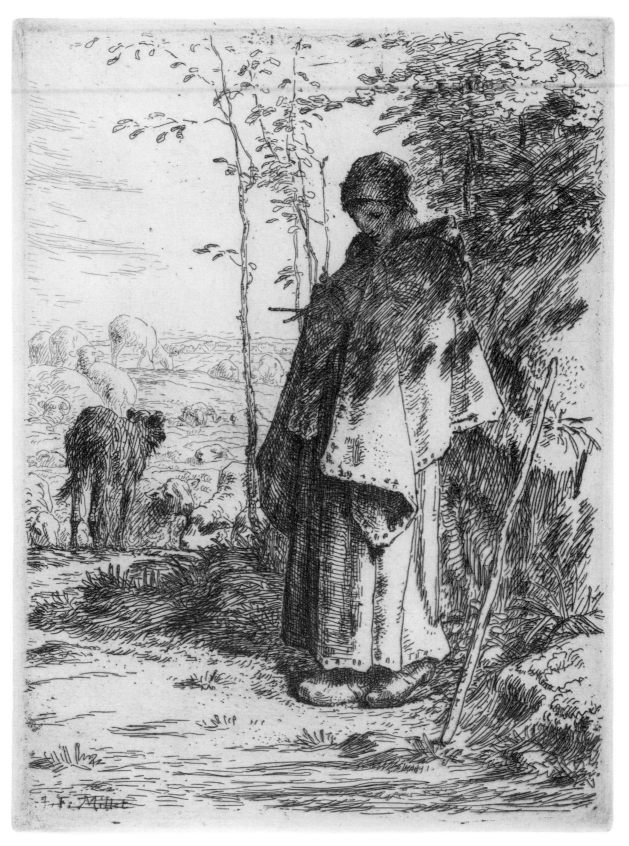

34

35

Le Départ Pour le Travail
Frère et soeur (Phillip Burty sale, London, 1876)
Allant Travailler (J.-F. Millet, letter to Sensier, Nov. 8, 1863;
Fine Art Society Catalogue, London, 1879; Cartwright)
Starting for Work (Henley)
Peasants Starting for Work (Keppel)
Peasants Going to Work (Keppel)
Going to Work (Wickenden; Melot)
Peasant Couple Going to Work (Murphy)

1863 (Lebrun; Delteil; Lei & Keil; Melot; Murphy)
Delteil 19 ii/vii; Lebrun 20 ii/iv; Lei & Keil 19 ii/viii; Melot 19 iib/vii
Etching

Inscriptions on plate:	In lower left corner: *J. F. Millet.*
Mark on sheet:	On verso: stamp of S. W. Pelletier in reddish brown ink (1990; 1 · 22 · 1)
Platemark:	388 x 310 mm. (15⁹⁄₃₂ x 12⁷⁄₃₂ in.)
Sheet:	483 x 395 mm. (19⅓₂ x 15⁹⁄₁₆ in.)
Provenance:	The Minot Estate, Beverly, Massachusetts; [Ernest S. Kramer Fine Arts & Prints, Wellesley Hills, Massachusetts, January 22, 1990].
Description:	Warm black ink on thin, beige-colored wove paper. Printed with light plate tone. The face of the little female figure at the lower left shows clearly. This is the second state before the addition of the address. Lebrun and Delteil described this state as *"rare."* This state is recorded in AIC, DIA, and YALE.
Literature:	*Inaugural Catalogue. A Selection of Fine Works on Paper for the Connoisseur.* Wellesley Hills, MA: Ernest S. Kramer Fine Arts & Prints, November 1989, p. 20 (illustrated).

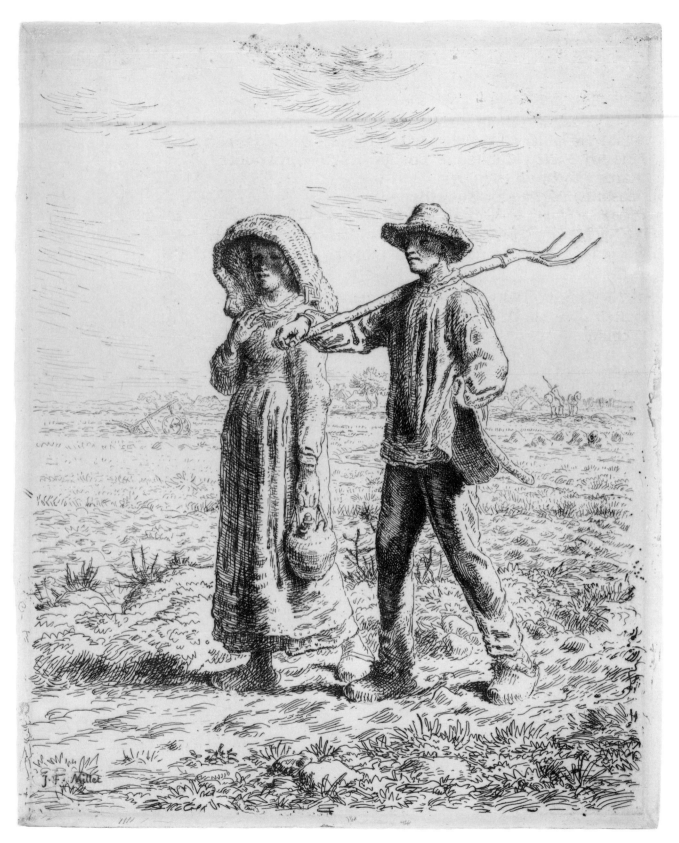

35

36

La Fileuse Auvergnate
La Fileuse (Lebrun; Beraldi)
Shepherd-Girl Spinning (Keppel)
The Spinner (Keppel)
A Spinner of Auvergne (Wickenden)
Fileuse Auvergnate (Melot)
Auvergnat Woman Spinning (Melot)
Auvergnat Goatherd Spinning (Murphy)

1868 (Delteil; Lei & Keil; Melot; Murphy)
Delteil 20 v/v; Lebrun 21 iii/iii; Lei & Keil 20 v/v; Melot 20 v/v
Etching

Inscriptions on plate:	In lower right corner: *J. F. Millet.*
Inscriptions and marks on sheet:	On recto: stamp of Alfred Beurdeley in black ink On verso: *A. V. bois Louis* (?) *XVI* (graphite); *ZZ 724* (graphite); *16* (graphite); *D. 20 v/v (Lugt 421)* (graphite); stamp of S. W. Pelletier in reddish brown ink (1986; 4 · 16 · 1)
Platemark:	198 x 130 mm. (7²⁵⁄₃₂ x 5⅛ in.)
Sheet:	304 x 217.5 mm. (11³¹⁄₃₂ x 8⁹⁄₁₆ in.)
Provenance:	Alfred Beurdeley, Paris (Lugt 421); [Theodore B. Donson, Ltd., New York, April 16, 1986].
Description:	Black ink on ivory-colored laid paper. Printed with plate tone and inky plate edges. This is the definitive state published in *Sonnets et eaux-fortes*, Paris: Alphonse Lemerre, 1869. This state is recorded in BMFA (2), AIC, TMA (2), YALE, and the Iida Gallery in Tokyo.

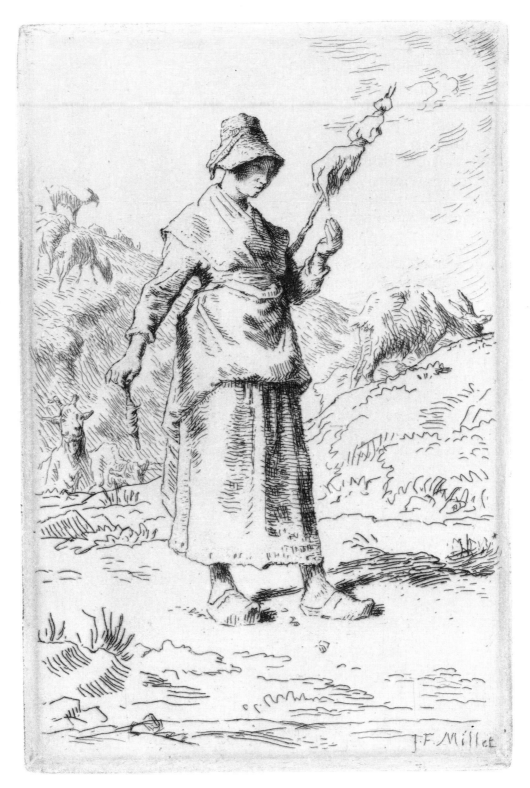

36

Selected Bibliography

General

Bailley-Herzberg, Janine, *Dictionnaire de l'Estampe en France, 1830-1950*. Paris: Arts et Metiers Graphiques, 1985.

Baudelaire, Charles, "Peintres et Aquafortistes," *Le Boulevard* (14 September 1862). Translated in Jonathan Mayne, ed., *Art in Paris 1845-1862: Salons and Other Exhibitions Reviewed by Charles Baudelaire*. London: Phaidon Publishers Inc., 1965, pp. 217-222.

"Bibliographie des Ouvrages Publiés en France sur les Beaux-Arts pendant 1 Année 1859," *Gazette des Beaux-Arts* IV (1859): 357-378.

"Bibliographie des Ouvrages Publiés en France sur les Beaux-Arts pendant le Second Semestre de 1 Année 1860," *Gazette des Beaux-Arts* VIII (1860): 375-386.

Blanc, Charles, "De la Gravure à l'Eau-Forte et des Eaux-Fortes de Jacque," *Gazette des Beaux-Arts* IX (1861): 193-208.

Burty, Philippe, "La Gravure et la Lithographie à l'Exposition de 1861," *Gazette des Beaux-Arts* XI (1861): 172-179.

City and Country in French Prints, 1850-1900, exhibition checklist, The University of Michigan Museum of Art, Ann Arbor, 1990.

Clark, T. J., The *Absolute Bourgeois; Artists and Politics in France, 1848-1851*. Princeton: Princeton University Press, 1982.

Costanzo, Dennis Paul, "Cityscape and the Transformation of Paris during the Second Empire," 2 vols., Ph.D. dissertation, University of Michigan, Ann Arbor, 1981.

Eiland, William U., "Napoleon III and the Administration of the Fine Arts," Ph.D. dissertation, University of Virginia, Charlottesville, 1978.

Hind, A.M., *A Short History of Engraving and Etching*. London: Archibald Constable and Co. Ltd., 1908.

Hugo, Victor, *Notre-Dame de Paris*. Paris: J. Claye, 1831.

Lawton, Richard, and Lee, Robert, eds., *Urban Population Development in Western Europe from the Late-Eighteenth to the Early-Twentieth Centuries*. Liverpool: Liverpool University Press, 1988.

Lugt, Frits, *Les Marques de collections de dessins et d'estampes*. La Haye: M. Nijhoff, 1956.

Mantz, Paul, "Salon de 1859," *Gazette des Beaux-Arts* III (1859): 21-39.

Pinkney, David H., *Napoleon III and the Rebuilding of Paris*. Princeton: Princeton University Press, 1958.

The Second Empire, 1852-1870: Art in France under Napoleon III, exhibition catalogue, Philadelphia Museum of Art, Philadelphia, Pennsylvania, 1978.

Weisberg, Gabriel P., ed., *The European Realist Tradition*. Bloomington: Indiana University Press, 1982.

Charles Meryon

Burke, James D., *Charles Meryon: Prints and Drawings*. New Haven, Connecticut: Yale University Art Gallery, 1974.

Burty, Philippe, "L'Oeuvre de M. Charles Meryon," *Gazette des Beaux-Arts* V (June 1863): 519-533; and (July 1863): 75-88.

Burty, Philippe, *Charles Meryon: Sailor Engraver, and Etcher. A Memoir and Complete Descriptive Catalogue of His Works*. London: Fine Art Society, 1879.

Delteil, Loys, *Charles Meryon*. Vol. II, *Le Peintre-graveur illustré*. Paris: Loys Delteil, 1907.

Delteil, Loys, and Wright, Harold J. L., *Catalogue Raisonné of the Etchings of Charles Meryon*. New York: Winfred Porter Truesdell, 1924. (Revision of Delteil, *Meryon*, 1907).

Ducros, Jean, *Charles Meryon, Officier de la Marine, Peintre-Graveur, 1821-1868*. Paris: Musée de la Marine, 1968.

Geoffroy, Gustave, *Charles Meryon*. Paris: Floury, 1926.

Hammel-Heider, Gabriele, "Bemerkungen zu Meryons Stadtland-schaften," *Zeitschrift für Kunstgeschichte* XL, no. 3-4 (1977): 245-264.

Holcomb, Adele M., "Le Stryge de Notre-Dame: Some Aspects of Meryon's Symbolism," *Art Journal* XXXI (Fall 1971): 150-157.

Schneiderman, Richard, with the assistance of Frank W. Raysor, II, *The Catalogue Raisonné of the Prints of Charles Meryon*. London: Garton and Co. in association with Scolar Press, 1990.

Stokes, Hugh, *Etchings of Charles Meryon*. London: George Newnes Ltd; and New York: Charles Scribner's Sons, 1906.

Stuffman, Margaret, et al., *Charles Meryon: Paris um 1850; Zeichnungen, Radierungen, Photographien*. Frankfurt: Stadtelsches Kunstinstitut und Stadtische Galerie, 1975.

Verdier, Philippe, "Charles Meryon: *Mes Observations (1863)*," *Gazette des Beaux-Arts* 102 (December 1983): 221-236.

Yarnall, James Leo, "Meryon's Mystical Transformations," *Art Bulletin* LXI (June 1979): 289-300.

Jean-François Millet

Alfred Lebrun's Catalogue of the Etchings, Heliographs, Lithographs, and Woodcuts Done by Jean-François Millet. New York: Frederick Keppel and Co., 1887.

Bartlett, T. H., "Barbizon and Jean-François Millet," *Scribner's Magazine* VII (May 1890): 531-555; and (June 1890): 735-755.

Beraldi, Henri, "Millet." *Les Graveurs du XIXe Siècle*, vol. X (Paris, 1890), pp. 63-71.

Burty, Philippe, "Les Eaux-Fortes de M. J.-F. Millet," *Gazette des Beaux-Arts* XI (1861): 262-266.

Delteil, Loys, *J.F. Millet, Th. Rousseau, Jules Dupré, J. Barthold Jongkind*. Vol. I, *Le Peintre-graveur illustré*. Paris: Chez l'Auteur, 1906.

Herbert, Robert L., *Barbizon Revisited*. New York: Clarke and Way, Inc., 1962.

_____. "City vs. Country: The Rural Image in French Painting from Millet to Gauguin," *Artforum* (February 1970): 44-55.

_____. "Millet Revisited - I," *Burlington Magazine* CIV (July 1962): 294-305; "Millet Revisited - II," (September 1962): 377-385.

Henly, William Ernest, *Jean-François Millet. Twenty Etchings and Woodcuts*. London: The Fine Art Society, 1881.

Keppel, Frederick, and Company, New York, *Catalogue of an Exhibition of Etchings, Wood-Cuts and Original Sketches by J.F. Millet*. New York: F. Keppel and Company, 1908.

Lei, Bonita Y., and Keil, Robert, *The Complete Etchings of Jean-François Millet*. New York: Great Modern Pictures (forthcoming).

Lebrun, Alfred, "Catalogue de l'Oeuvre Gravé de J.-F. Millet," in Alfred Sensier and Paul Mantz, *La Vie et l'Oeuvre de J.-F. Millet*. Paris: A. Quantin, 1881.

Melot, Michel, *Graphic Art of the Pre-Impressionists*. New York: Harry N. Abrams, Incorporated, 1981.

Melot, Michel, *L Oeuvre gravé de Boudin, Corot, Daubigny, Dupré, Jongkind, Millet, Théodore Rousseau*. Paris: Arts et Métiers Graphiques, 1978.

Murphy, Alexandra R., *Jean-François Millet*. Boston: Museum of Fine Arts, 1984.

Sensier, Alfred, *Jean-François Millet: Peasant and Painter*. Boston: James R. Osgood and Co., 1881.

Thyssen, Esther, *Natural and Pastoral Themes by Barbizon Printmakers*. Middletown, Connecticut: Davison Art Center, Wesleyan University, 1985.

Wheelright, Edward, "Personal Recollections of Jean-François Millet," *Atlantic Monthly* 38 (September 1876): 257-276.

Wickenden, Robert J., "The Art and Etchings of Jean-François Millet," *Print-Collector's Quarterly* 2 (1912): 224-250.